CD ROM WITH

BRAUN & SCHNEIDER S HISTORIC COSTUME CD-ROM AND BOOK

DATE DUE			
DEC 1	5 2004	DEC 1 4 2004	
NOV 2	9 2005		
		NOV 2 8 2005	_
DEC	1 1 2007	NUA 3 U 200	7
		NOV 3 0 200	
OCT	2 8 2009	OCT 2 2 2009	_
DE	C 0 9 2014	DEC 1 6 2014 16	_
			_
			_
		· · · · · · · · · · · · · · · · · · ·	_
	'		-
			_
	•		_
			_
			_
			_
			_

DOVER PUBLICATIONS, INC. MINEOLA, NEW YORK

The CD-ROM on the inside back cover contains all of the images shown in the book. There is no installation necessary. Just insert the CD into your computer and call the images into your favorite software (refer to the documentation with your software for further instructions). Each image is saved in three different formats—600-dpi TIFF; high-resolution JPEG, and 72-dpi Internet-ready JPEG. The images can be used in a wide variety of word processing and graphics applications.

The IMAGES folder on the CD contains a number of different folders. All of the TIFF images have been placed in one folder, as have all of the high-resolution JPEG and the 72-dpi JPEG. The images in each of these

folders are identical except for file format. Every image has a file name that corresponds to the number printed with that image in the book.

For technical support, contact:

Telephone: 1 (617) 249-0245 Fax: 1 (617) 249-0245

Email: dover@artimaging.com

Internet:

http://www.artimaging.com/dover.html

The fastest way to receive technical support is via email or the Internet.

Copyright

Copyright © 1975 by Dover Publications, Inc. Electronic images copyright © 2003 by Dover Publications, Inc. All rights reserved.

Bibliographical Note

Braun & Schneider's Historic Costume CD-ROM and Book, first published in 2003, contains all of the plates from Historic Costume in Pictures: Over 1450 Costumes on 125 Plates, published by Dover Publications in 1975. The plates were originally published serially by Braun & Schneider between 1861 and 1890.

Dover Electronic Clip Art®

These images belong to the Dover Electronic Clip Art Series. You may use them for graphics and crafts applications, free and without special permission, provided that you include no more than ten in the same publication or project. For permission for additional use, please write to Permissions Department, Dover Publications, Inc., 31 East 2nd Street, Mineola, New York 11501.

However, republication or reproduction of any illustration by any other graphic service, whether it be in a book, electronic, or in any other design resource, is strictly prohibited.

International Standard Book Number: 0-486-99566-6

Manufactured in the United States of America Dover Publications, Inc., 31 East 2nd Street, Mineola, N.Y. 11501

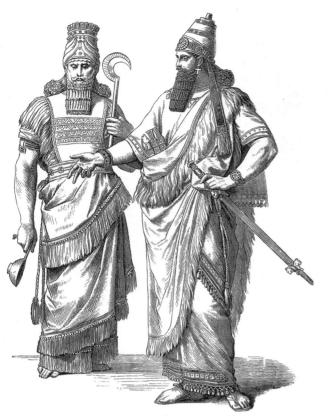

Assyrian high priest 001

Assyrian king

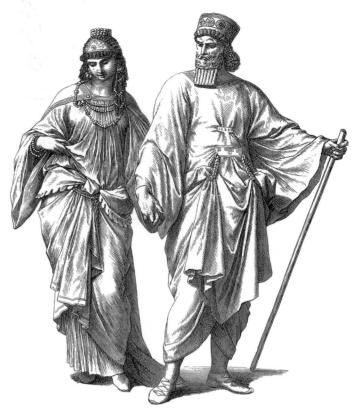

Mede nobility 002

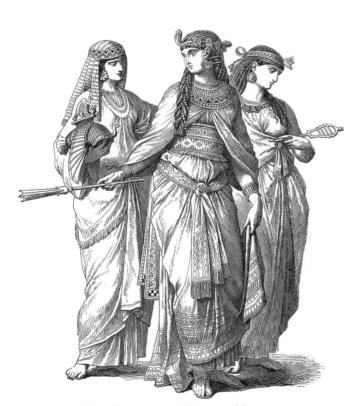

Egyptian queen with two noblewomen $003\,$

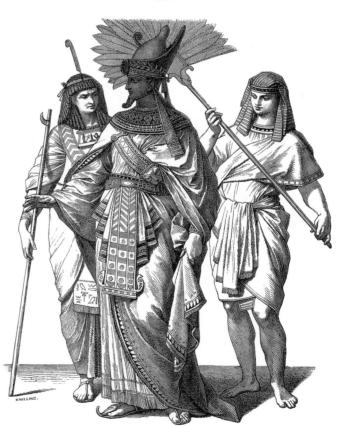

Egyptian court official

PLATE 1 Ancient Near East

Egyptian king Fanbearer

Humber College Library 3199 Lakeshore Blvd. West Toronto, ON M8V 1K8

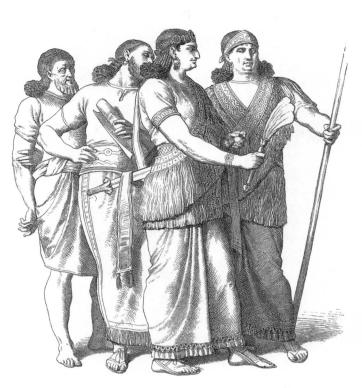

Commoner

Assyrian court official 005

Assyrian noblemen

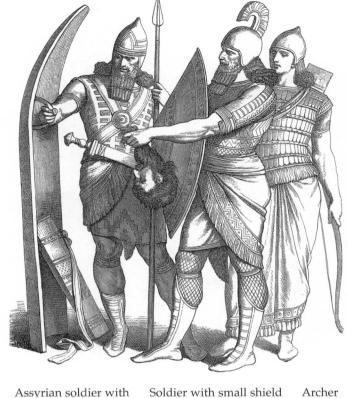

Assyrian soldier with standing shield

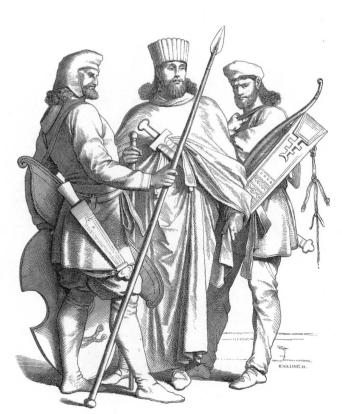

Persian nobleman with two Persian soldiers

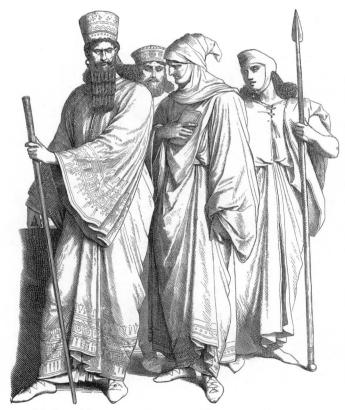

Mede nobleman

Persian nobleman 008

Persian

PLATE 2 ANCIENT NEAR EAST

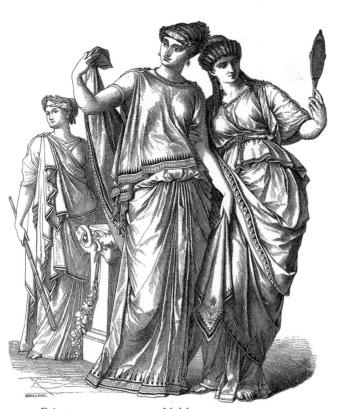

Priestess

Noblewomen 009

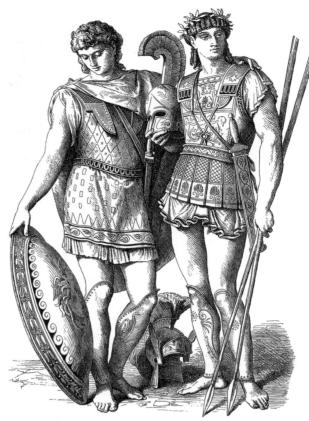

Captains 010

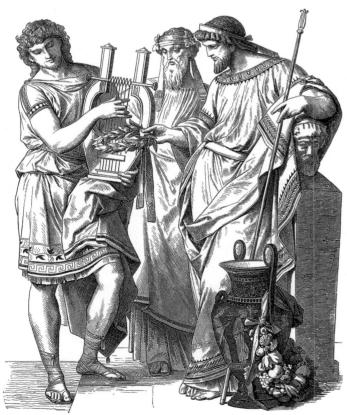

Olympic victor

Priest of Dionysus 011

King

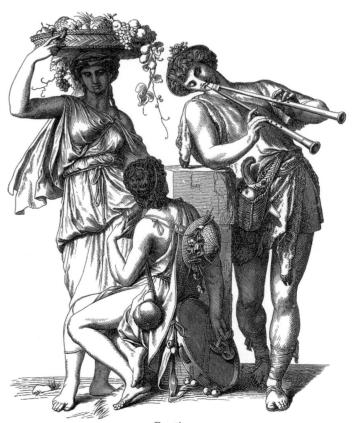

Rustics 012

PLATE 3 ANCIENT GREECE

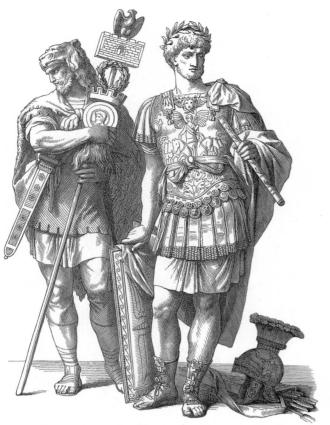

Germanic standard-bearer 013

Roman general

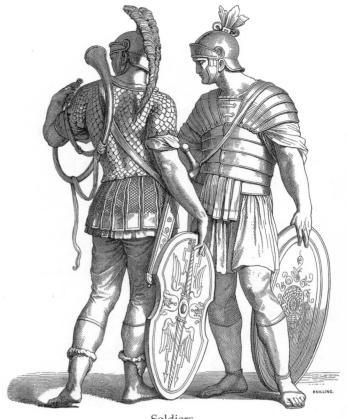

Soldiers 014

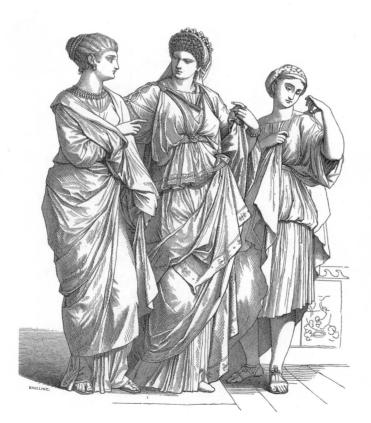

Noblewomen 015

Slave girl

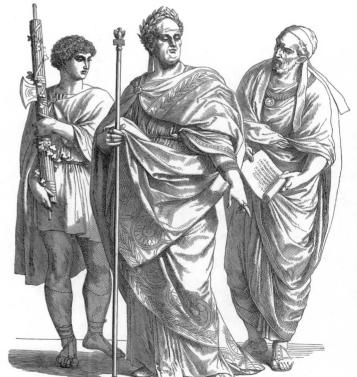

Lictor

Emperor 016

Nobleman

PLATE 4
ANCIENT ROME

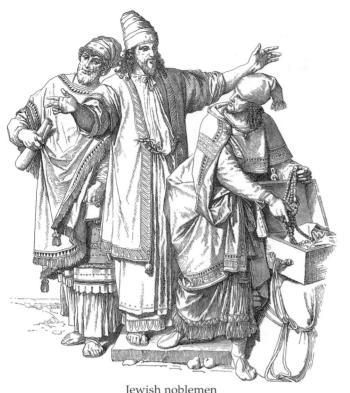

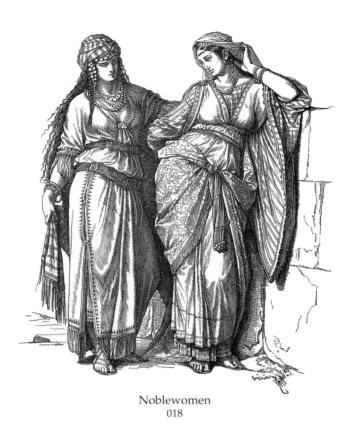

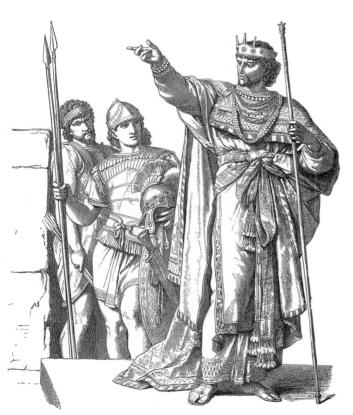

Soldiers 019

King

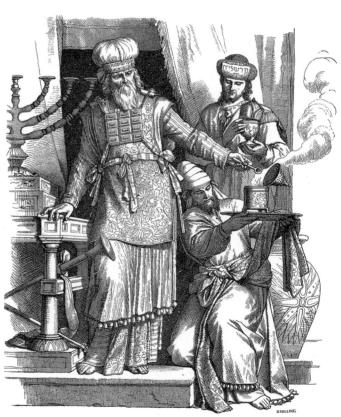

High priest

020

Levites

Plate 5 Ancient Judaea

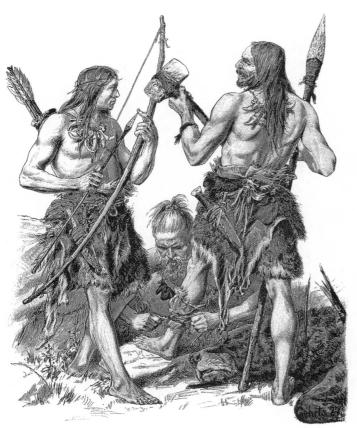

In the Stone Age 021

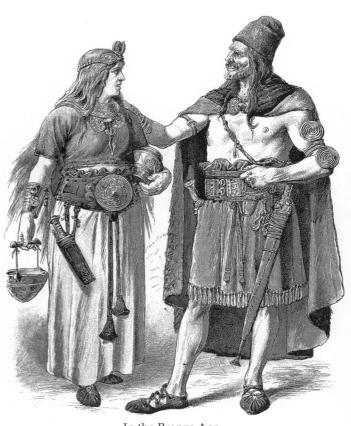

In the Bronze Age 022

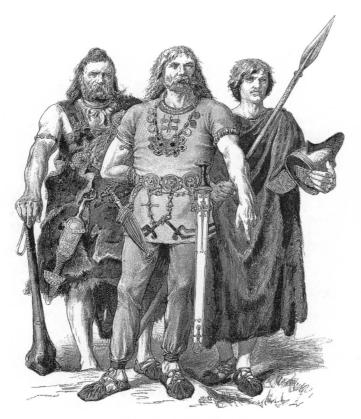

At the beginning of the Christian Era $$\operatorname{\textsc{023}}$$

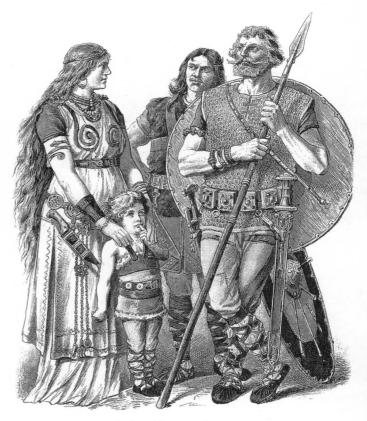

3rd to 4th centuries A.D. $$\tt 024$$

PLATE 6 Ancient Germans

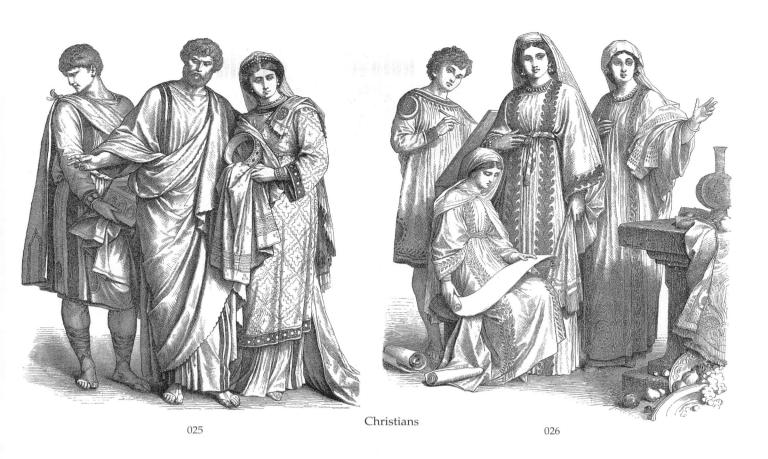

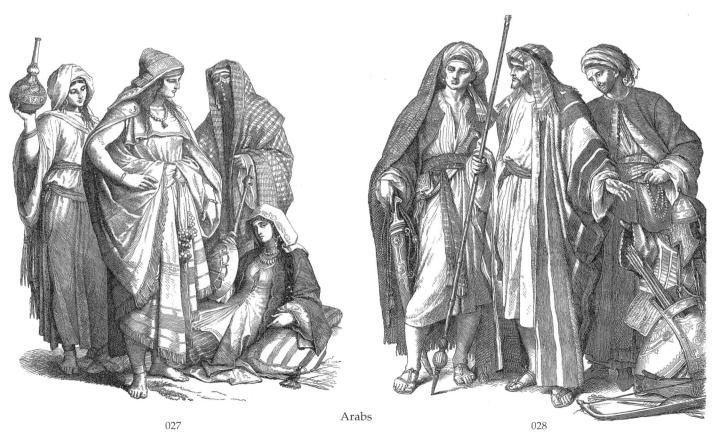

PLATE 7
4TH TO 6TH CENTURIES

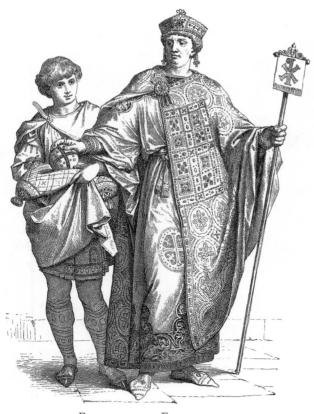

Page

Emperor 029

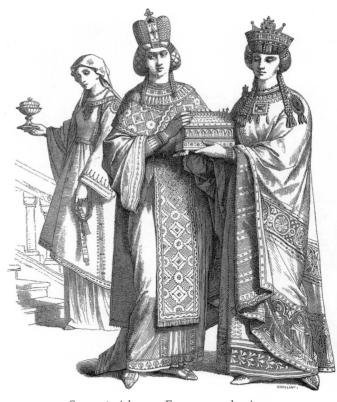

Servant girl

Empress and princess 030

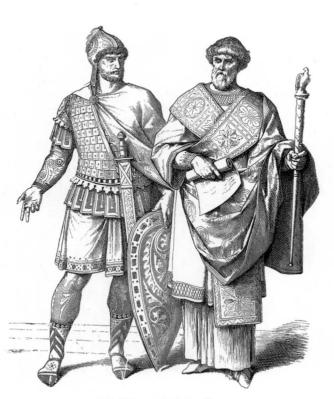

Soldier and chancellor 031

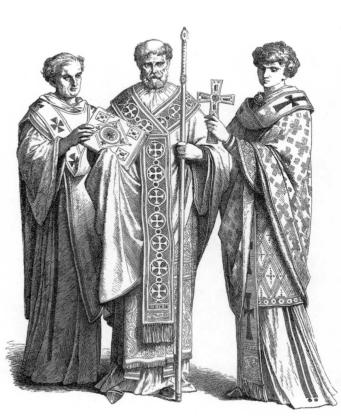

Deacon

Bishop 032

Levite

Plate 8
Byzantine Empire

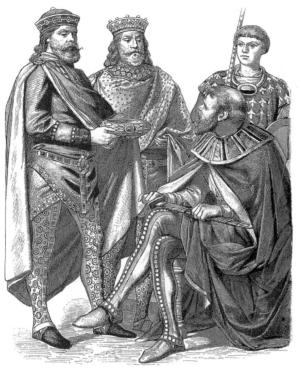

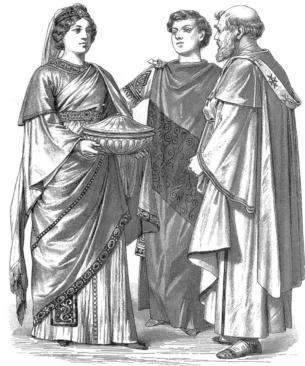

Early 6th century

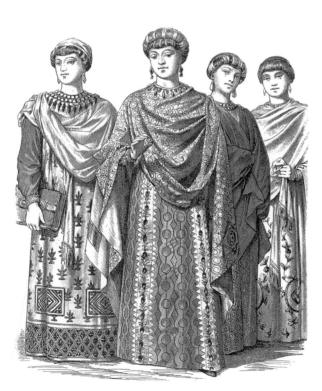

Retinue of Empress Theodora, 547 A.D. 035

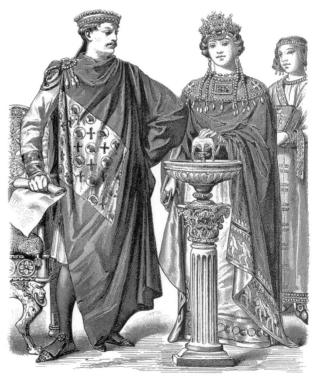

Emperor Justinian (482–565) Empress Theodora (d. 548) \$036\$

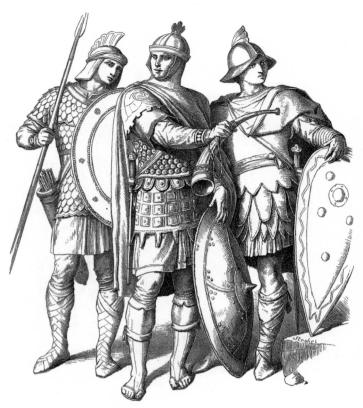

Soldiers of the Eastern Roman Empire $$\operatorname{\mathtt{O}37}$$

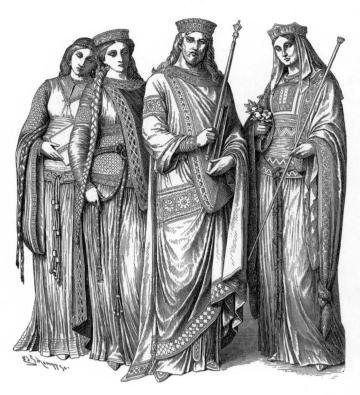

Frankish ladies Charlemagne 038

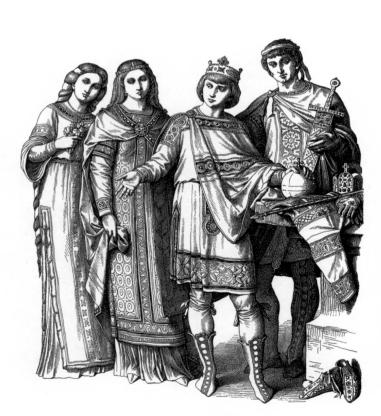

Frankish court dress 039

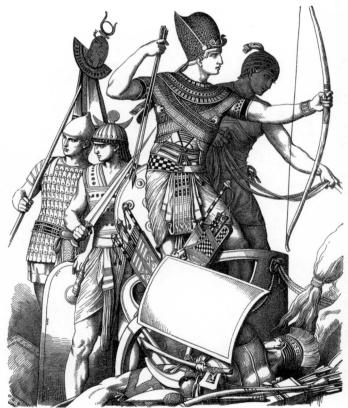

Egyptian soldiers

Egyptian king in battle garb 040

Charioteer

PLATE 10
5TH TO 10TH CENTURIES
(AND ANCIENT EGYPT)

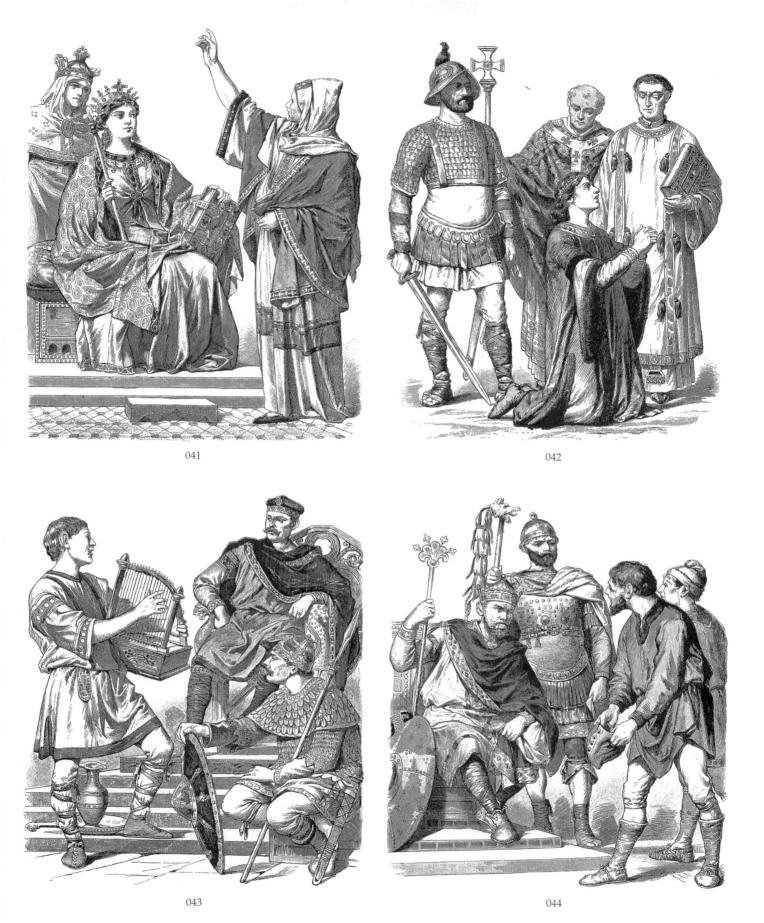

Plate 11 700–800; Carolingians

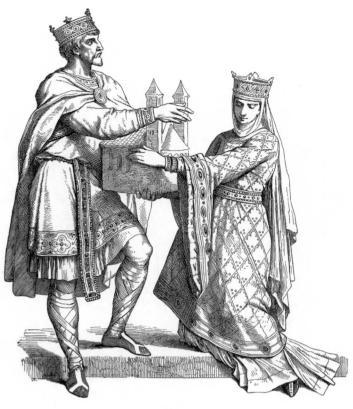

Frankish king and queen 045

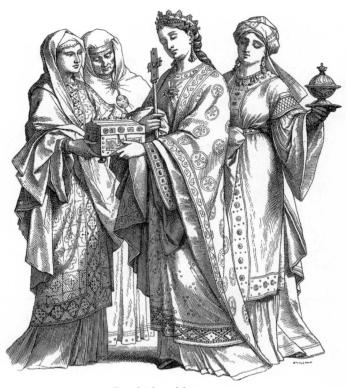

Frankish noblewomen 046

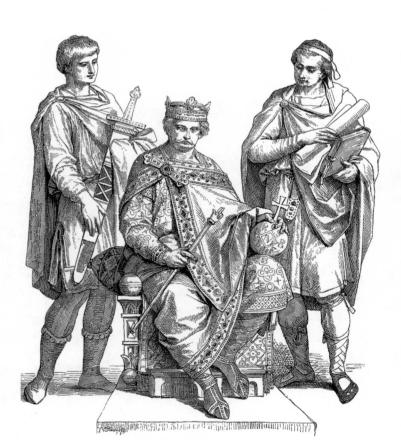

King Charles the Bald 047

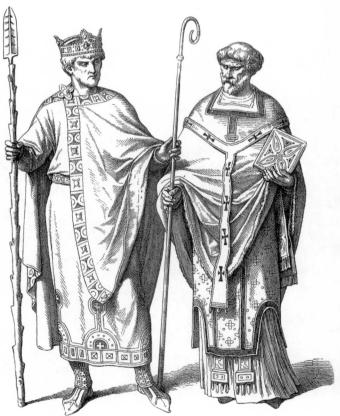

Emperor Henry II Frankish bishop

PLATE 12 10th Century

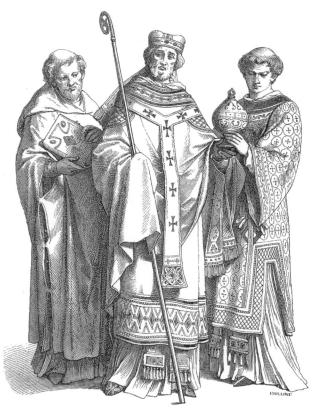

Monk Occidental bishop 049

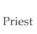

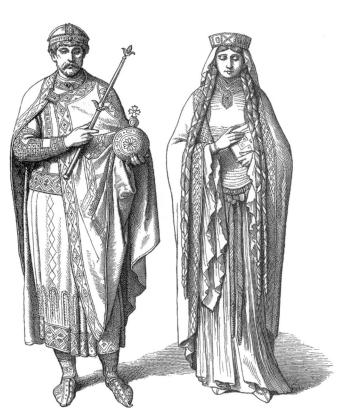

Frankish king and queen 050

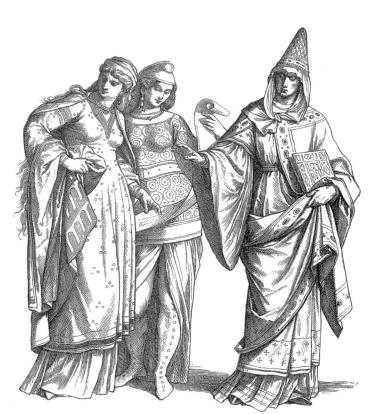

Norman ladies

Norman noblewoman 051

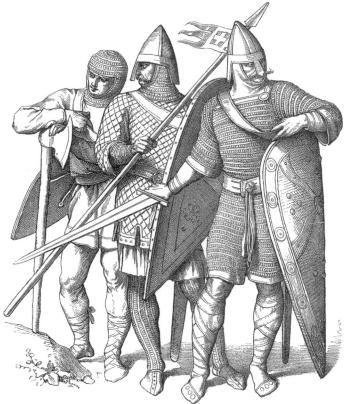

Knights and common soldier in the First Crusade

PLATE 13 11th Century

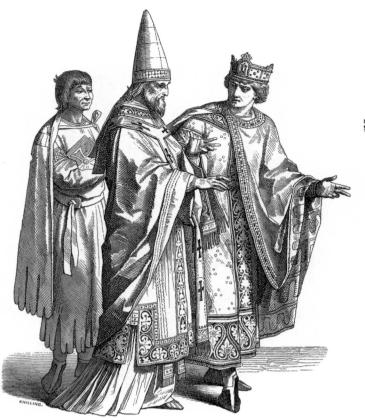

Servant

Pope of Rome 053

King

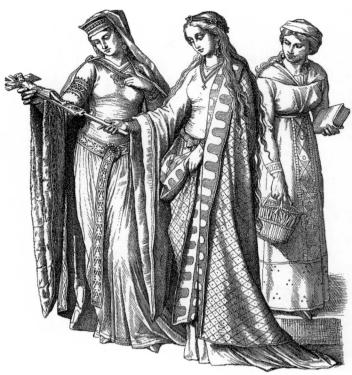

German noblewomen 054

German middle-class woman

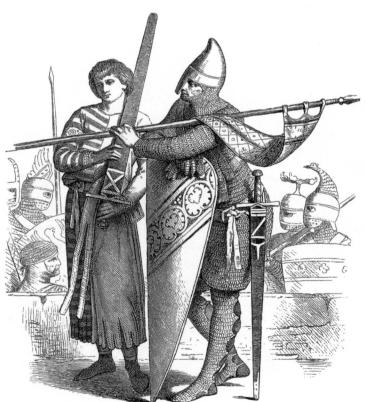

Squire and knight in the First Crusade $$\it 055$$

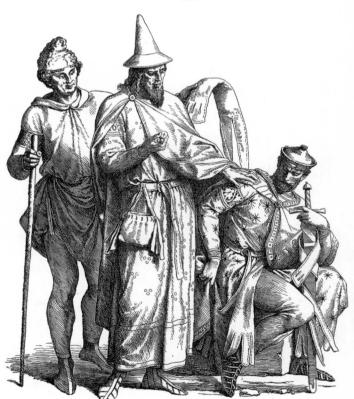

Commoner

Rich Jew 056

Knight

PLATE 14 12TH CENTURY

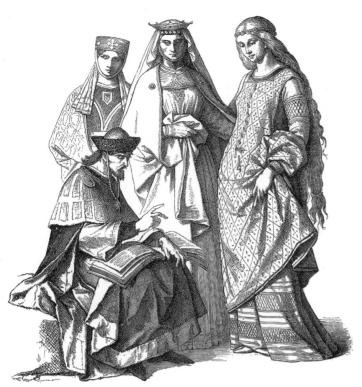

German prince German ladies 057

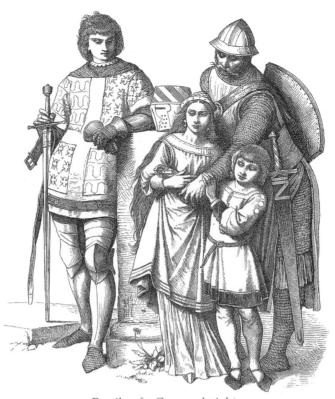

Family of a German knight 058

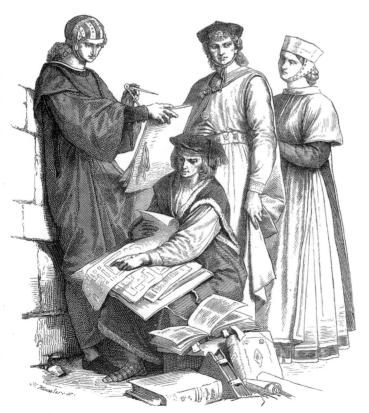

Italian scholars

German middle-class woman

Knight

Prince 060

Templar

059

PLATE 15 13TH CENTURY

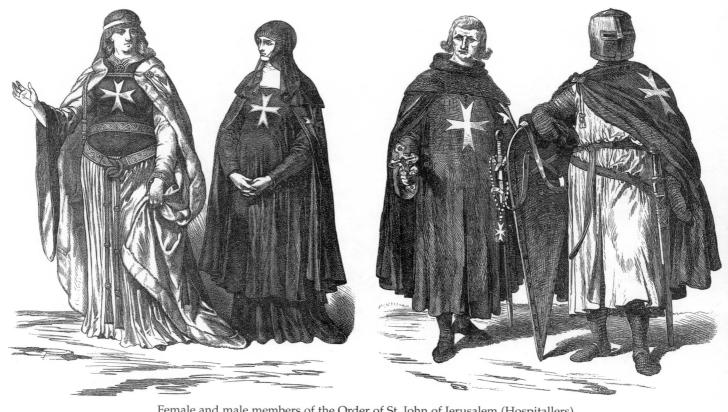

Female and male members of the Order of St. John of Jerusalem (Hospitallers) 061

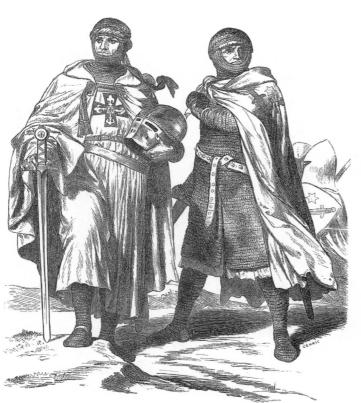

Master and Knight of the Teutonic Order $$\operatorname{\textsc{0}}63$$

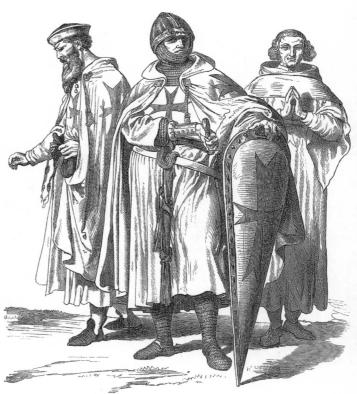

Templars 064

PLATE 16
12TH & 13TH CENTURIES;
MILITARY-RELIGIOUS ORDERS

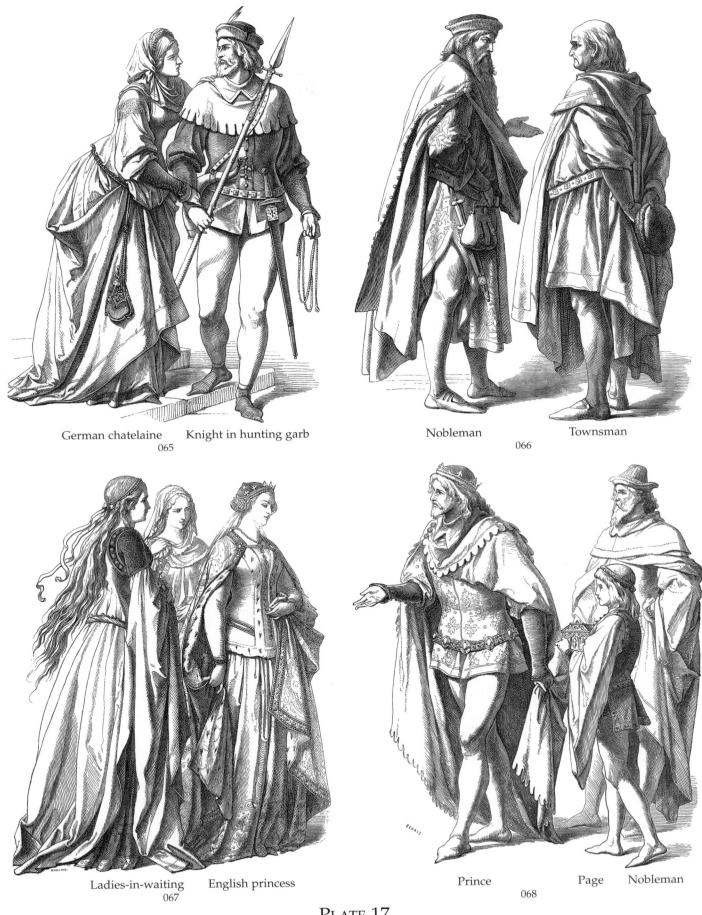

PLATE 17 14TH CENTURY

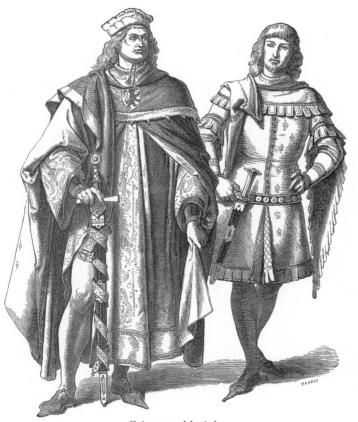

Prince and knight 069

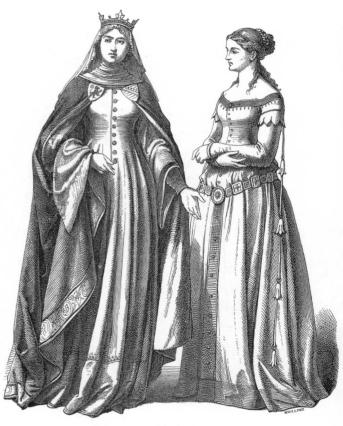

Princess and lady-in-waiting 070

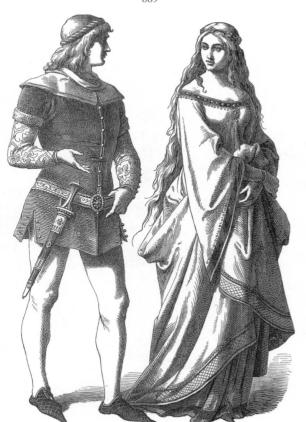

Knight and noble maiden 071

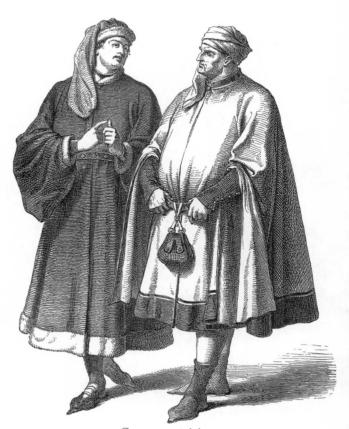

German patricians 072

PLATE 18 14TH CENTURY

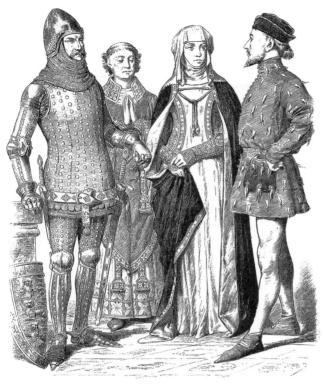

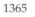

1330 073

1350

1390

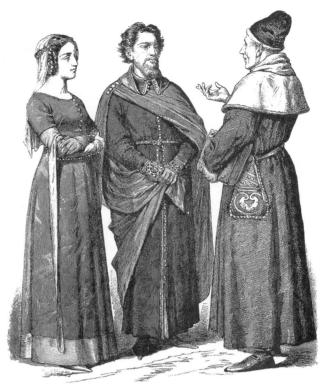

1365

1376 (middle-class garb) 074

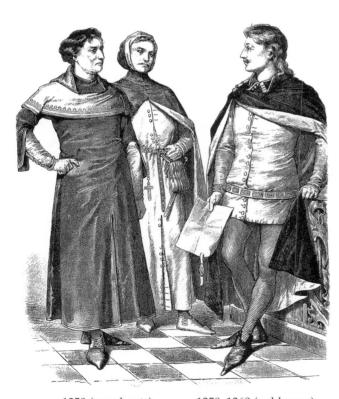

1350 (merchants)

075

1350-1360 (nobleman)

1330–1370 076

Plate 19 14th Century; England

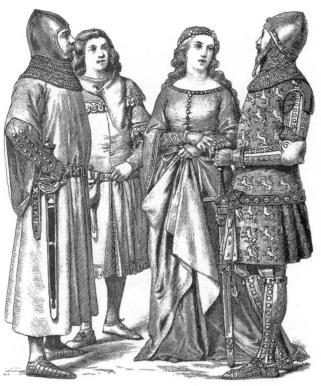

Knightly dress (2nd half of century)

Günther von Schwarzburg, King of Germany, 1349

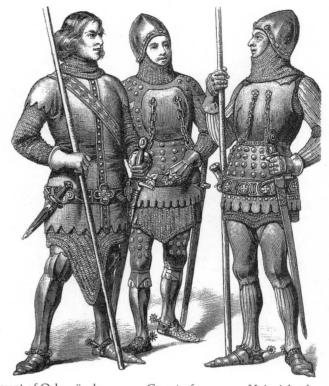

Count of Orlamünde (mid-century)

Count of Katzenellenbogen, 1315 078

Heinrich of Seinsheim, 1360

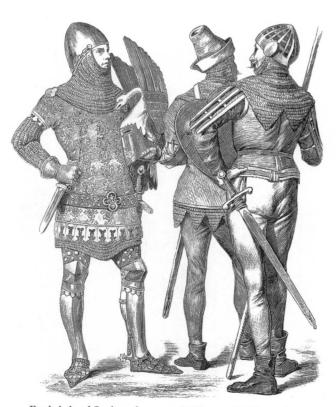

Rudolph of Sachsenhausen, 1370

Battle garb (2nd half of century)

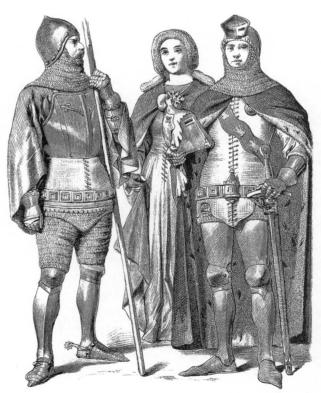

Konrad of Bikenbach, 1393 Weikhard Frosch, 1378 Gudela of Holzhausen, 1371

PLATE 20 14TH CENTURY; GERMANY

Vittore Pisani, Venetian admiral (d. 1380)

Squire 081

Neapolitan knight

Soldiers 082

Girl

Noblewoman 083

Lady of Siena

Young man Roman senator Venetian nobleman 084

 $\begin{array}{c} \textbf{PLATE 21} \\ \textbf{Second Half of the 14th Century; Italy} \end{array}$

Burgundian court dress 085

German court dress 086

German patricians 087

Judge

Townsman

Peasant

PLATE 22 First Half of the 15th Century

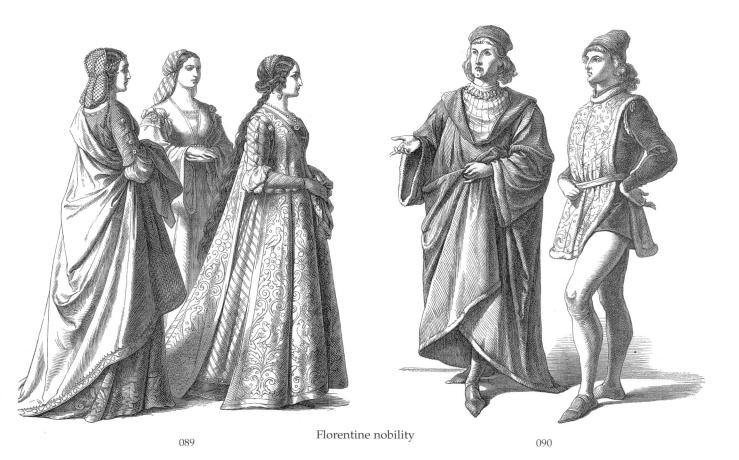

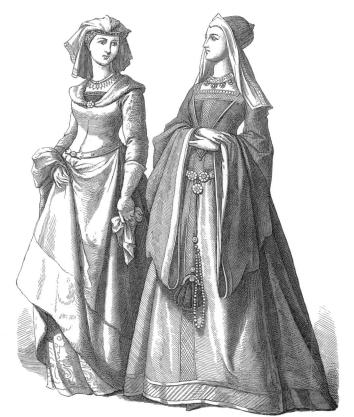

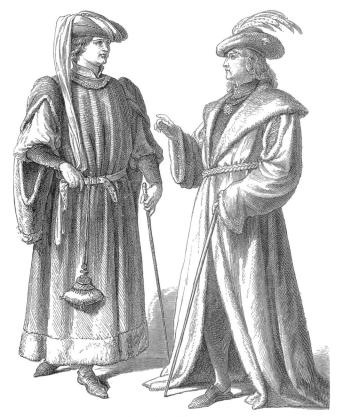

French noblemen 092

PLATE 23
FIRST HALF OF THE 15TH CENTURY

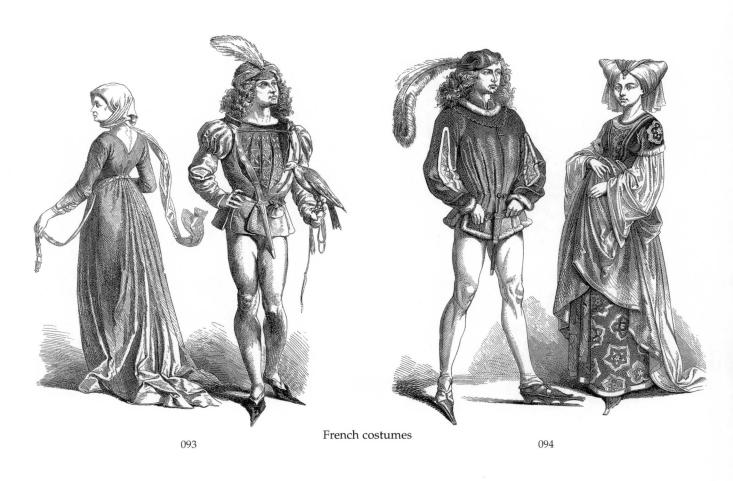

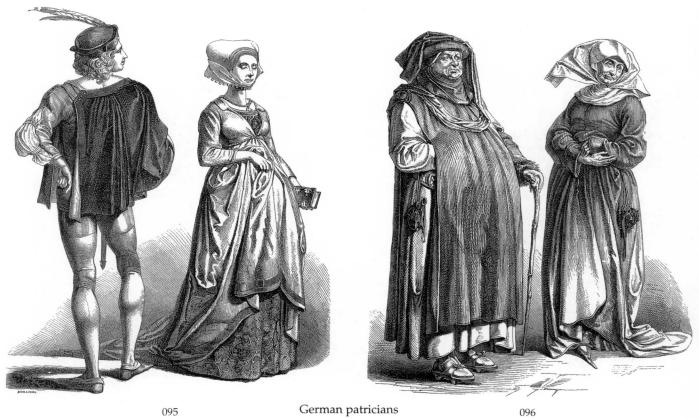

PLATE 24
SECOND HALF OF THE 15TH CENTURY

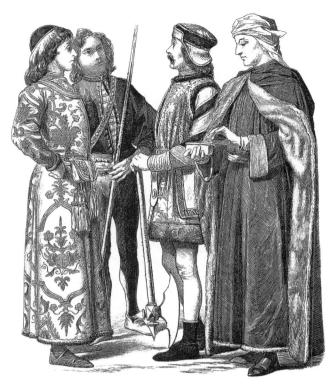

Mid-century 097

Apothecary (1st half of century)

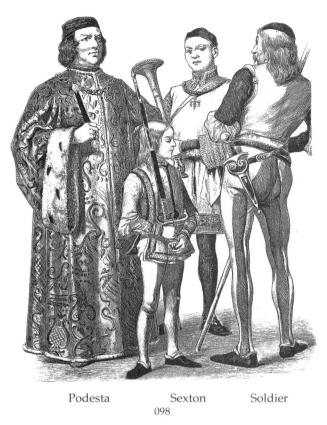

Podesta

Soldier

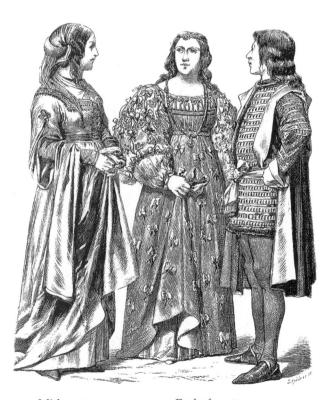

Mid-century

End of century 099

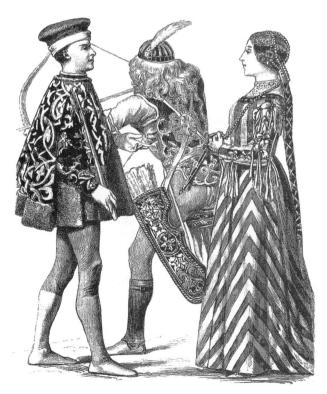

Lord of Rimini

1488 100

Beatrice d'Este, 1490

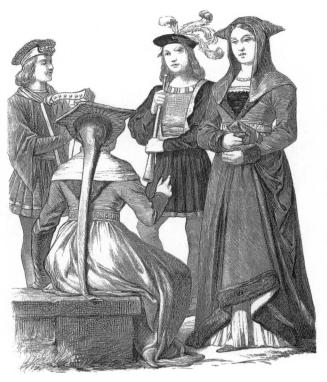

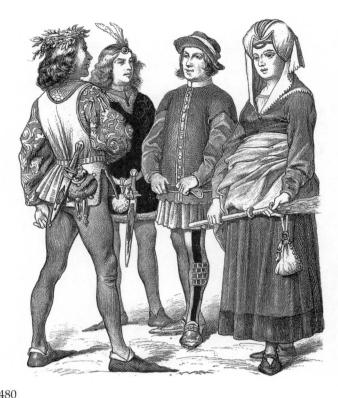

1460–1480

102

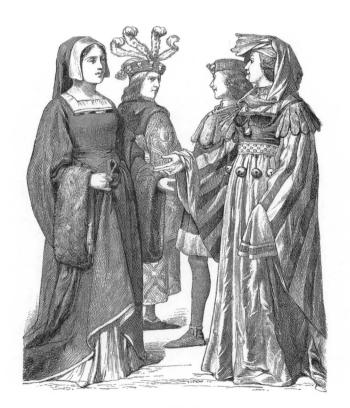

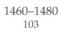

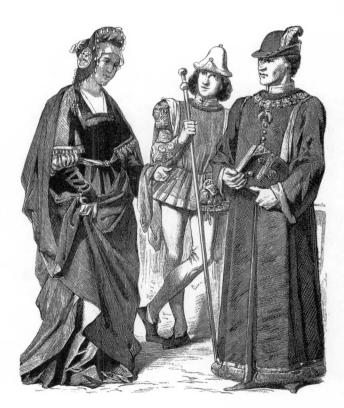

Women's dress, 1480

Charles the Bold, 1477

104

Plate 26 15th Century; France

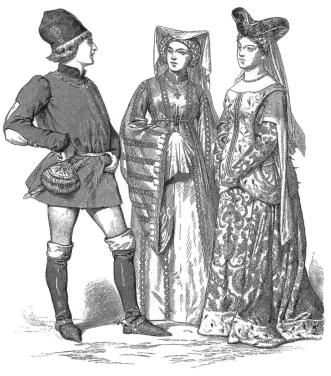

England, 1400 105

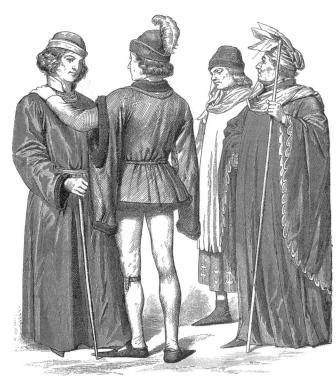

France, 1470 106

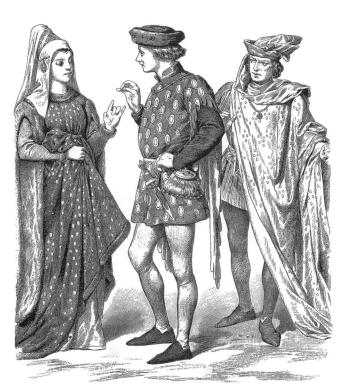

England (1st third of century) 107

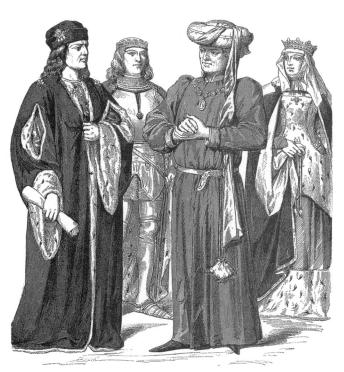

Henry VII Duke of of England (1456–1509) Duke of Suffolk, 1470

Henry VI, 1471

Duchess of Suffolk, 1470

Plate 27
15th Century; France and England

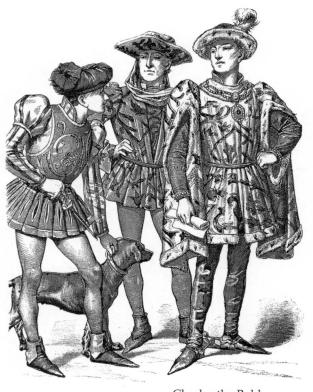

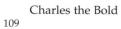

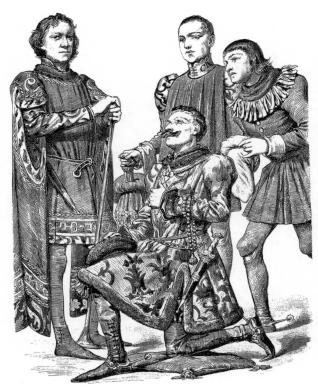

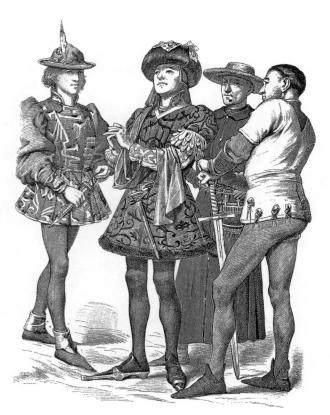

111

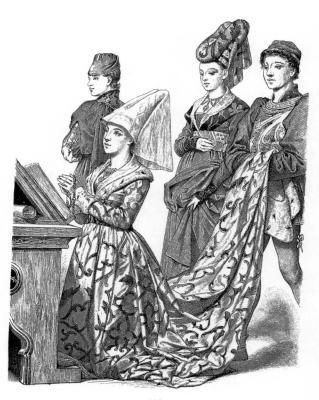

112

Plate 28 Mid-15th Century; Burgundy

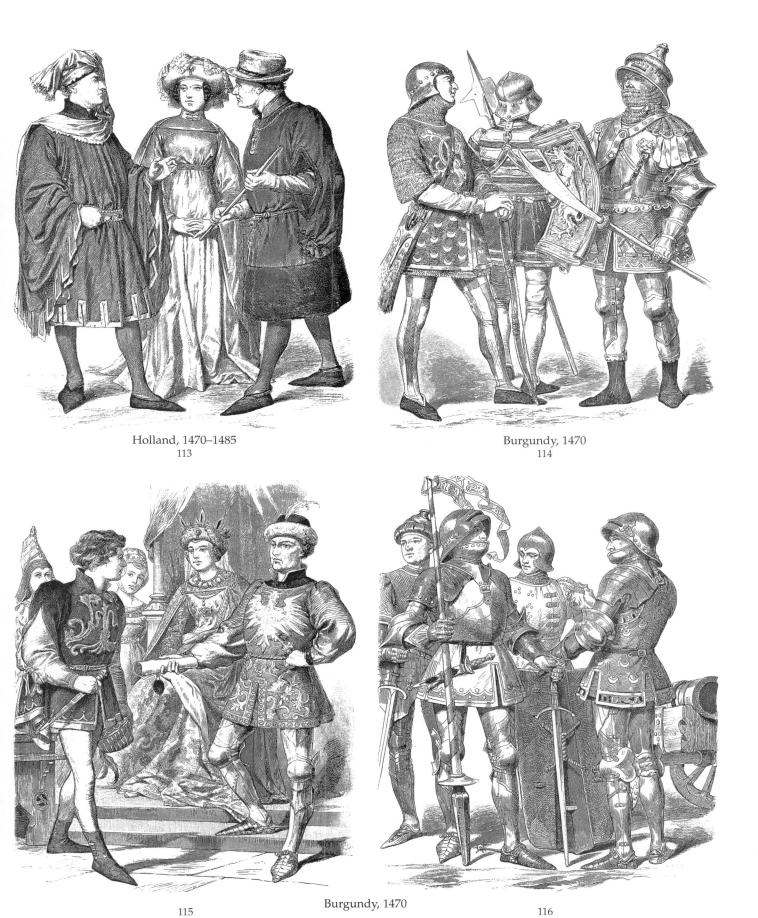

PLATE 29
SECOND HALF OF THE 15TH CENTURY;
BURGUNDY AND HOLLAND

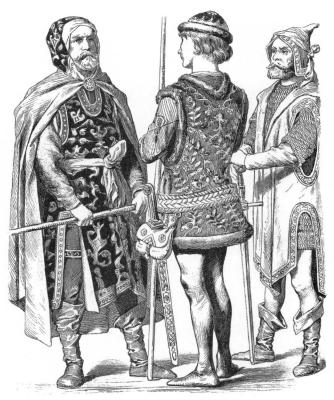

Lower Rhenish costume, 1400

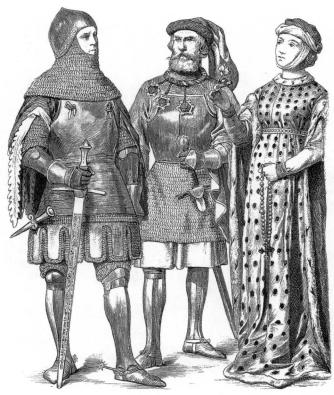

Philipp of Ingelheim, 1431

Martin of Seinsheim, 1434 118

About 1410

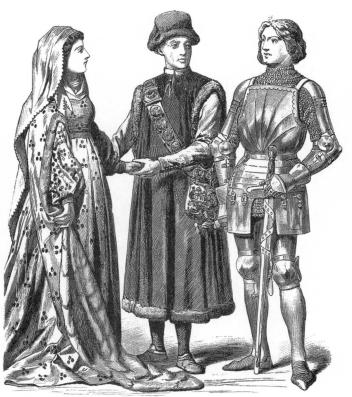

Lady's costume (mid-century)

Townsman of Ravensburg, 1429 119

Knight of Stettenberg, 1428

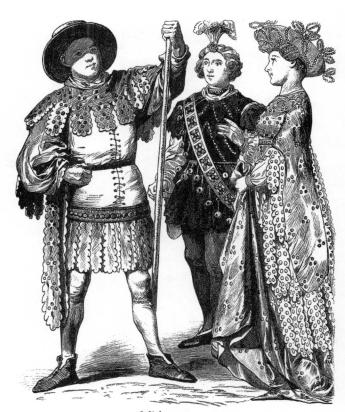

Mid-century 120

Plate 30 15th Century; Germany

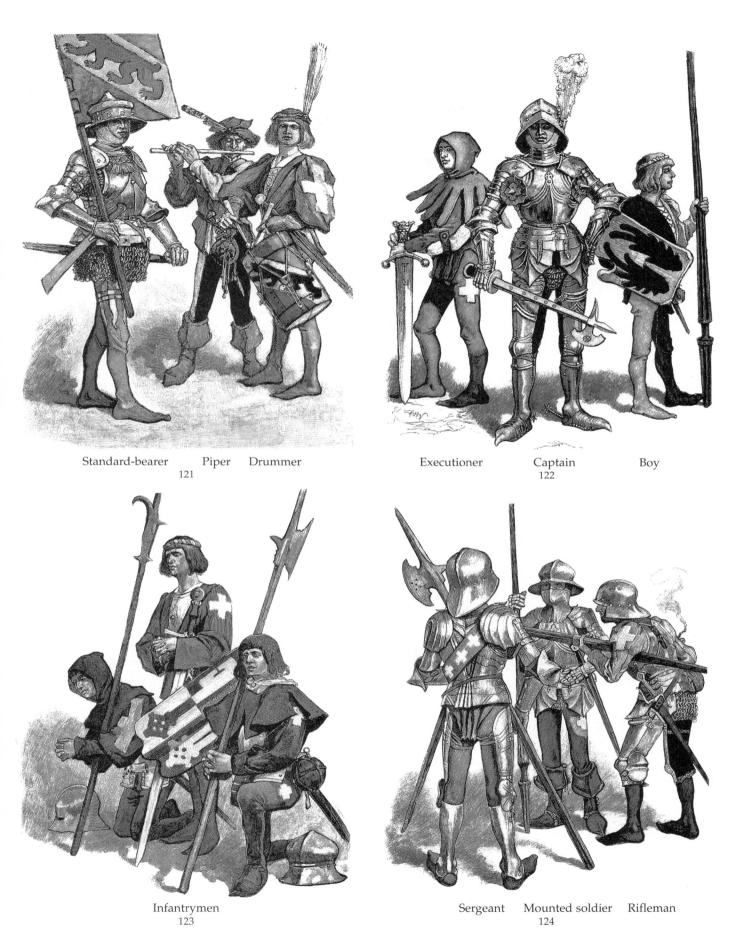

PLATE 31
15TH CENTURY; SWISS MILITARY COSTUME

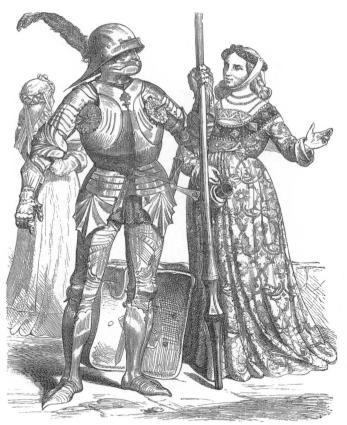

German knight and noblewoman (mid-15th century)
125

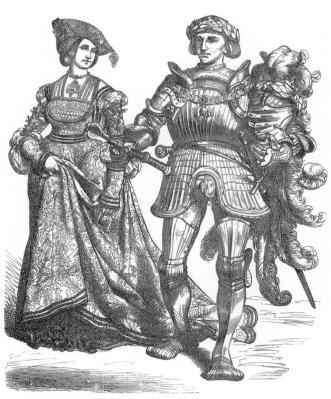

Prince and princess (1st third of 16th century) 126

German townswoman and armed townsman (1st third of 16th century) 127

Knight and noblewoman (1st third of 16th century) \$128\$

Plate 32 15TH AND 16TH CENTURIES

French noblewoman and page 129

German magistrate and knight 130

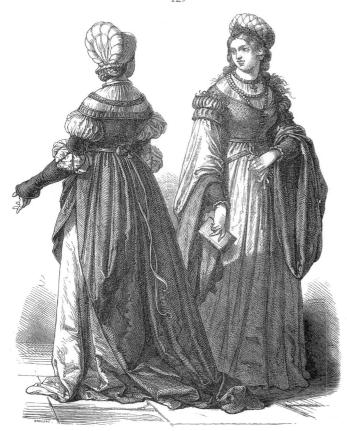

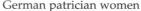

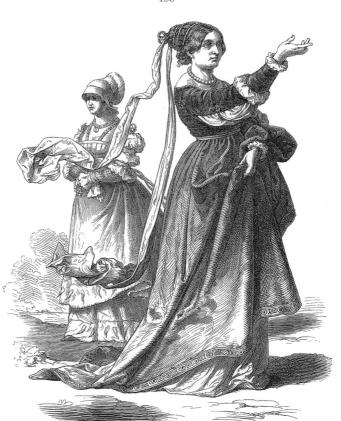

German patrician women

Plate 33 FIRST THIRD OF THE 16TH CENTURY

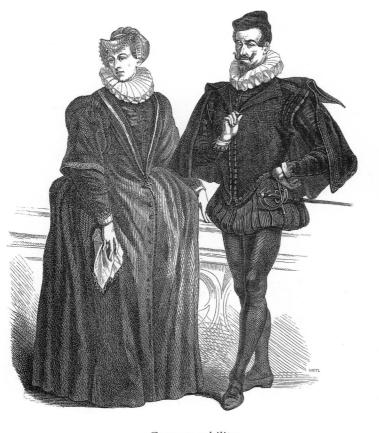

German nobility 133

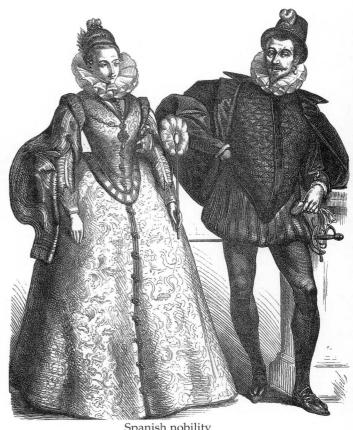

Spanish nobility 134

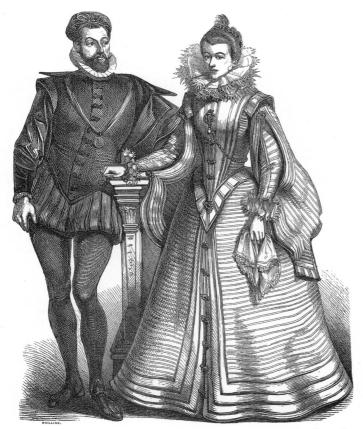

French court dress

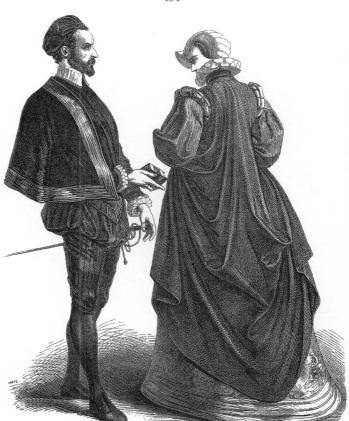

136

Plate 34
Second Third of the 16th Century

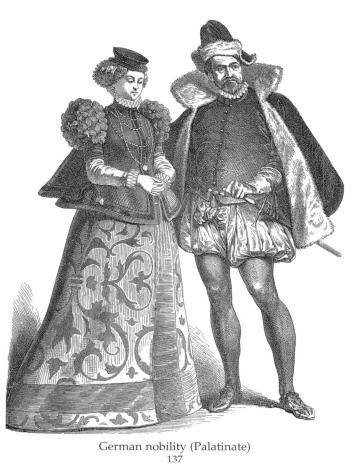

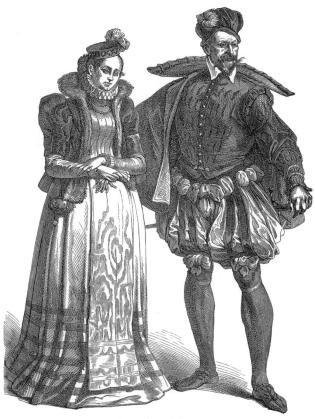

French nobility 138

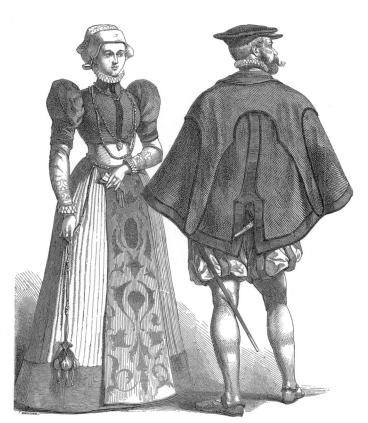

German townspeople 139

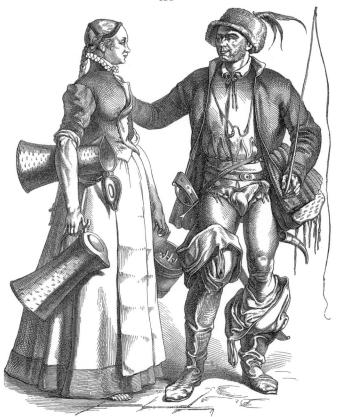

Nuremberg maid Carter 140

PLATE 35 Last Third of the 16th Century

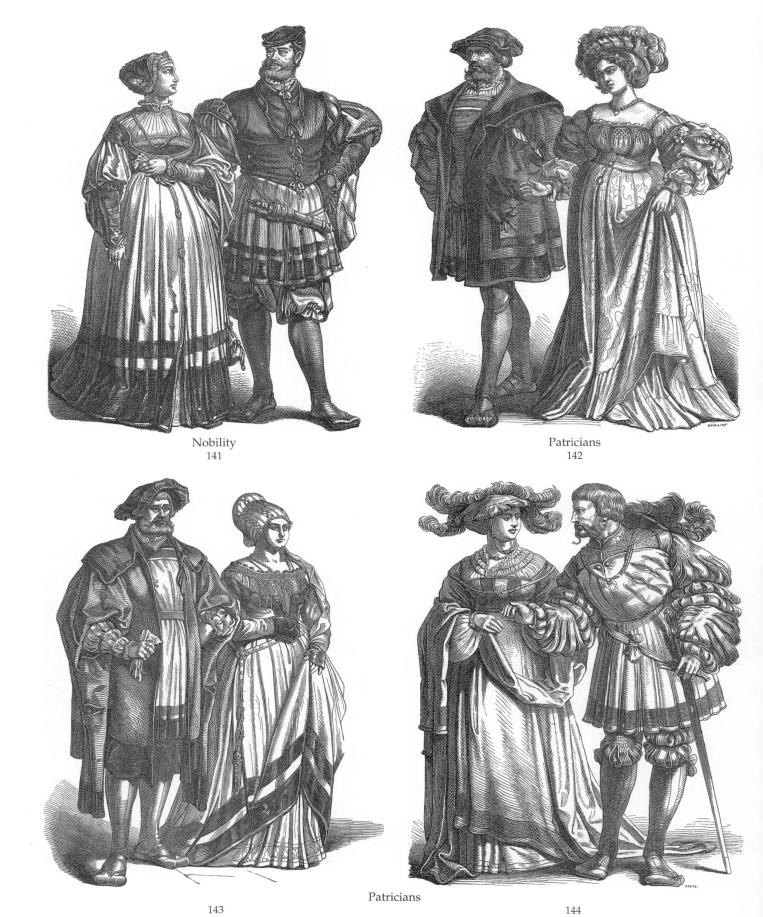

Plate 36 First Third of the 16th Century; Germany

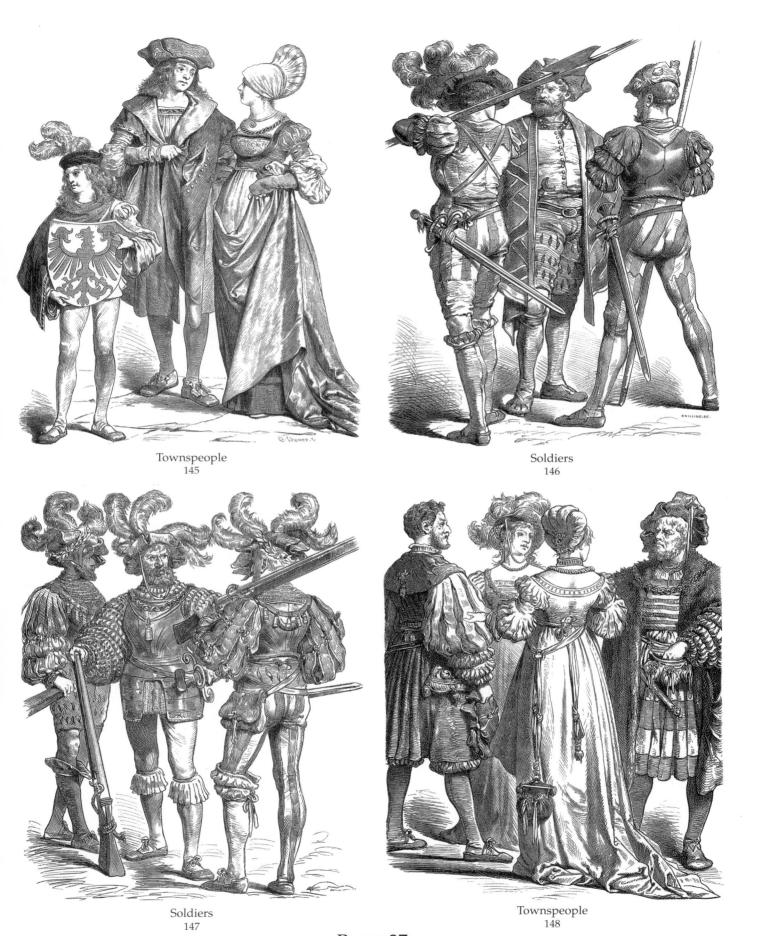

 $\begin{array}{c} \text{Plate 37} \\ \text{First Third of the 16th Century; Germany} \end{array}$

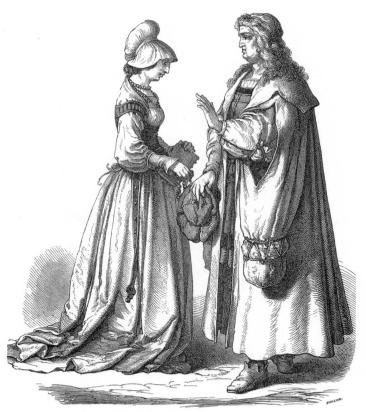

Scholar and townswoman 149

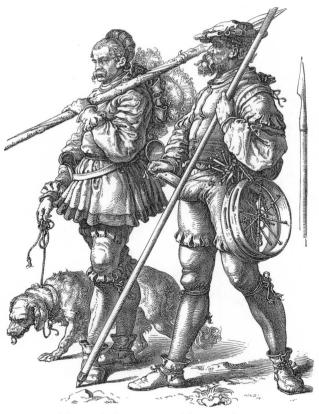

 $\begin{array}{c} \text{Mountain huntsmen with snowshoes} \\ 150 \end{array}$

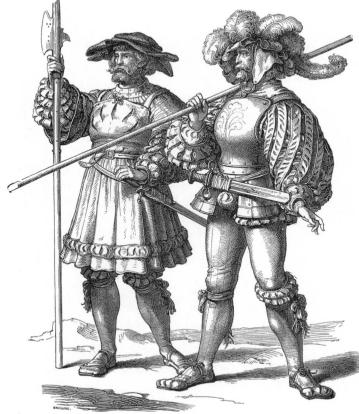

Soldiers 151

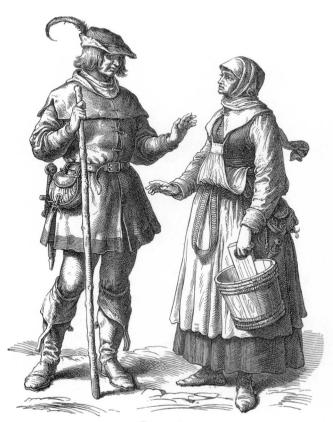

Peasants 152

Plate 38
First Third of the 16th Century; Germany

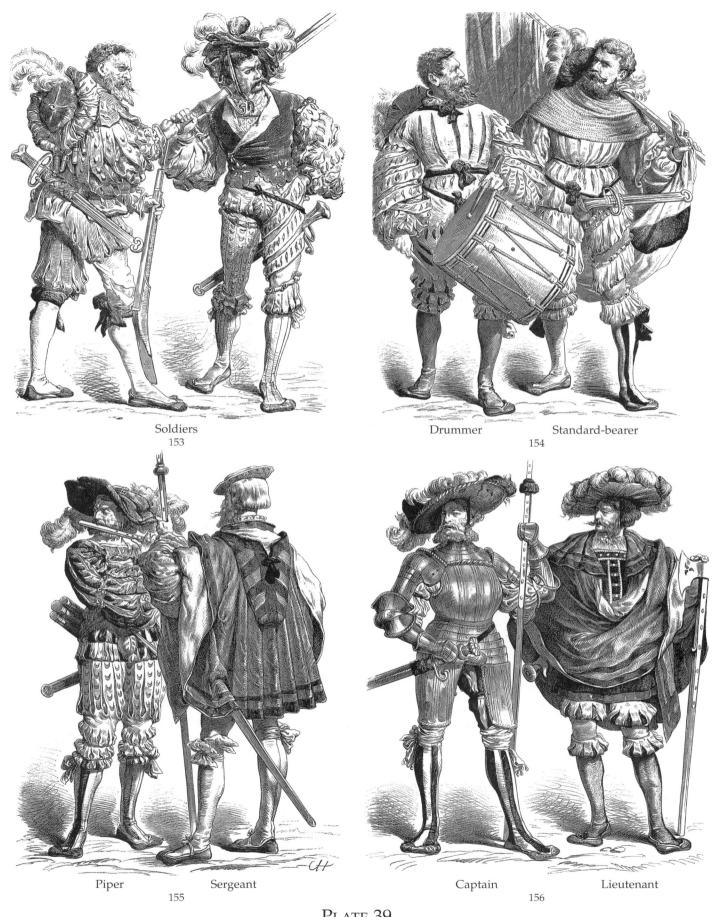

PLATE 39
FIRST THIRD OF THE 16TH CENTURY;
GERMAN MILITARY COSTUME

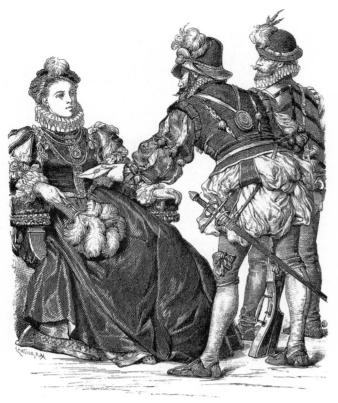

Noblewoman 157

1565-1570

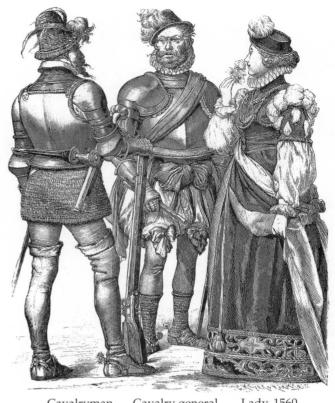

Cavalryman

Cavalry general under Charles V 158

Lady, 1560

Nobleman, about 1570

Citizen of Nuremberg in festive attire, 1588

Standard-bearer

About 1570 160

Itinerant musician

Plate 40 Mid-16th Century; Germany

Woman from Rostock

Councilman and lady from Wismar, 1590 161

Man from Dithmarschen

Pomerania, 1590

Merchant and peasants from Rostock, 1590 163

Girl from Ockholm

Man and woman from Pomerania, 1590 164

Plate 41 Late 16th Century; Germany

Dithmarschen, 1590 Man from Eiderstadt 165

Woman from Stapelholm on the Eider

Man from the North Sea coast, 1590 166

Man from Stapelholm

the North Sea coast

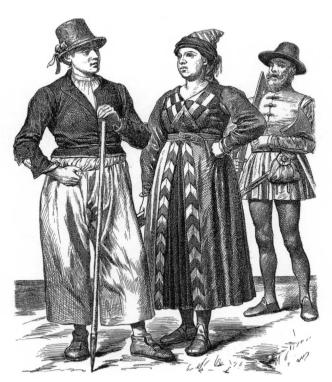

Man and woman from the island of Sylt, 1590 167

Man from Haderstedt

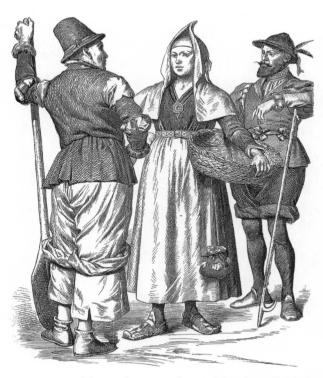

Man and woman from Man from Ockholm the island of Föhr, 1590 168

Plate 42 LATE 16TH CENTURY; FRISIA

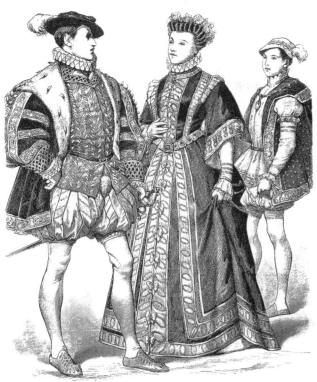

Francis II (1543–1560)

Elizabeth, daughter of Henry II, as a bride (1545 - 1568)169

Francis II as Dauphin

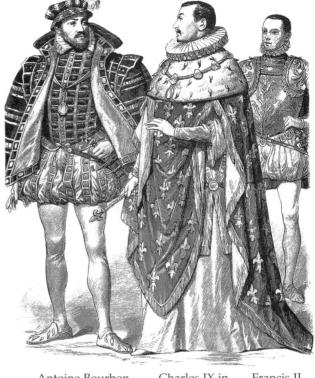

Antoine Bourbon, King of Navarre, father of Henry IV (1518–1562)

Charles IX in full regalia

Francis II

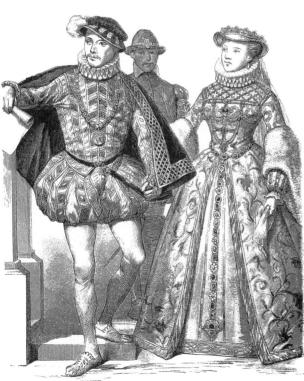

Charles IX (1550–1574) 171

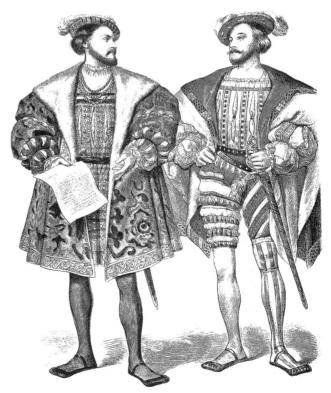

Henri d'Albret, King of Navarre (1505–1555)

Claude de Lorraine, Duke of Aumale, 1515–1550

Plate 43 16TH CENTURY; FRANCE

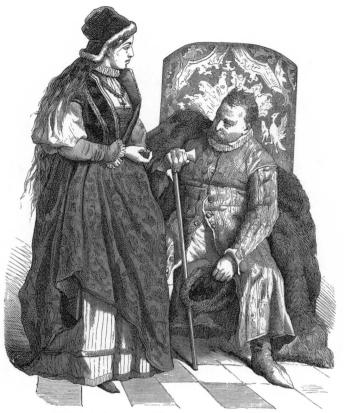

Polish lady and nobleman in national dress 173

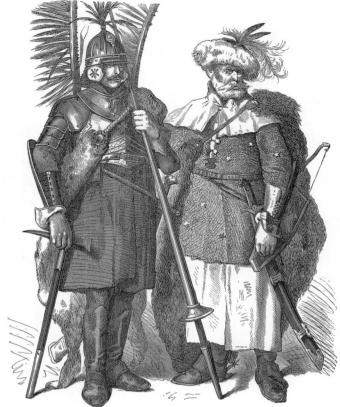

Lancer Armored cavalryman 174

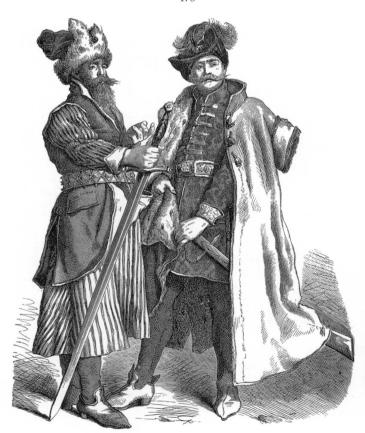

Russian aristocrat

Polish nobleman 175

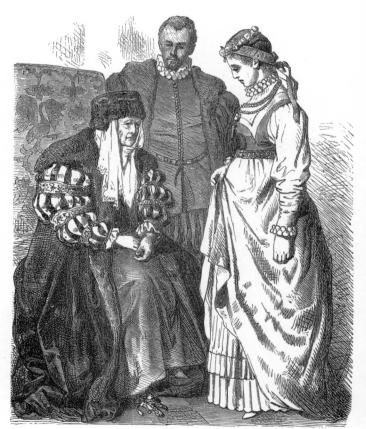

Polish nobility in court dress 176

Plate 44 16th Century; Poland and Russia

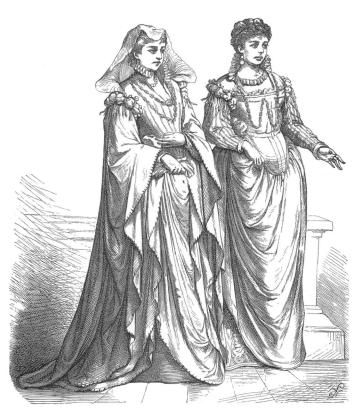

Rome and Siena 177

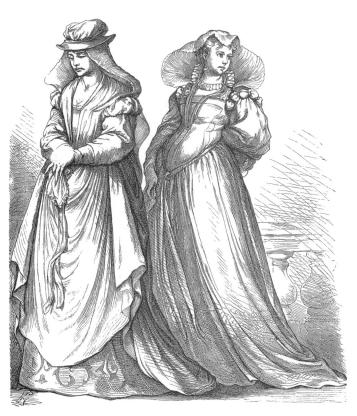

Florence and Padua 178

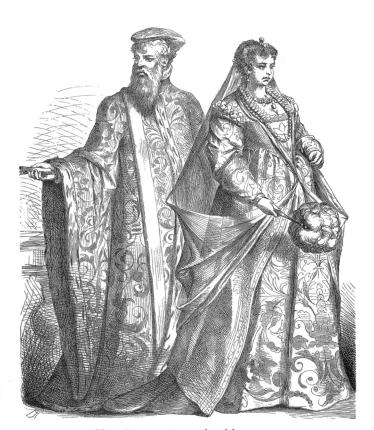

Venetian senator and noblewoman 179

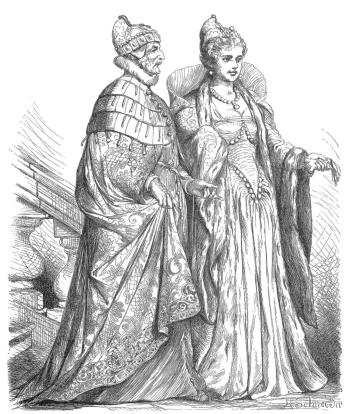

Venetian doge and dogaressa 180

Plate 45 16th Century; Italy

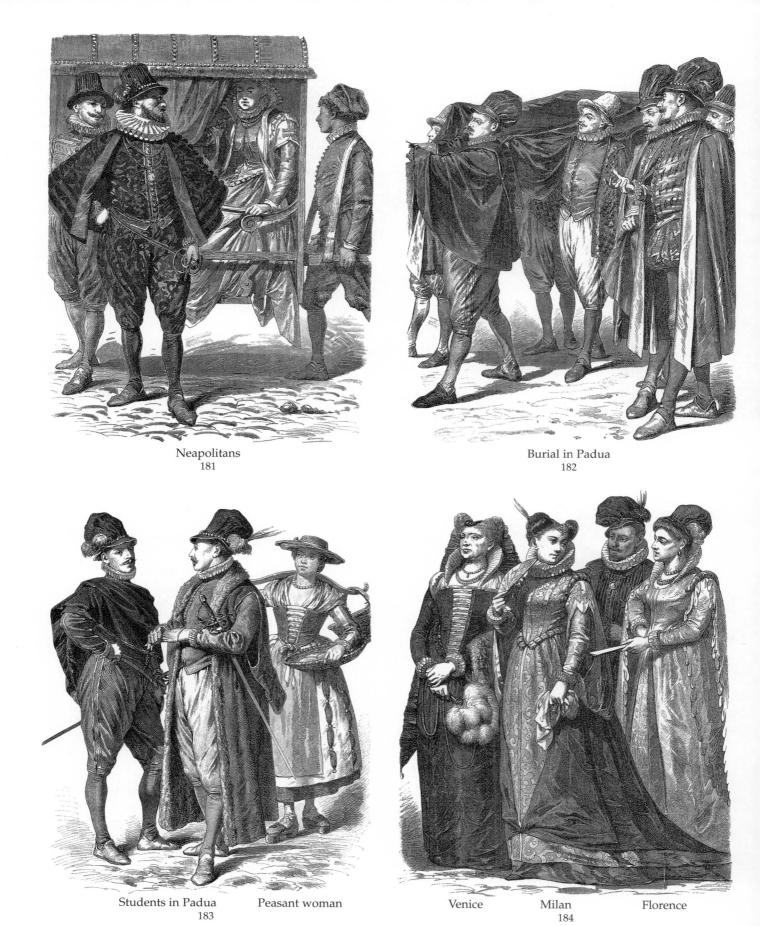

PLATE 46 LATE 16TH CENTURY (1583); ITALY

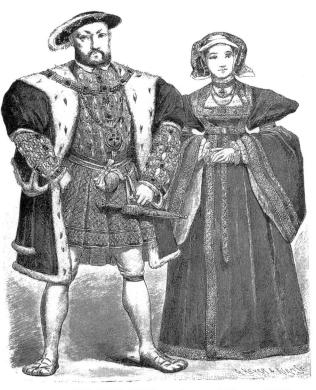

Henry VIII (1509–1546) 185

Anne of Cleves, 1525

London merchant

Cavalier, 1550–1600 186

Lady of Queen Elizabeth's court

Mary of Scotland, late 16th century

Earl Douglas of Edward VI, Angus, 1570 1550 187

Lord Darnley, Marchiones husband of Queen of Dorset Mary of Scotland, 1566

Marchioness

Queen Mary of Scotland, 1566

PLATE 47 16TH CENTURY; ENGLAND

Noblewomen, London, 1590 189

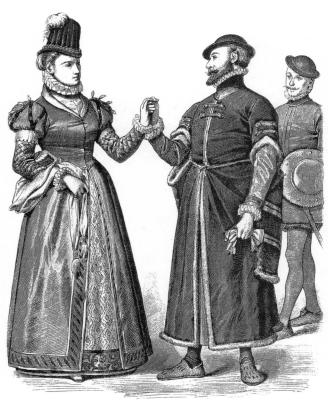

London, 1590: Merchant and wife 190

Officer

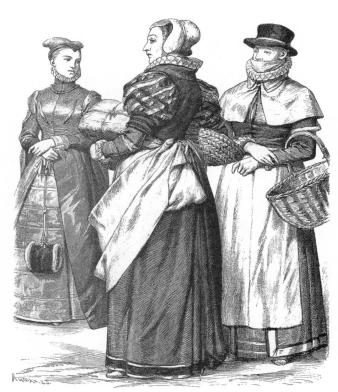

London, 1590 Merchant's wife

Servant woman

Townswoman

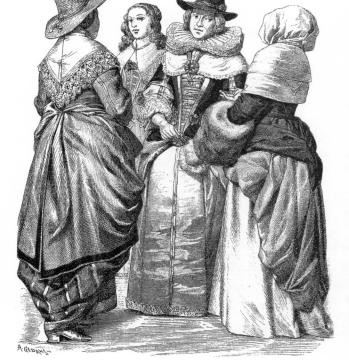

1640: Lady in Townswoman street dress

Lord Mayor's wife

Matron

Plate 48 16TH AND 17TH CENTURIES; ENGLAND

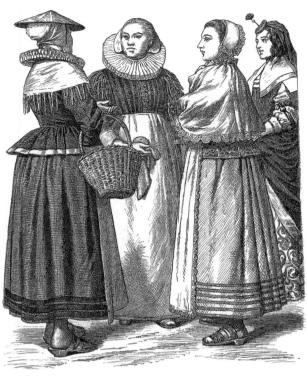

1640: Dutch Woman from Dutch woman Woman from skipper's wife Amsterdam at home Antwerp

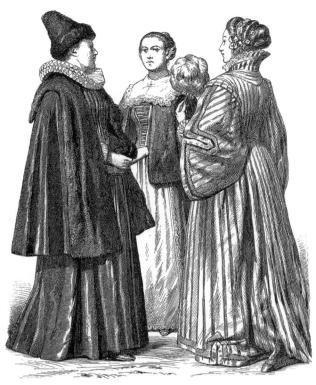

1640: Bohemian Girl from Prague Woman from Spain woman 194

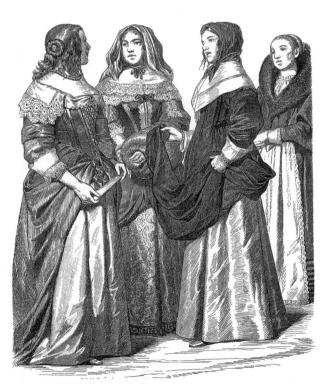

1640: English Woman Woman Woman noblewoman from Paris from Rouen from Dieppe

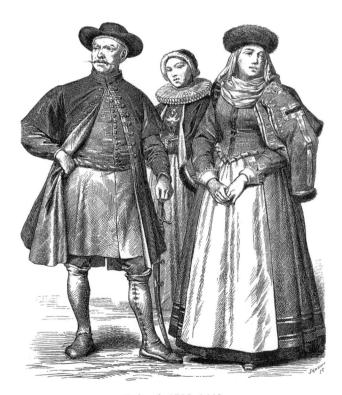

Poland, 1590–1660 196

Plate 49 16th and 17th Centuries

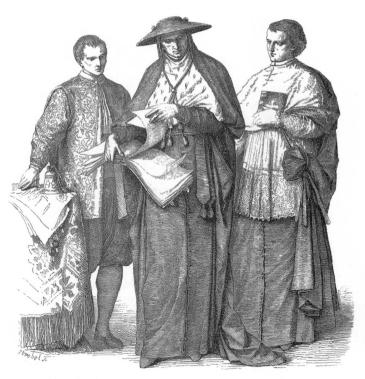

Chamberlain

Cardinal

Prelate

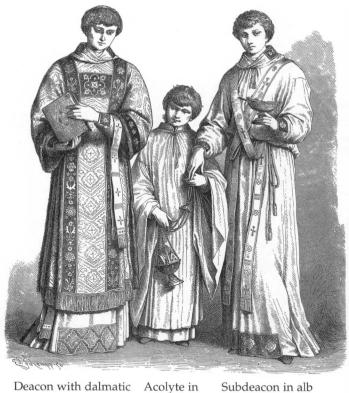

and alb

Acolyte in surplice 198

Subdeacon in alb and colored stole

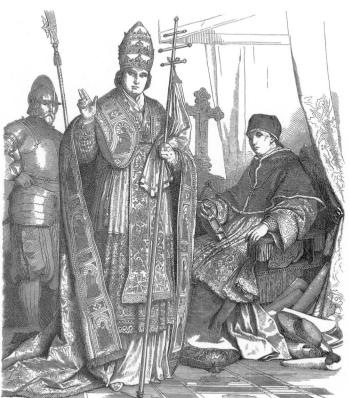

Swiss guard

Pope in ceremonial dress 199

Pope in domestic dress

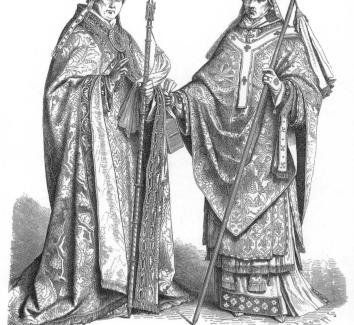

Bishop in pluvial

200

Bishop in chasuble

Plate 50 16TH AND 17TH CENTURIES; ECCLESIASTICAL VESTMENTS

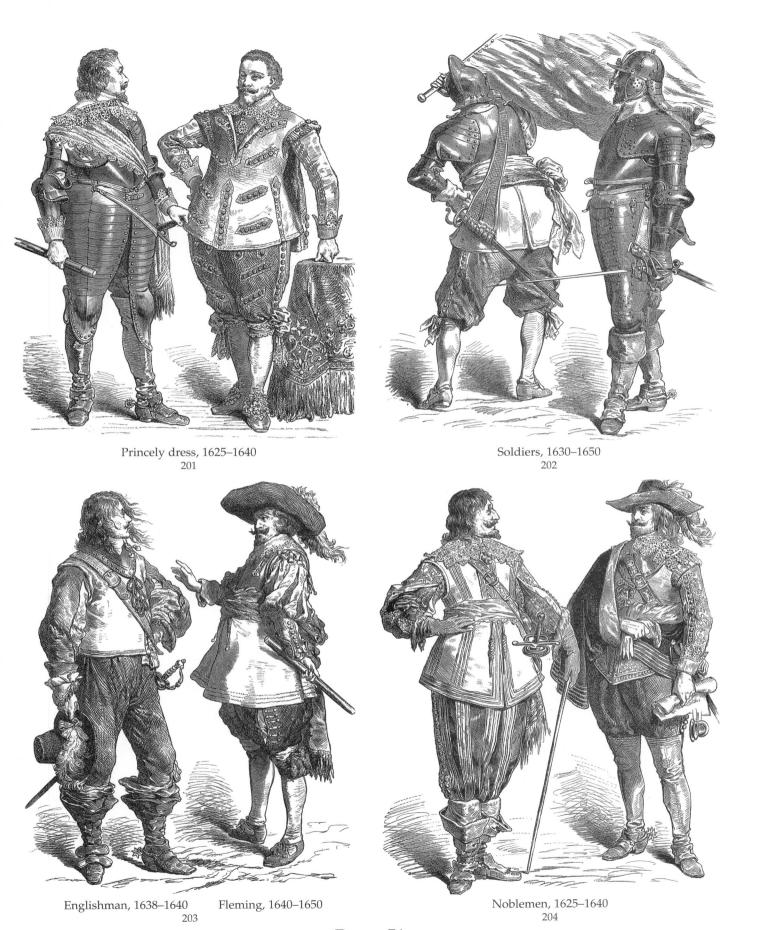

 $\begin{array}{c} P\text{LATE 51} \\ \text{First Half of the 17th Century} \end{array}$

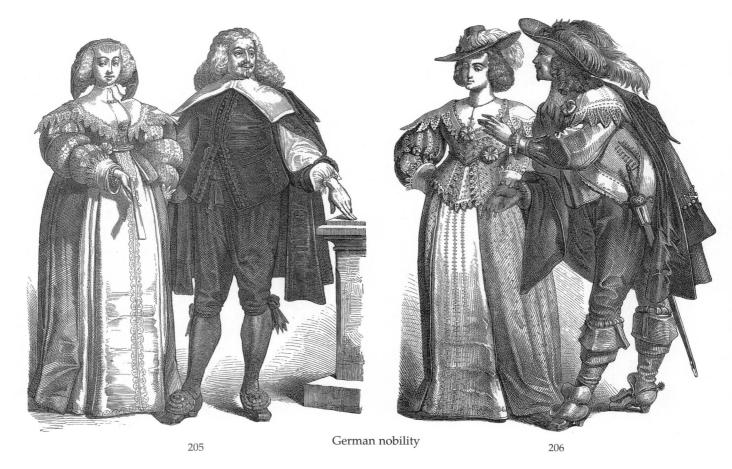

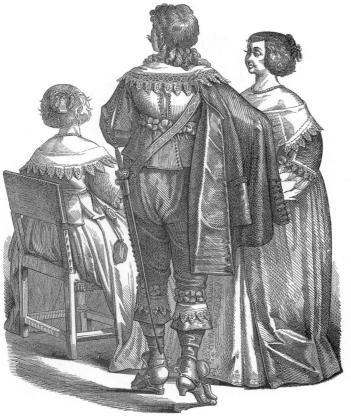

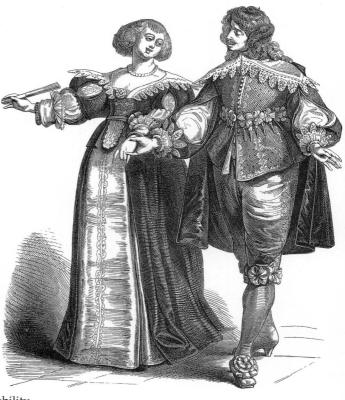

208

French nobility

 $\begin{array}{c} \text{Plate 52} \\ \text{Second Third of the 17th Century} \end{array}$

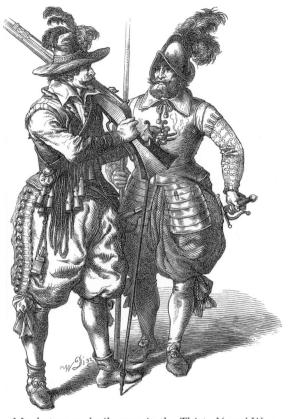

Musketeer and pikeman in the Thirty Years' War \$209\$

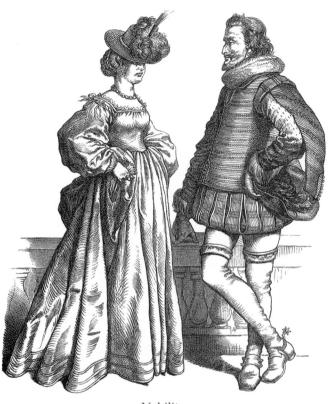

Nobility 210

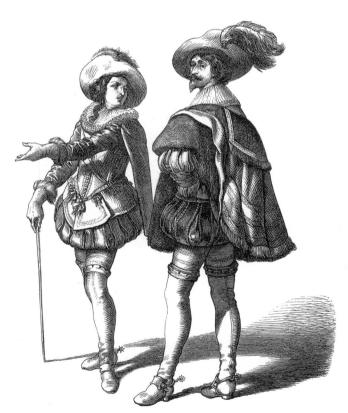

French cavalrymen 211

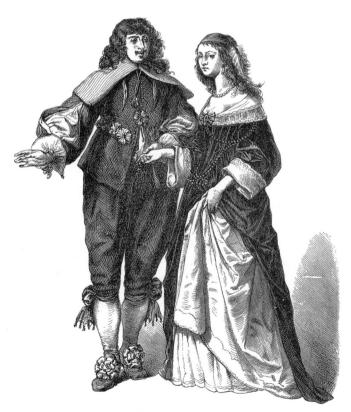

Dutch nobility 212

Plate 53 Second Third of the 17th Century

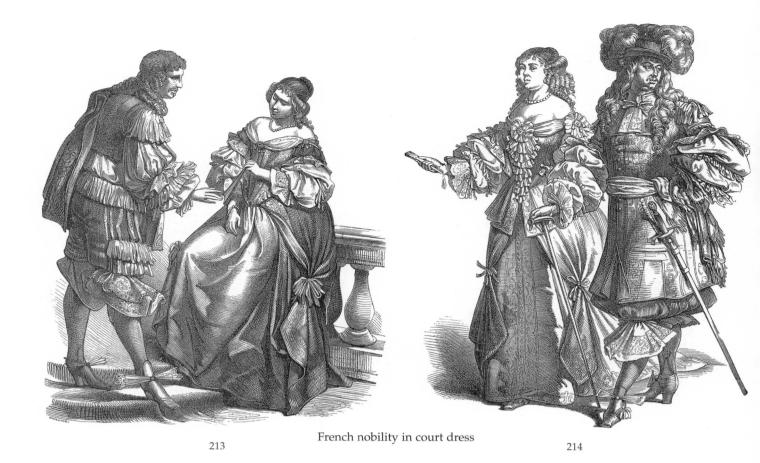

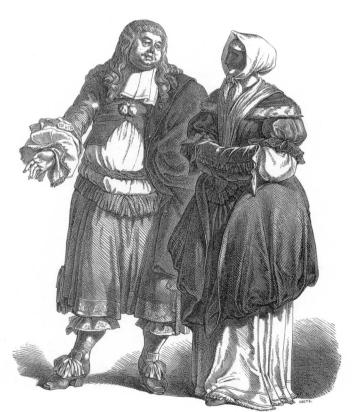

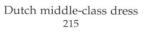

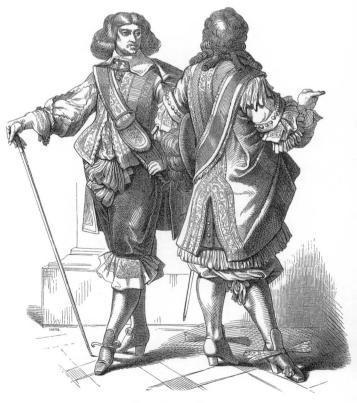

French cavaliers 216

PLATE 54
LAST THIRD OF THE 17TH CENTURY

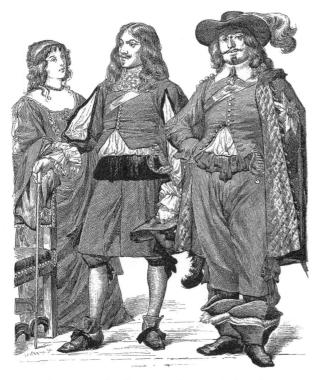

Anne, Countess of Courtier of Chesterfield, 1640

Charles II, 1665 217

Duke of Newcastle, 1646

William Villiers, Viscount of Grandison, 1640

Royalist soldier, Nobleman, 1649 1649

Slingsby Bethel, Sheriff of London, 1680

Cavalier of 1680 219

Duchess of Charles II, Cleveland, 1675

James, Marquess of Hamilton, 1620

Townsman

220

Frances, Duchess of Richmond, 1620

1625

PLATE 55 17th Century; England

Spanish court dress in the Netherlands $$\tt 221$$

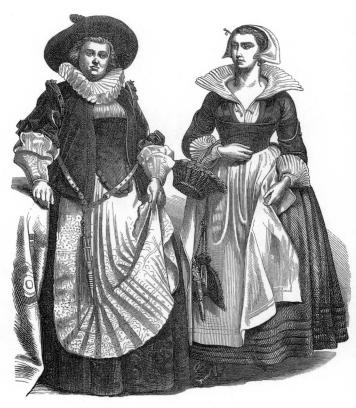

Middle-class dress in the Netherlands 222

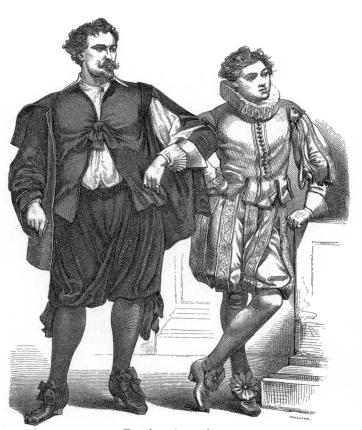

Dutch artist and page 223

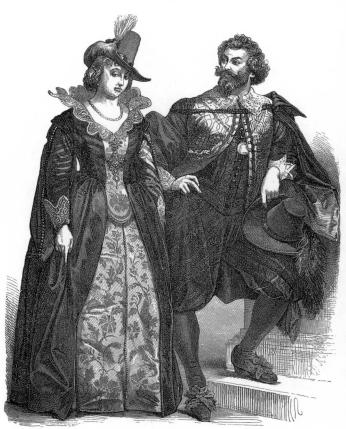

Dutch aristocrats 224

 $\begin{array}{c} \text{Plate 56} \\ \text{First Third of the 17th Century; Netherlands} \end{array}$

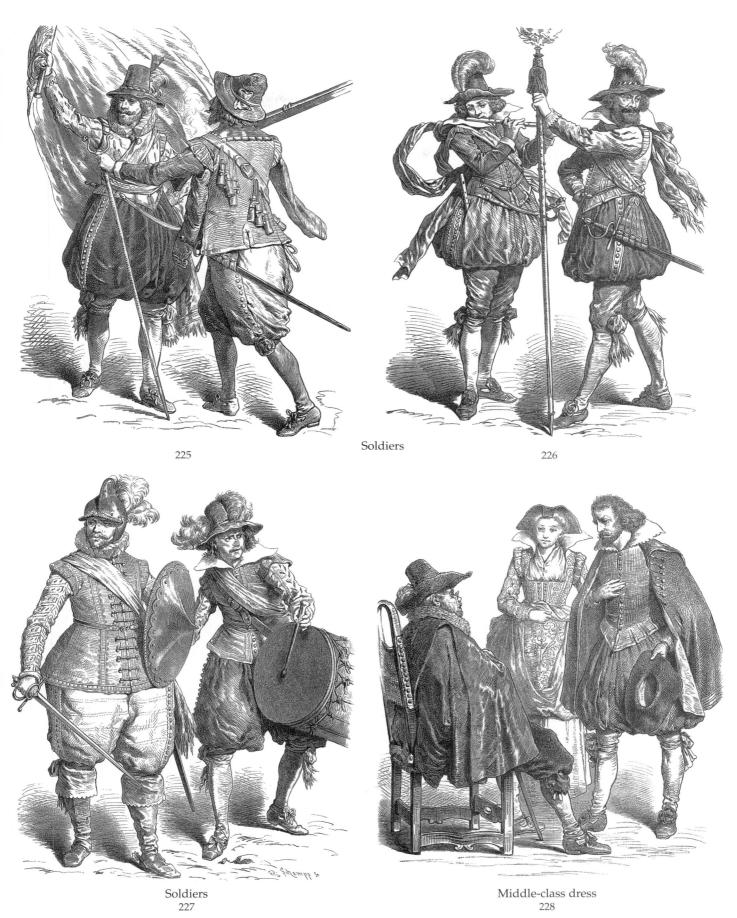

Plate 57
First Third of the 17th Century; Germany

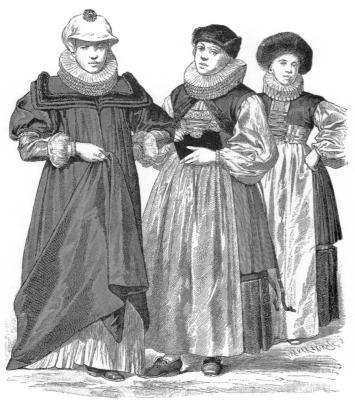

Strasbourg

Strasbourg 229

Basel

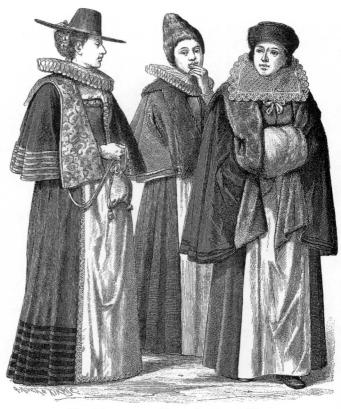

Munich

Nuremberg 230

Vienna

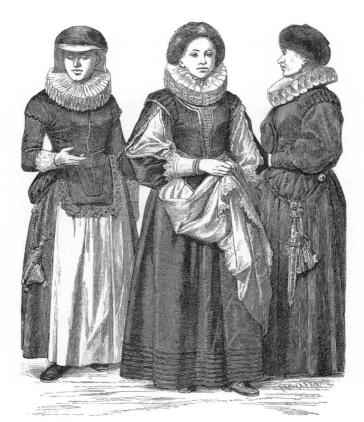

Frankfurt am Main

Palatinate 231

Swabian woman

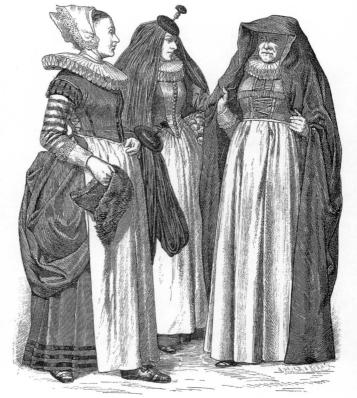

Servant girl Townswoman from Cologne 232

Matron

Plate 58 MID-17TH CENTURY; GERMAN LANDS

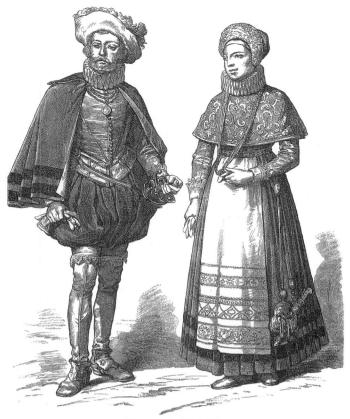

Denmark: Nobility 233

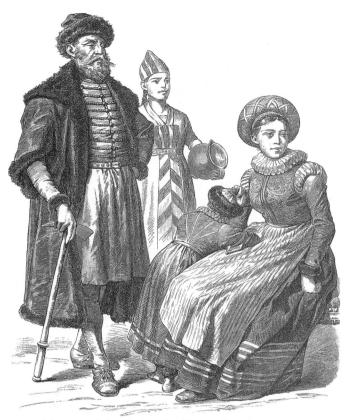

Norway: Aristocrat and wife 234

Countrywoman

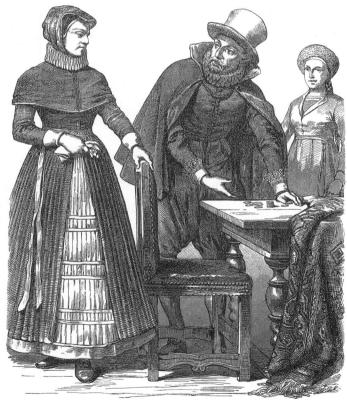

Denmark: Townswoman

Merchant 235

Woman from Stappelhall

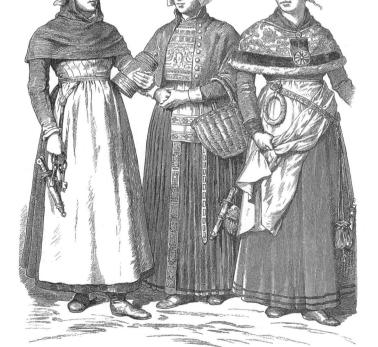

Denmark: Upford

Dithmarschen 236

Eiderstadt

PLATE 59
FIRST THIRD OF THE 17TH CENTURY;
NORWAY AND DENMARK

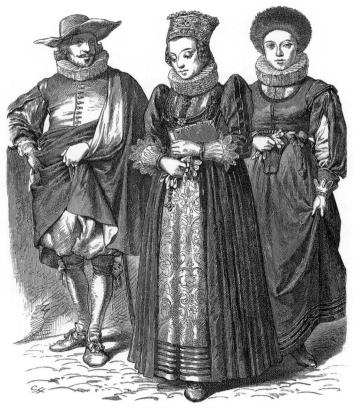

Young townsman

Bride 237

Young townswoman

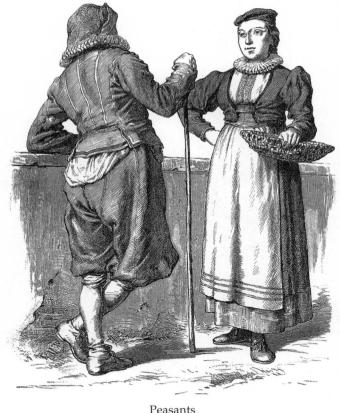

Peasants 238

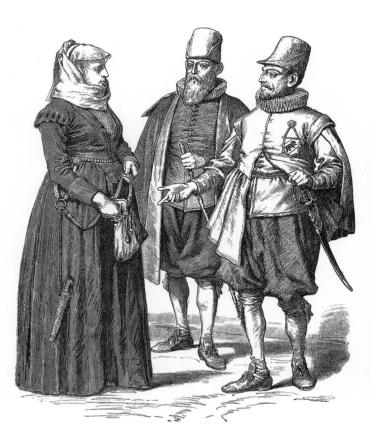

Churchgoing dress

Bailiff 239

Messenger

Mourning

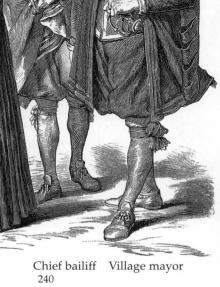

Plate 60 SECOND THIRD OF THE 17TH CENTURY; **SWITZERLAND**

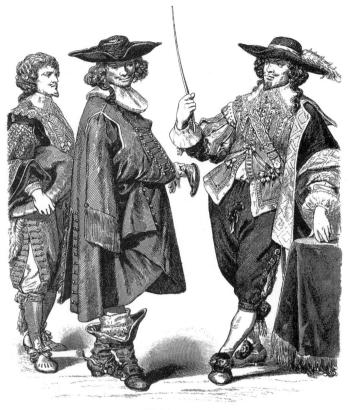

Noblemen 241

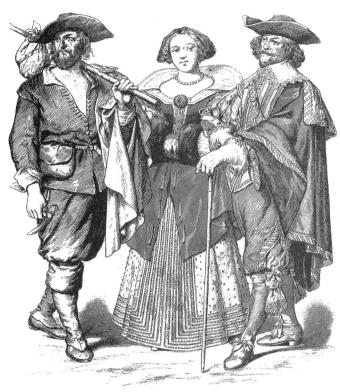

Peasant

Townswoman 242

Merchant

Noblewomen 243

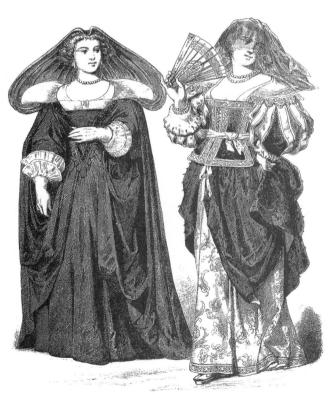

Lady in mourning 244

Plate 61 Mid-17th Century; France

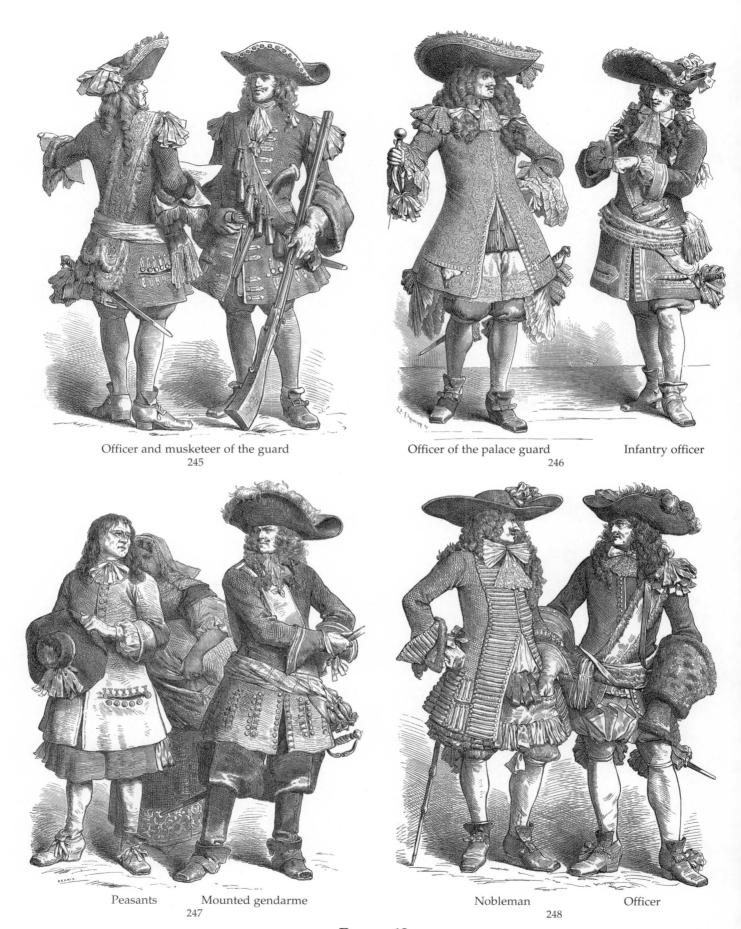

 $\begin{array}{c} \text{Plate 62} \\ \text{Last Third of the 17th Century; France} \end{array}$

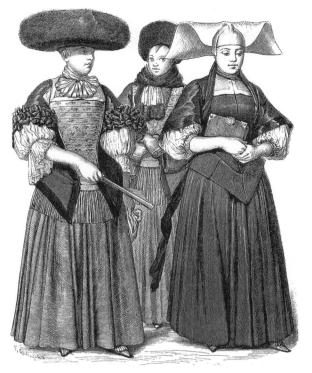

1670: Woman with broad cap

Woman in winter dress 249

Woman in mourning

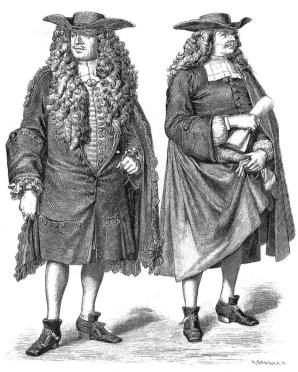

1670: Consul

Councilman 250

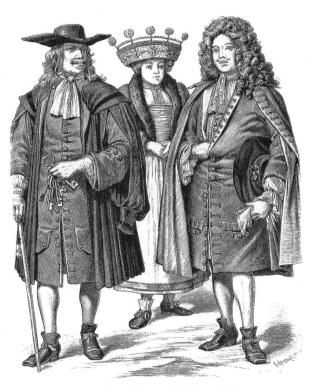

1670: Tower warden Peasant bride Bridegroom 251

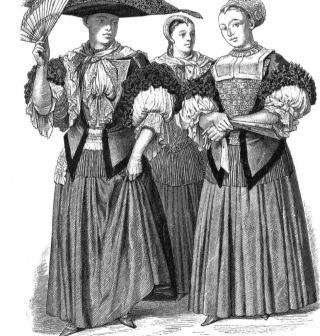

1670–1690: Girls 252

Bride

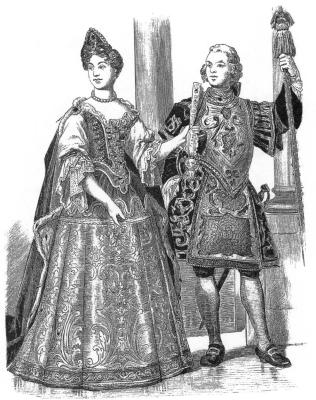

Françoise Marie de Bourbon, Duchess of Orleans, 1702

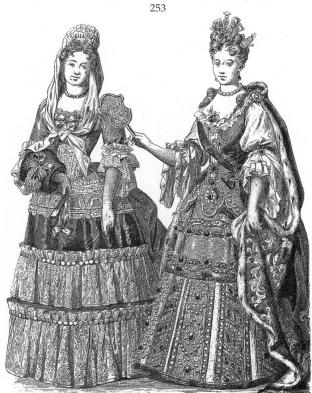

Hedwig Sophie, Princess Elizabeth of Brunswick, of Sweden, Duchess of 1707 Holstein, 1700 255

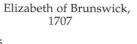

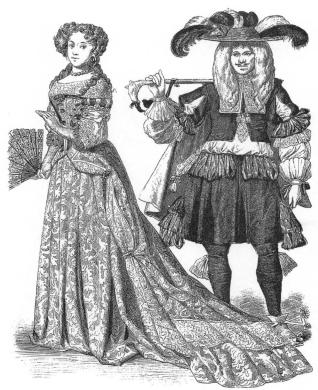

Maria Anna of Bavaria as Crown Princess of France, court dress, 1679 254

Young dandy, 1670

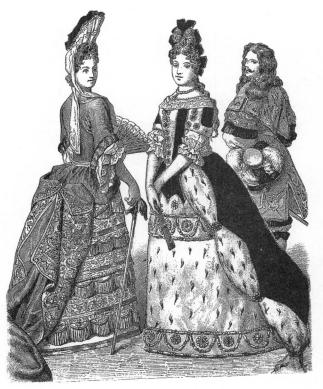

Duchess of Portsmouth (Louise de Kéroualle), 1694

Maria Anna Palace guard 1670 of Bavaria, 1694 256

Plate 64 Late 17th and Early 18th Centuries

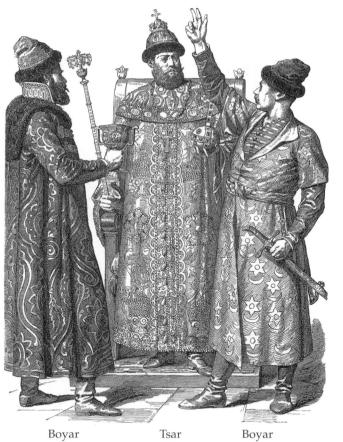

Tsar 257

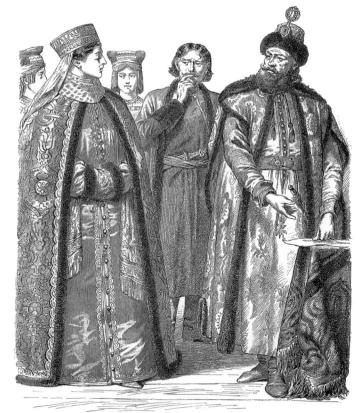

Boyarina

Boyars

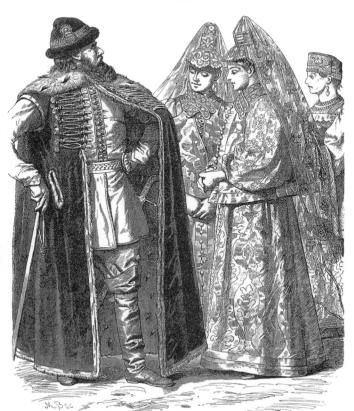

Princely dress

Women's summer dress Woman from in Torshko 259

Belosersk

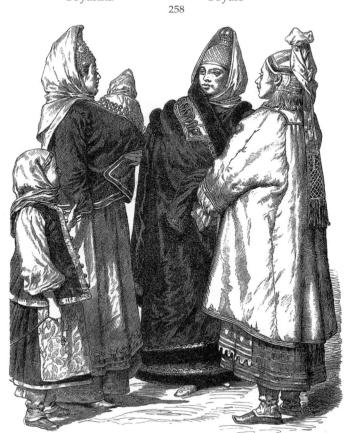

Women's winter dress in Torshko

Woman from Ryazan

Plate 65 17th and 18th Centuries; Russia

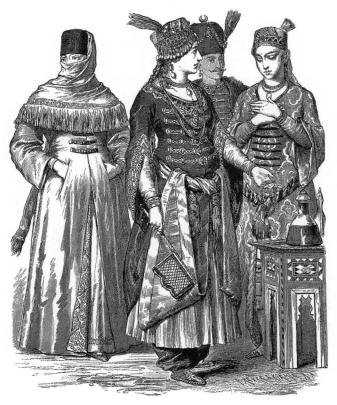

Street dress

Sultana 261

Sultan

Dancer

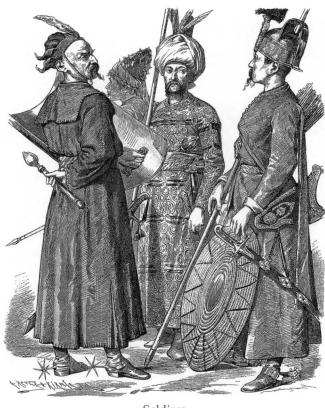

Soldiers 262

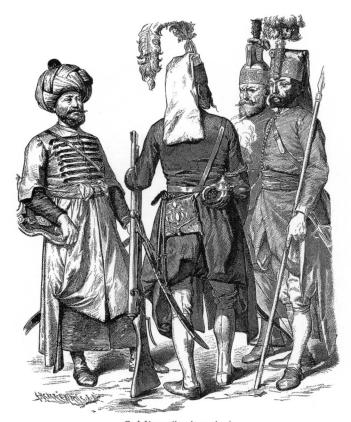

Soldiers (janissaries) 263

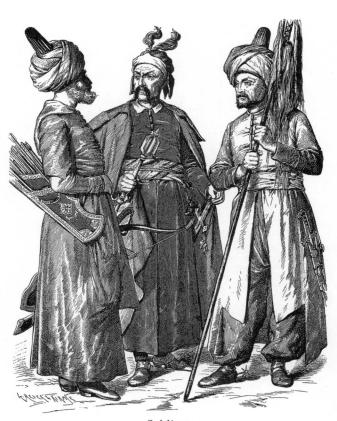

Soldiers 264

Plate 66 17th and Early 18th Centuries; Turks

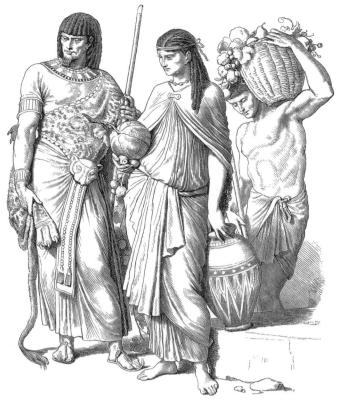

Egyptian king (ancient)

265

Commoners

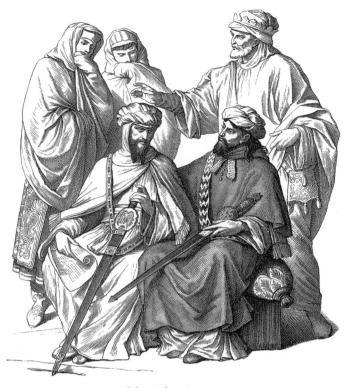

Moorish princes 266

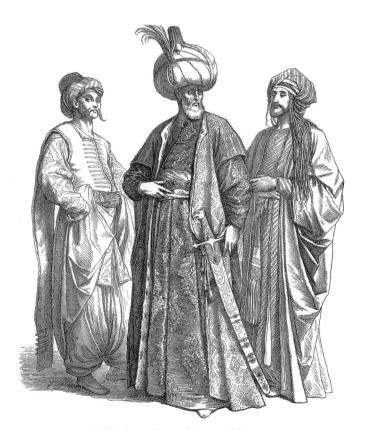

Turkish pasha and two noblemen 267

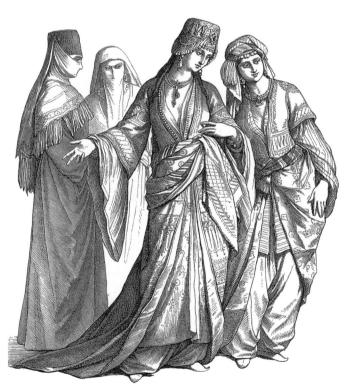

Turkish women 268

PLATE 67 EGYPTIANS, MOORS, TURKS

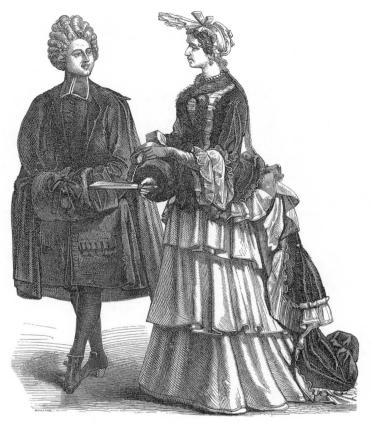

French abbé

Noblewoman 269

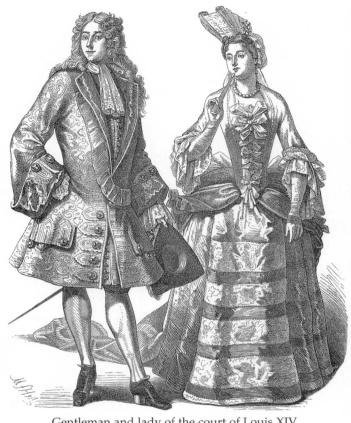

Gentleman and lady of the court of Louis XIV $$\operatorname{270}$$

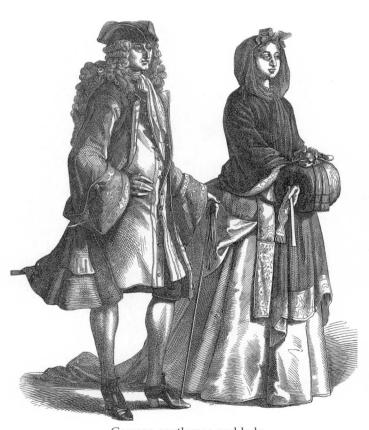

German gentleman and lady 271

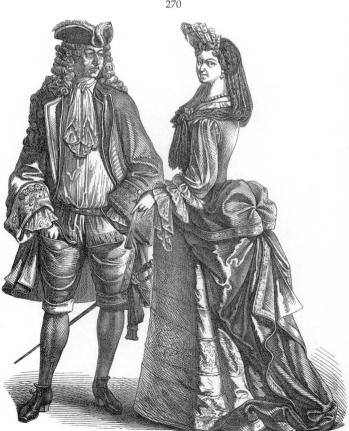

French gentleman and lady 272

PLATE 68
FIRST THIRD OF THE 18TH CENTURY

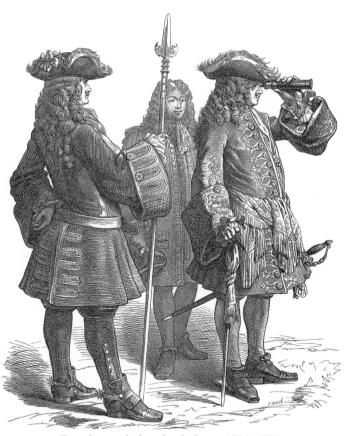

French marshal and subaltern, 1704–1730 \$273\$

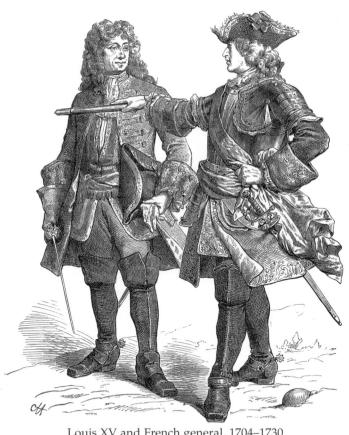

Louis XV and French general, 1704–1730 274

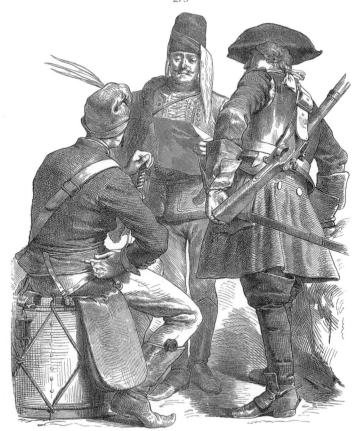

Austrian cavalrymen, 1704–1710 275

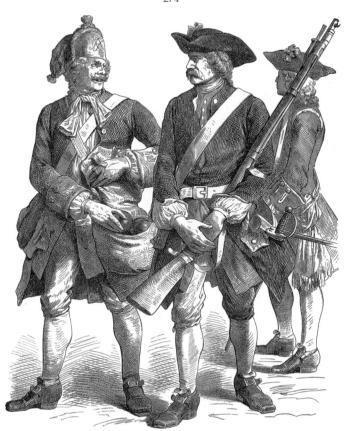

Austrian infantrymen, 1704–1710 276

PLATE 69
FIRST THIRD OF THE 18TH CENTURY;
MILITARY COSTUME

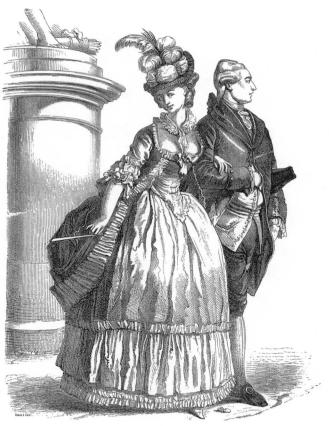

Dress before 1780 277

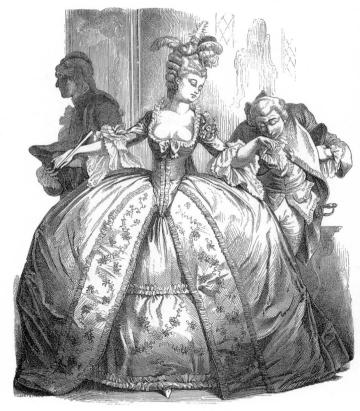

Lady in hoopskirt 278

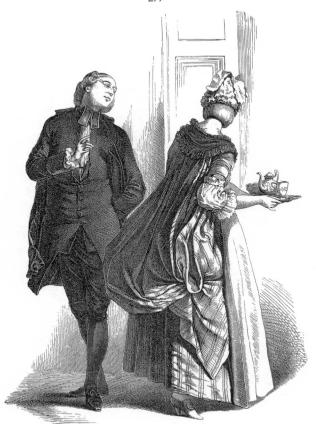

Abbé Servant girl in a contouche 279

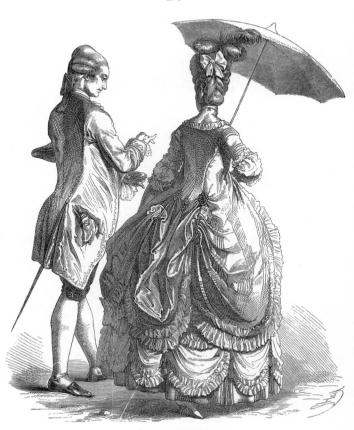

Dress of 1780 280

PLATE 70 SECOND HALF OF THE 18TH CENTURY

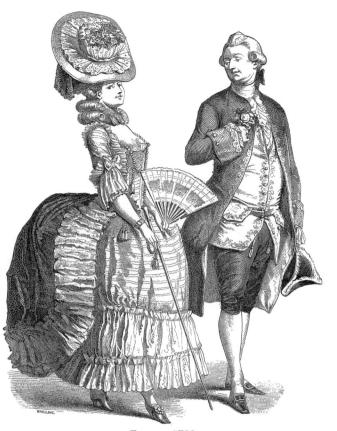

France, 1780 281

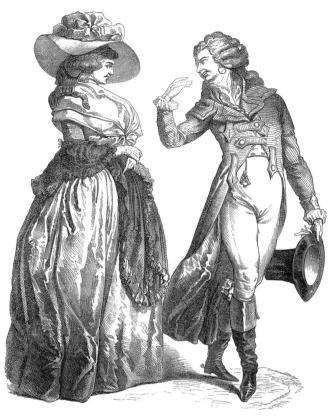

Germany at the time of Werther (ca. 1775) 282

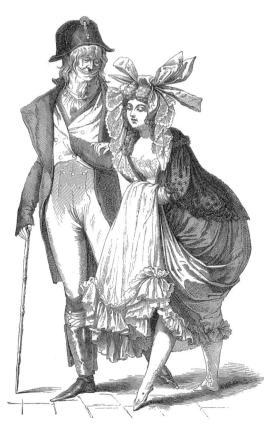

French incroyables, 1794 283

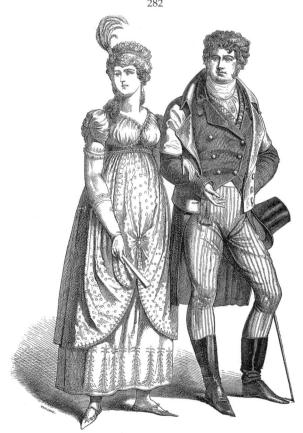

Germany, after 1800 284

PLATE 71
LAST THIRD OF THE 18TH CENTURY

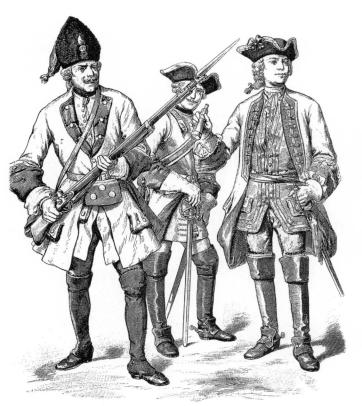

Württemberg, ca. 1730: Grenadier

Cuirassier

General

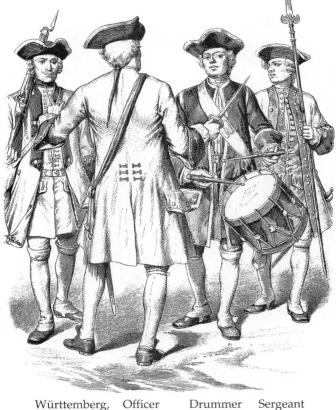

Württemberg, 1724–1738: Private

286

Drummer

Sergeant

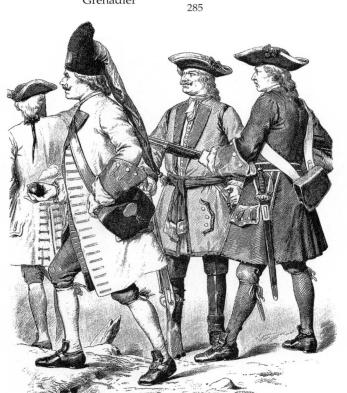

Army of the Archbishop of Konstanz, 1738: Officer of grenadiers

Grenadier

Dragoon Infantryman

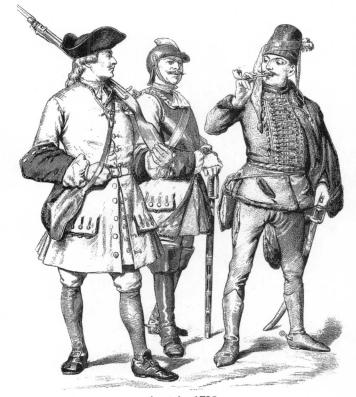

Austria, 1728

Plate 72 FIRST HALF OF THE 18TH CENTURY; GERMAN AND AUSTRIAN ARMIES

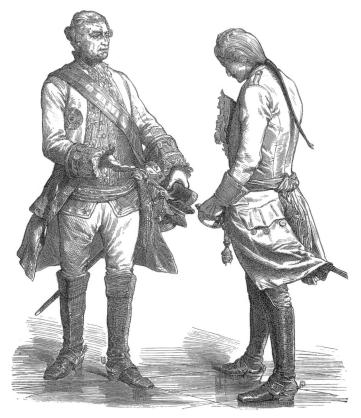

Austria, 1760-1775; General

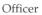

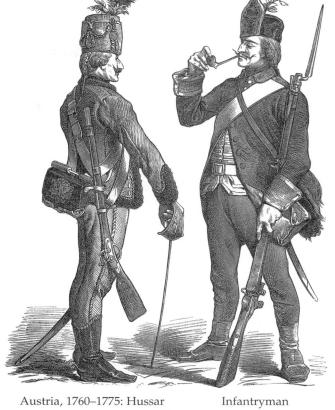

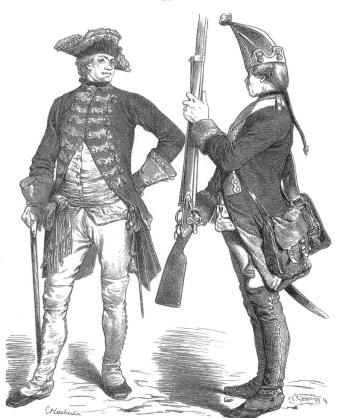

Prussia, 1760: Officer of guard battalion

Grenadier

Prussia, 1760: Officer of hussars

Cuirassier in Seydlitz' army 292 Mounted grenadier (private)

Plate 73 SECOND HALF OF THE 18TH CENTURY; GERMAN AND AUSTRIAN ARMIES

Mannheim

German and French dress in Strasbourg 293

Karlsruhe

Vienna 294

Frankfurt

Girl and woman from Augsburg 295

Ludwigsburg

Munich

Black Forest peasant girl

Plate 74 1770–1790; German Middle Class

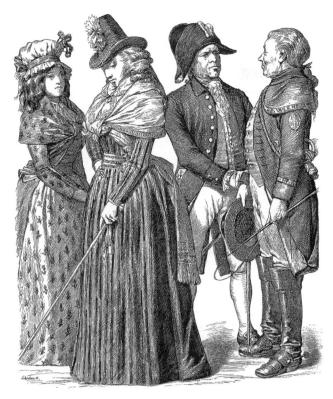

Saxon army Hessian postmaster postilion

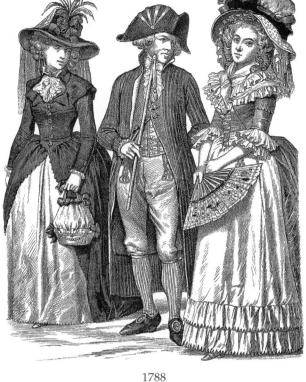

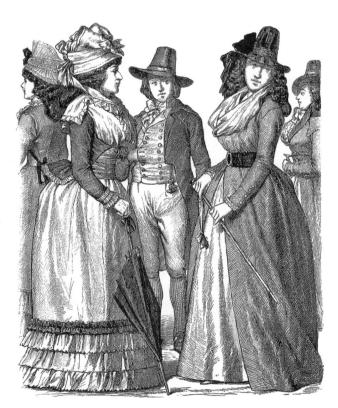

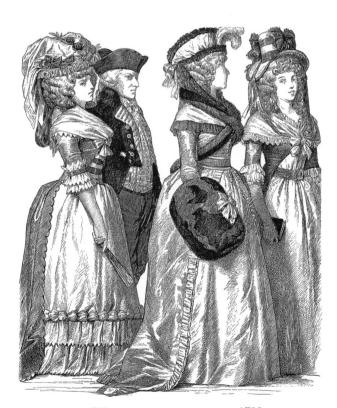

Plate 75 Late 18th Century; Germany

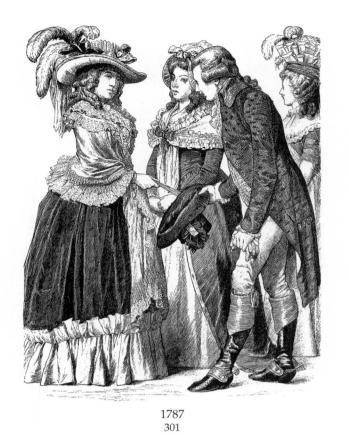

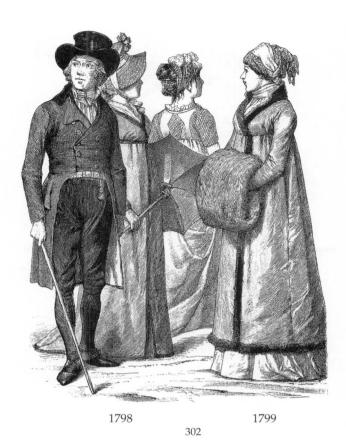

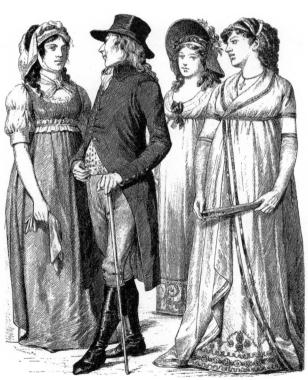

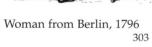

1797

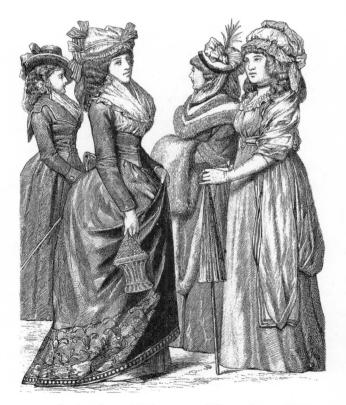

Spring dress, 1794

Winter dress, 1795

304

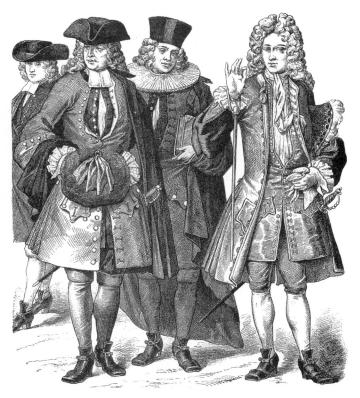

Student

Townsman

Councilman 305

Nobleman

Noblewoman Girl's Girl Women's ceremonial dress in mourning domestic attire with "rose cap"

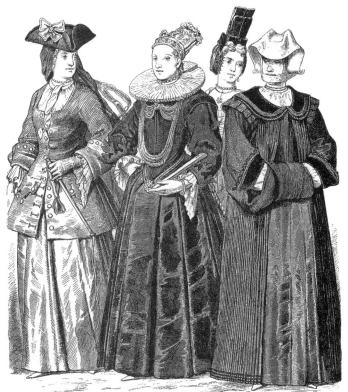

weddings

Riding attire, Festive middle- Girls' and Churchgoing dress, also worn at class women's women's called *Hussegken* visiting dress attire

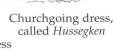

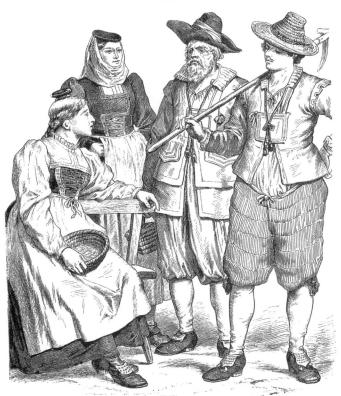

Peasants 308

Plate 77 EARLY 18TH CENTURY; SWITZERLAND (CANTON OF ZURICH)

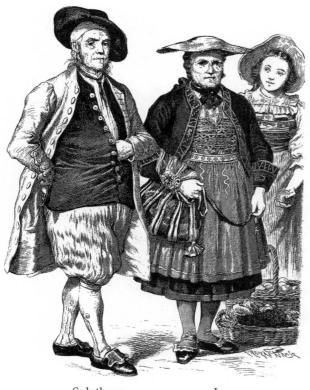

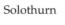

Lucerne

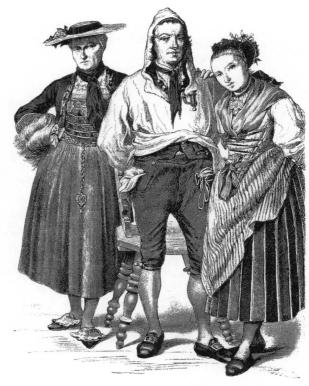

Zug

Schwyz 310

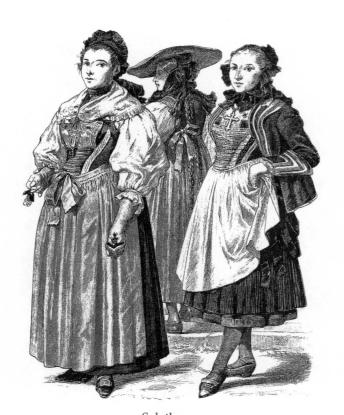

Solothurn 311

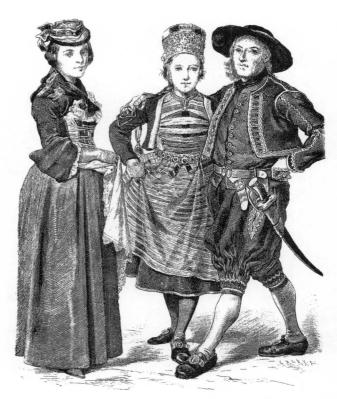

Valais

Wedding costume, Zurich 312

Plate 78 Late 18th Century; Switzerland

Aargau

Unterwalden

Fribourg 314

Aargau

315

St. Gallen

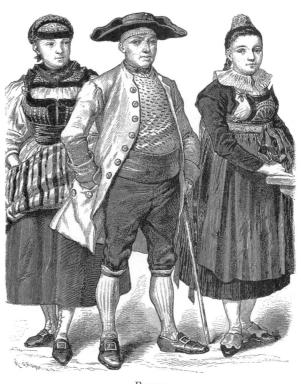

Berne 316

PLATE 79
LATE 18TH CENTURY; SWITZERLAND

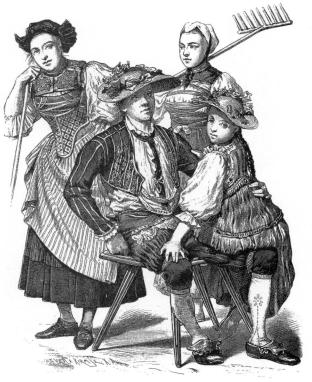

St. Gallen

Zug 317

Zurich

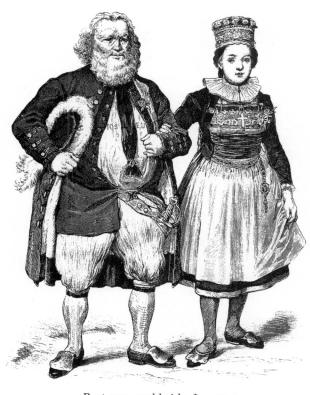

Best man and bride, Lucerne 318

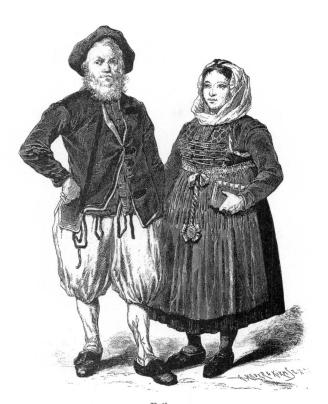

Fribourg 319

Schaffhausen, festive dress and winter dress 320

Ausser Rhoden, Appenzell

 $\begin{array}{c} P \text{LATE 80} \\ \text{LATE 18TH CENTURY; SWITZERLAND} \end{array}$

1774–1779

1778-1780

1778-1780

1774–1779

1777-1780

PLATE 81
LATE 18TH CENTURY;
FRANCE JUST BEFORE THE REVOLUTION

Middle class, 1790–1792 325

Infantryman, 1799 326

Grenadier, 1795

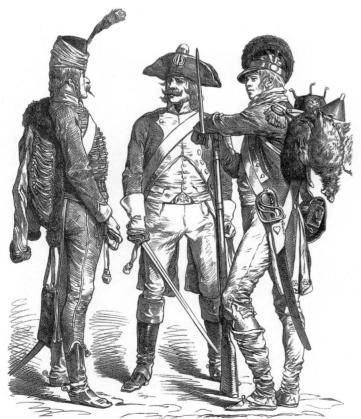

Hussar, 1795

Line cavalryman, Infantryman, 1796 1795 327

Officer of light Line infantryman, 1795 infantry, 1795

Plate 82 LATE 18TH CENTURY; FRENCH REPUBLIC

1794–1799: Member of the Council of the Five Hundred

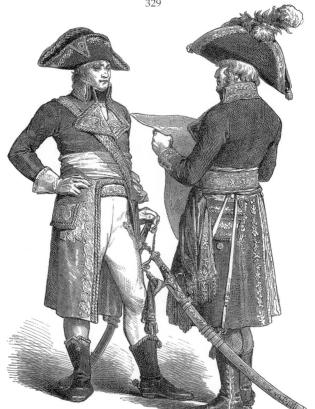

Generals, 1799–1800 331

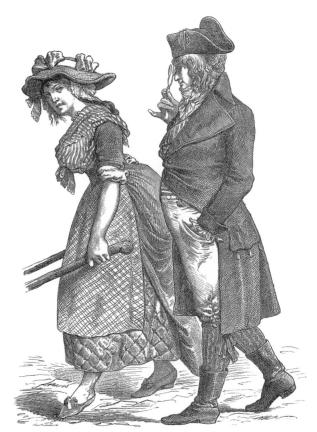

Middle-class dress, 1796 330

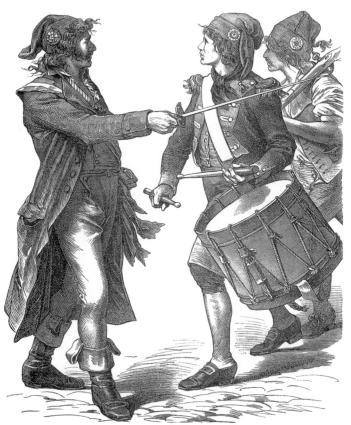

Members of the Commune, 1793–1794 $$\operatorname{332}$$

Plate 83 LATE 18TH CENTURY; FRENCH REPUBLIC

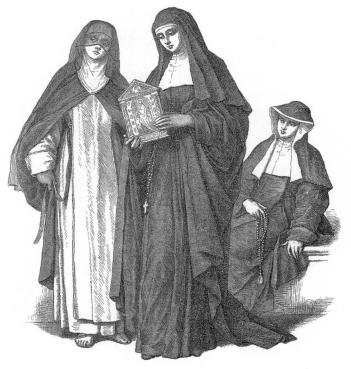

Augustinians 333

Dominicans 334

Benedictines 335

Ursulines 336

PLATE 84 LATE 18TH CENTURY; NUN'S GARB

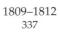

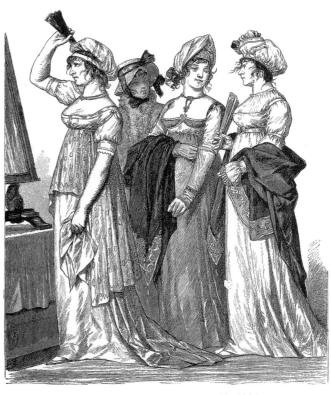

1802 1803–1804 338

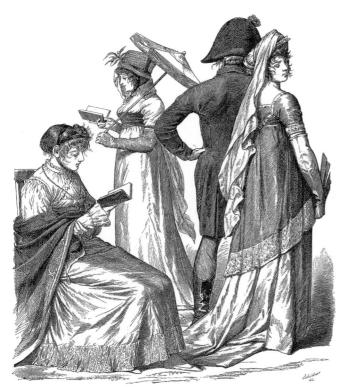

1802–1804 339

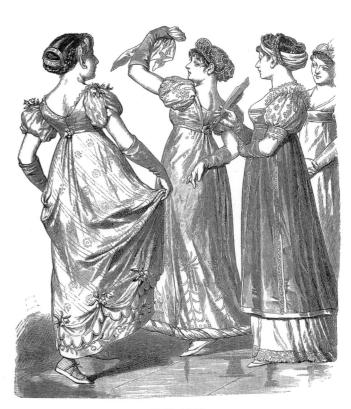

1808–1809 340

PLATE 85
EARLY 19TH CENTURY;
EMPIRE STYLE, GERMANY AND FRANCE

Lady with a spencer 341

Lady in ball gown, 1805

Lady with high hat

Lady in douillette

Lady in gown

Court dress

Man with carrick

344

PLATE 86
EARLY 19TH CENTURY; EMPIRE STYLE

1818 346

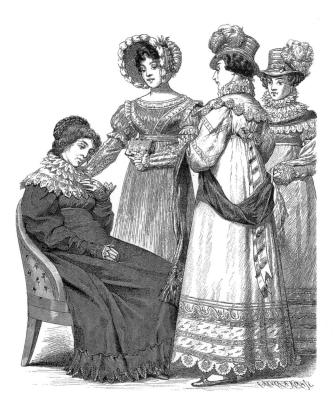

1819 347

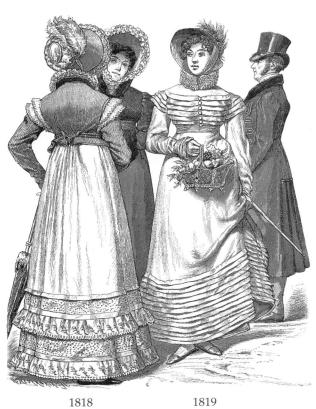

Plate 87 EARLY 19TH CENTURY; RESTORATION

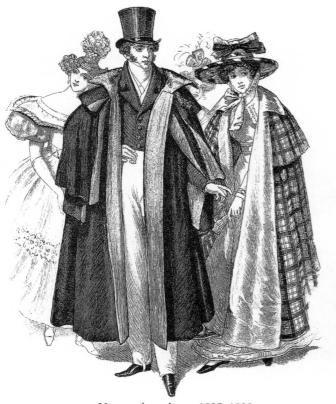

Upper-class dress, 1825–1830 349

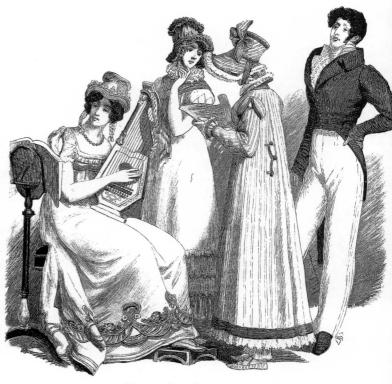

Upper-class dress, 1815–1820 350

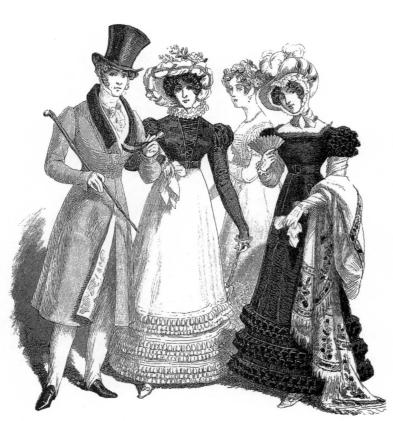

Upper-class dress, 1820–1825 351

Munich, 1822: Waitress

Middle-class family

PLATE 88
FIRST HALF OF THE 19TH CENTURY; GERMANY

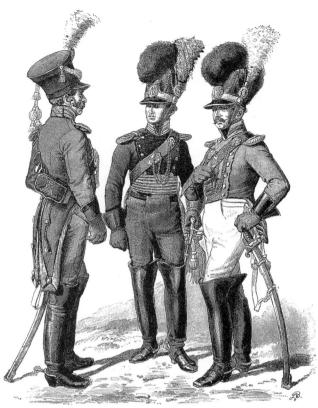

Cavalry captain in the gendarmerie, 1812–1815

First lieutenant of artillery, 1811–1825 353

Lieutenant of transport, 1815–1825

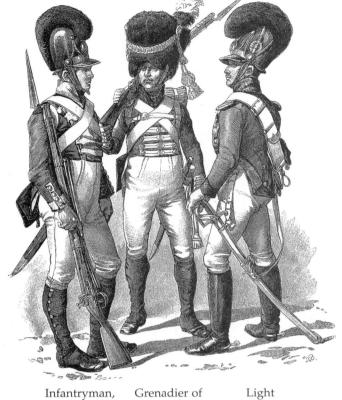

Infantryman, 1814–1825

the guard, 1812–1815 354

Light cavalryman, 1805–1812

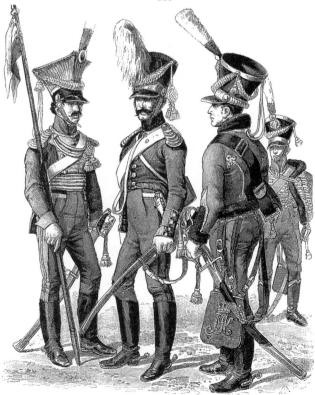

Uhlan private, 1814-1822

National light cavalryman in Prince Karl's regiment, 1813–1815

Hussar of the 2nd regiment, 1815-1822 (dissolved)

Uhlan officer, Officer in the 1813 Garde du Corps, 1814-1823

Cuirassier private, 1815–1825

356

Trumpeter of the Garde du Corps in gala

PLATE 89

EARLY 19TH CENTURY; BAVARIAN ARMY

Benedictines 357

Franciscans 358

Hieronymites (hermits) 359

Capuchins 360

Plate 90 Late 19th Century; Monastic Orders

Outskirts of Rome 361

In the Volscian Mountains

Fisherman from the Neapolitan Apennines

San Germano

On the Roman coast 363

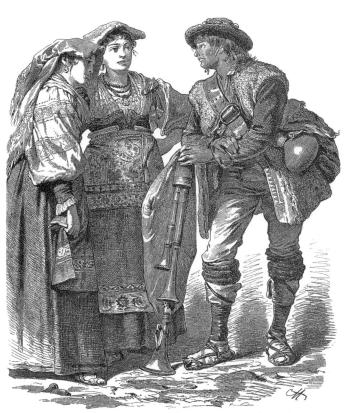

Genzano Piper (*pifferario*) from the Neapolitan Apennines 364

Plate 91 Late 19th Century; Italian Folk Dress

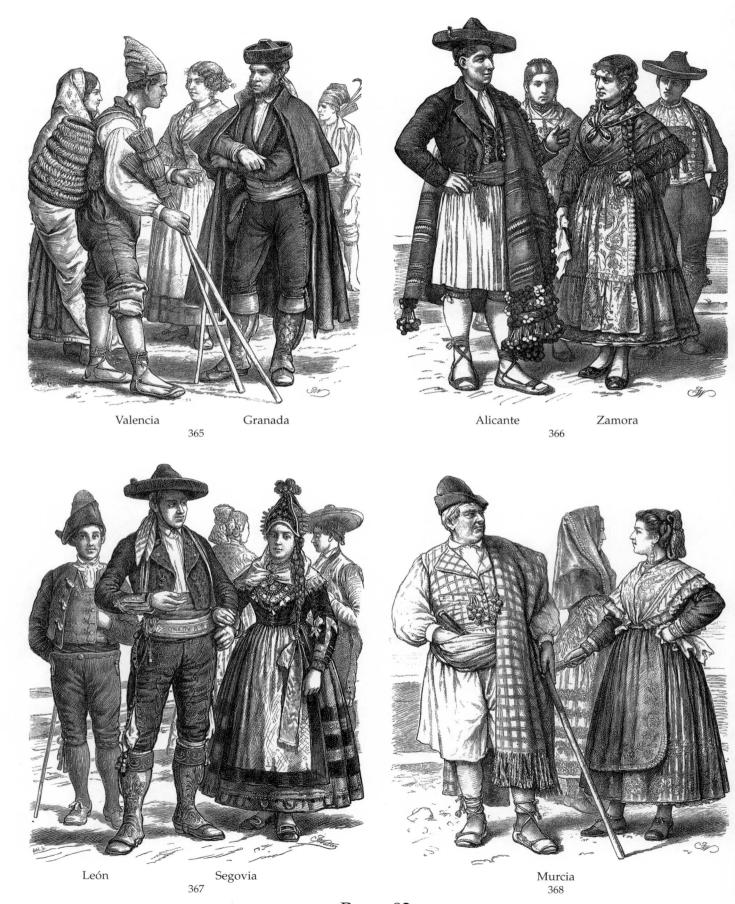

Plate 92 Late 19th Century; Spanish Folk Dress

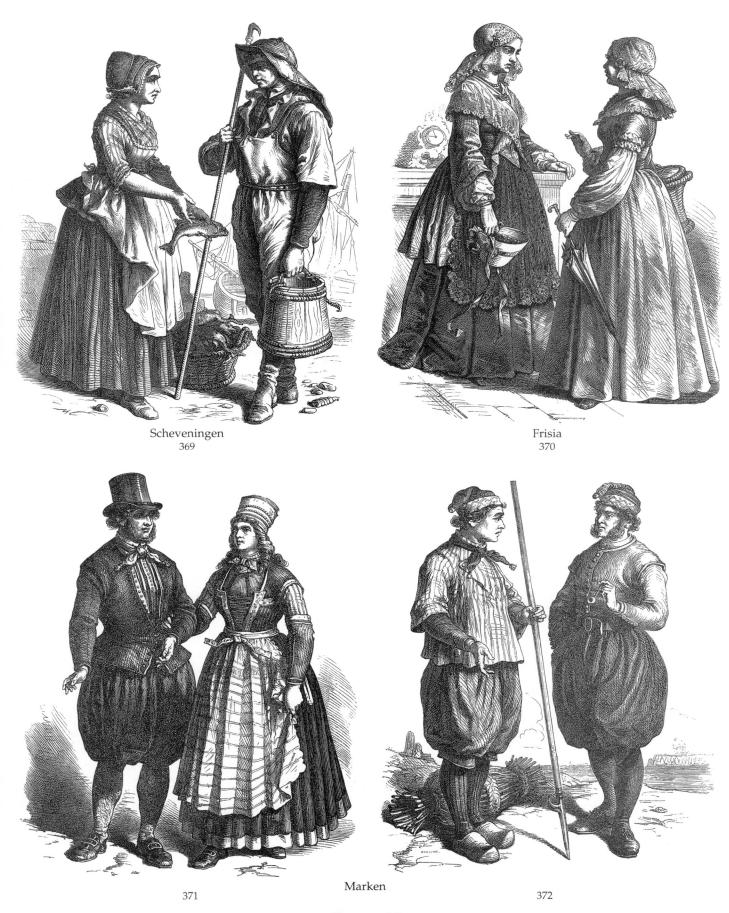

Plate 93 Late 19th Century; Dutch Folk Dress

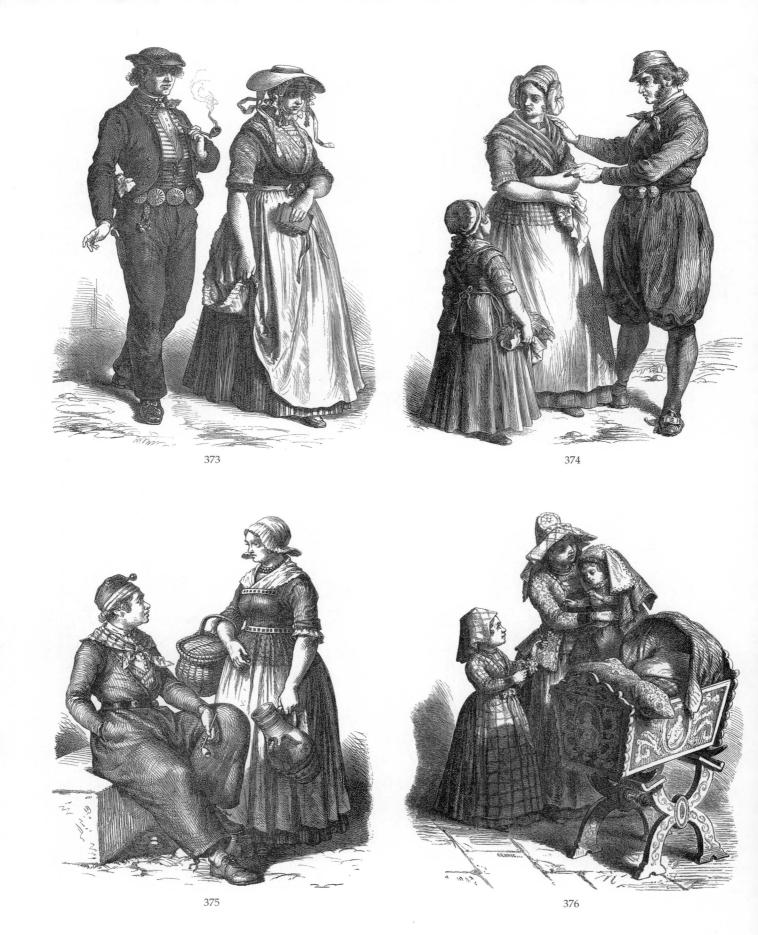

Plate 94 Late 19th Century; Dutch Folk Dress

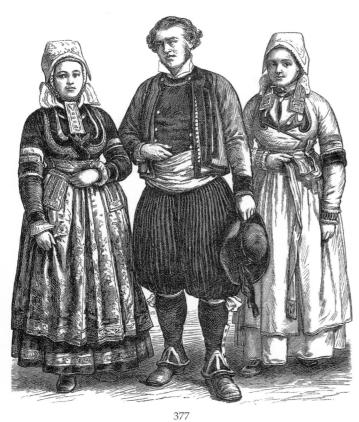

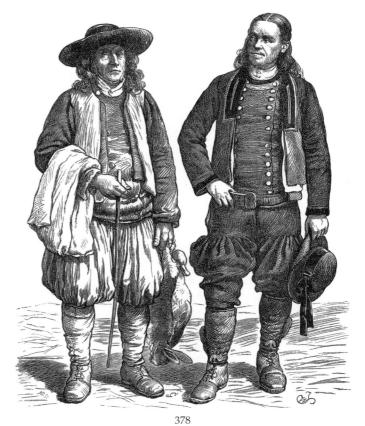

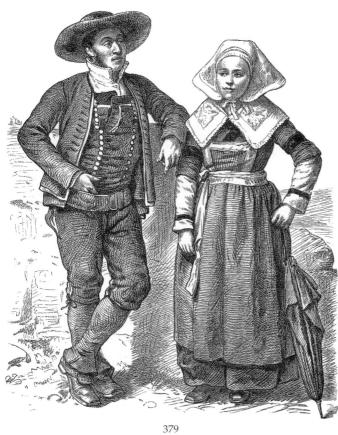

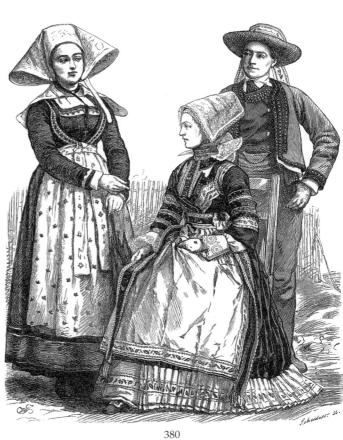

Plate 95 LATE 19TH CENTURY; FRENCH FOLK DRESS (BRITTANY)

Outskirts of Schlettstadt

Brumath

Near Weissenburg 381

Oberseebach

Aschbach

Weissenburg 382

Kochersberg

Oberseebach

Aschbach (Sulz) 383

Outskirts of Strasbourg

Kochersberg Krautgersheim Colmar Oberseebach (Schlettstadt)

Plate 96 LATE 19TH CENTURY; ALSATIAN FOLK DRESS

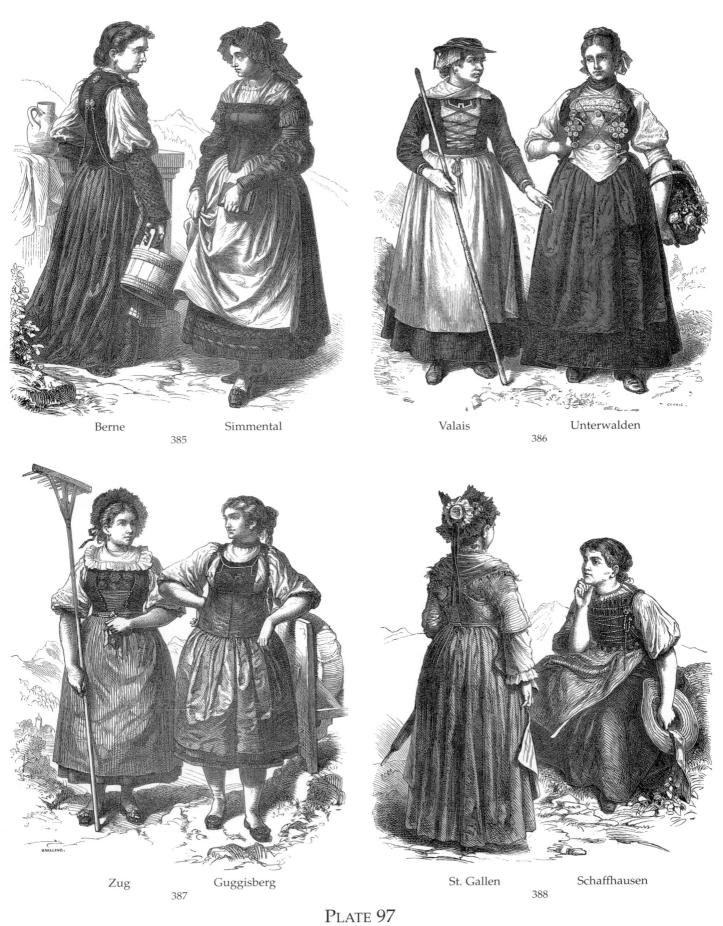

PLATE 97
LATE 19TH CENTURY; SWISS FOLK DRESS

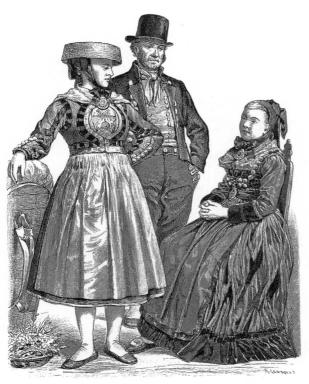

Hamburg, man and woman from the Vierlande from Nottendorf (Geest)

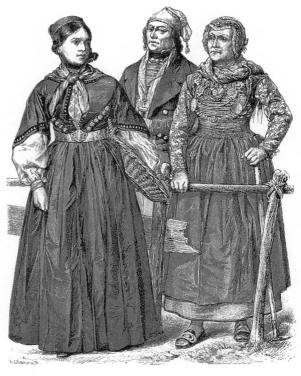

Schleswig-Holstein: Woman in Communion dress

Peasant from Woman from Hohenwested the Halligen

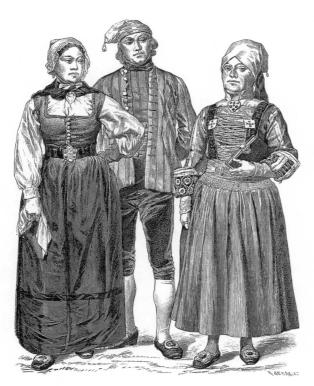

Frisia: Girl and peasant from the Viölkaspel

Peasant woman from Ostenfeld (older costume)

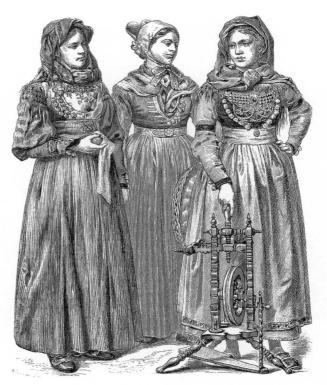

Frisian peasant women: From the island of Föhr

From Romoe

From Wyck (on Föhr)

392

PLATE 98 LATE 19TH CENTURY; NORTH GERMAN FOLK DRESS

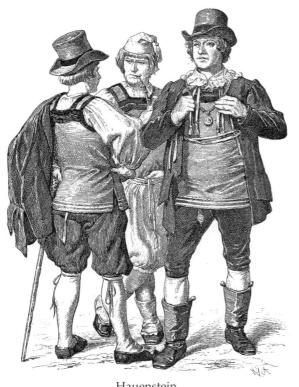

Hauenstein 393

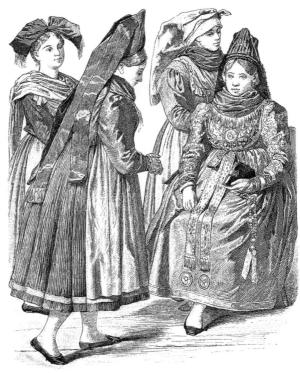

Breisgau Witichhausen Vilchband (Tauber area)

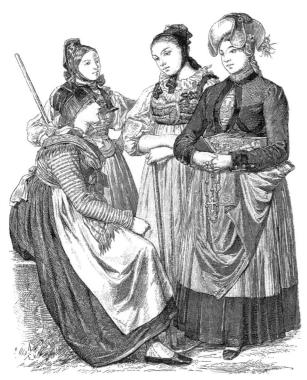

Black Forest

Schapbachthal 395

Hauenstein

Hardt area (Iffezheim)

Tauber area (Witichhausen, Vilchband) 396

Plate 99
Late 19th Century; German Folk Dress (Former Grand-Duchy of Baden)

Western Baar

Catholic Baar

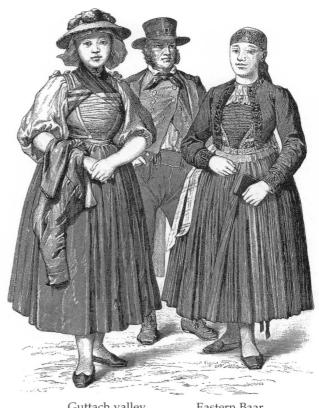

Guttach valley

398

Eastern Baar

Wedding costume, Hauenstein 399

Western Baar 400

Plate 100 LATE 19TH CENTURY; GERMAN FOLK DRESS (BADEN)

Hanau region 401

Renchthal 402

Eastern Baar 403

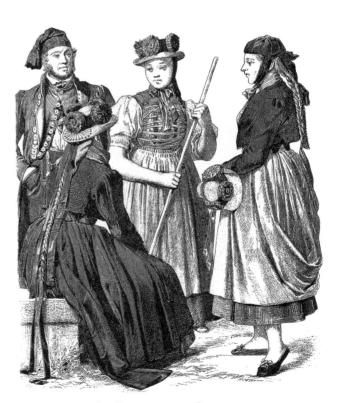

St. Georgen 404

Sommerau

Plate 101 Late 19th Century; German Folk Dress (Baden)

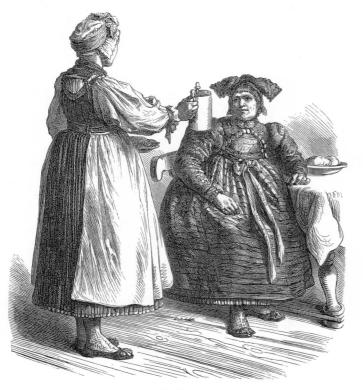

Dachau 405

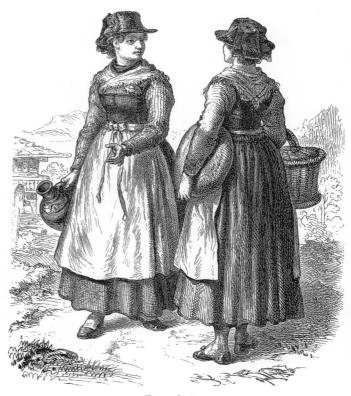

Rosenheim 406

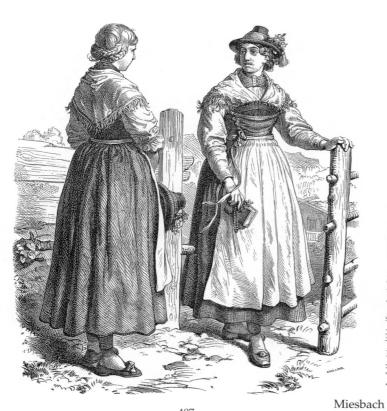

407

408

Plate 102 Late 19th Century; German Folk Dress (BAVARIA)

Starnberg and vicinity 410

Bridesmaids, Starnberg 411 Wolfratshausen 412

Plate 103 Late 19th Century; German Folk Dress (Bavaria)

Meran (Merano) 413

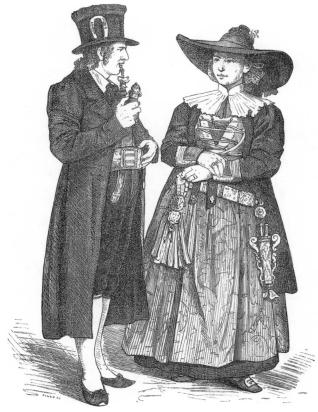

Grödner valley 414

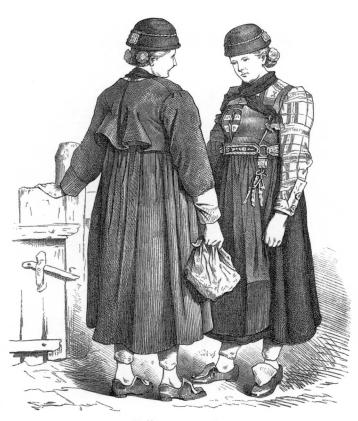

Teffereggen valley 415

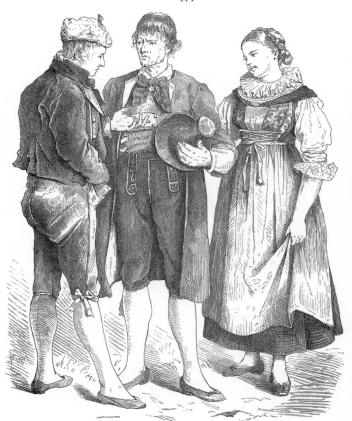

Puster valley 416

 $\begin{array}{c} P_{LATE\ 104} \\ \text{Late\ 19th\ Century;\ Tyrolean\ Folk\ Dress} \end{array}$

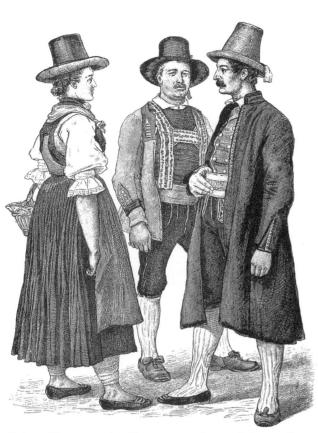

Brixen (Bressanone) Unterwangenberg Brixen valley valley

417

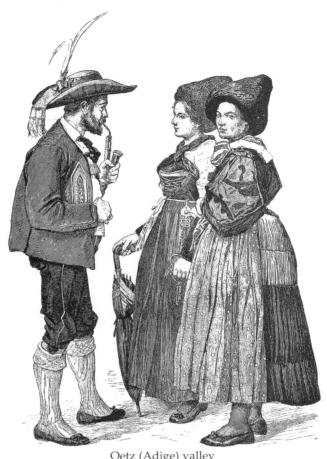

Oetz (Adige) valley 418

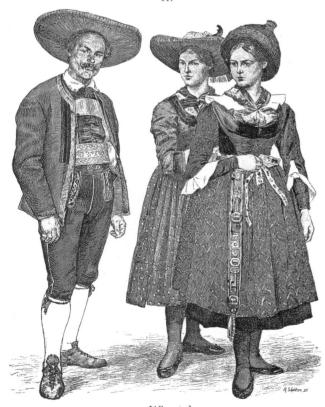

Wipptal 419

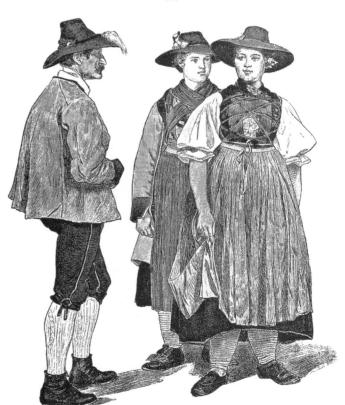

Alpbach 420

PLATE 105 LATE 19TH CENTURY; TYROLEAN FOLK DRESS

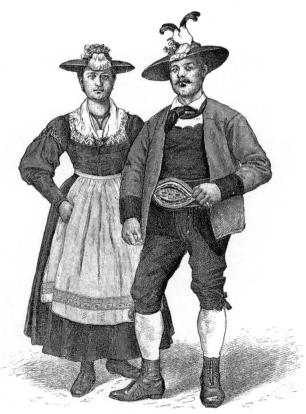

Jung-Zillertal 421

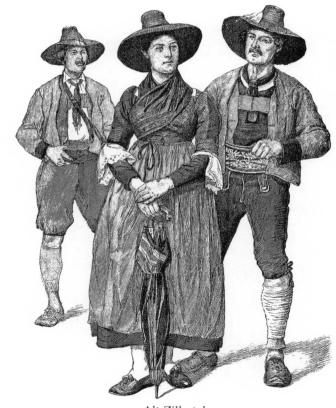

Alt-Zillertal 422

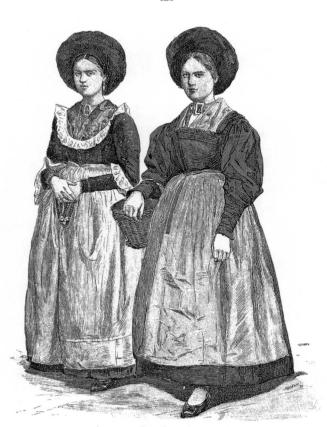

Amras—Innsbruck vicinity 423

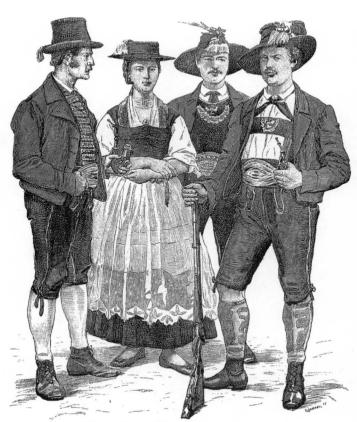

Lower Inn valley in an earlier period 424

Plate 106 Late 19th Century; Tyrolean Folk Dress

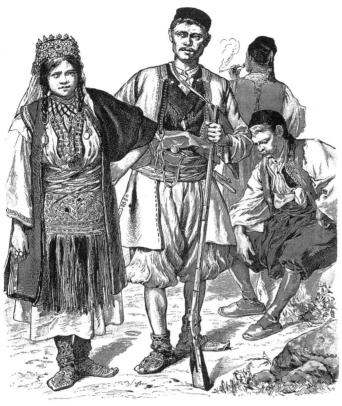

Inhabitants of Kruzevice (Crivoscie) 425

Porter from Dubrovnik (Ragusa)

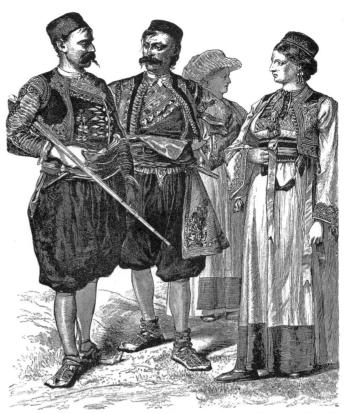

near Dubrovnik

Man from Gruda, Risan, Boka Kotorska (Risano, bocche di Cattaro) 426

Girl from Gruda

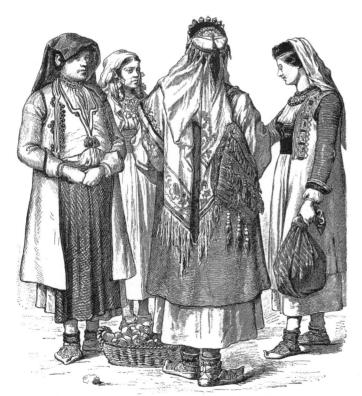

Girl from Draste, Boka Kotorska

Women and girl from Kruzevice, Boka Kotorska

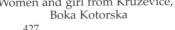

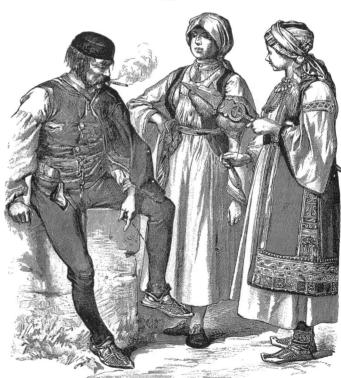

Man from Tartaro, near Sibenik (Sebenico)

Woman from the islands off Sibenik

Girl from Bukovica

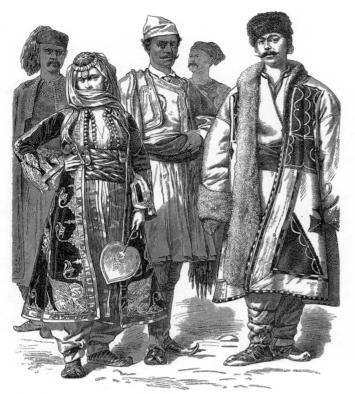

Skodra (Scutari)

Prizren

Arnauts (Albanians) from Janina 429

Bulgar

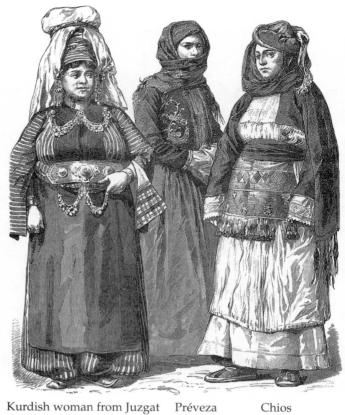

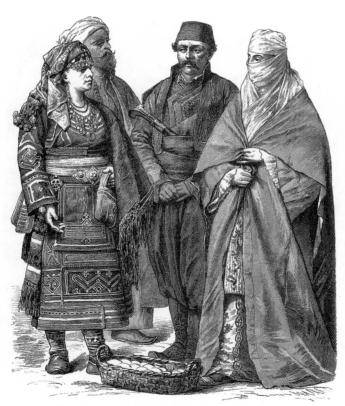

Skodra

Adrianople (Edirne) 431

Saloniki

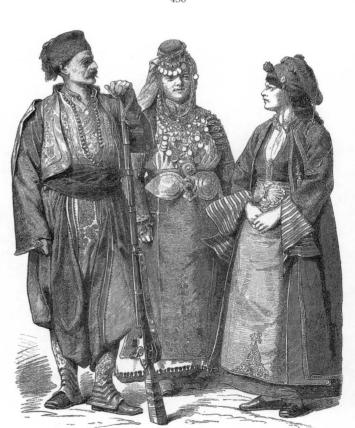

Monastir

Thessaly 432

PLATE 108 Late 19th Century; Folk Dress in European Turkey (Now Parts of Albania, Yugoslavia, Bulgaria, and Greece)

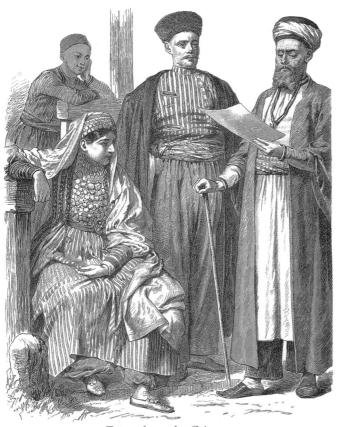

Tatars from the Crimea 433

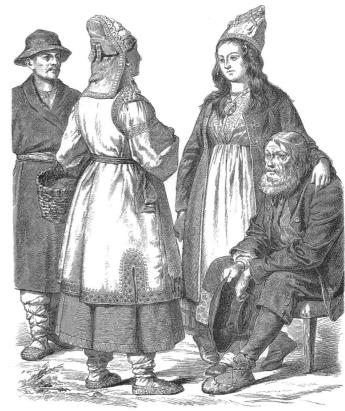

Mordvin (Volga Finn)

Cheremiss (Mari) woman 434

Estonians

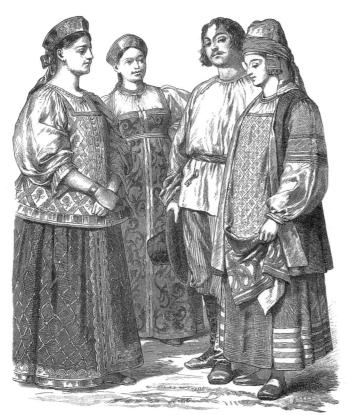

Tver 435

Woman from Yaroslavl Woman from Man and woman Tver from Kaluga

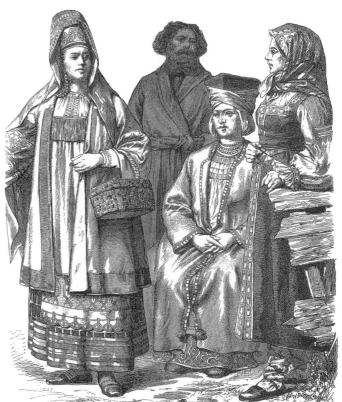

Woman from Guberniya of Ryazan Voronezh 436

Finnish woman

Guberniya of Petersburg

PLATE 109 LATE 19TH CENTURY; RUSSIAN FOLK DRESS

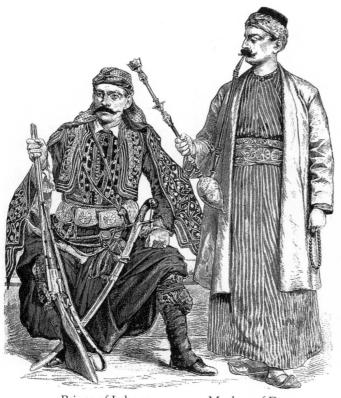

Prince of Lebanon

Moslem of Damascus

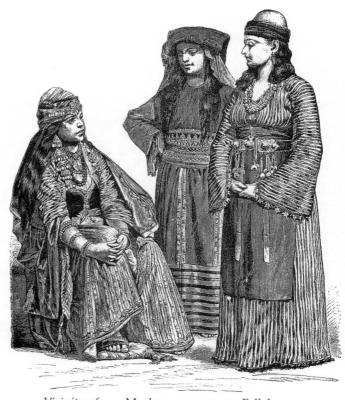

Vicinity of Damascus

Moslem woman, vicinity of Mecca vicinity of Damascus
438

Fellah woman,

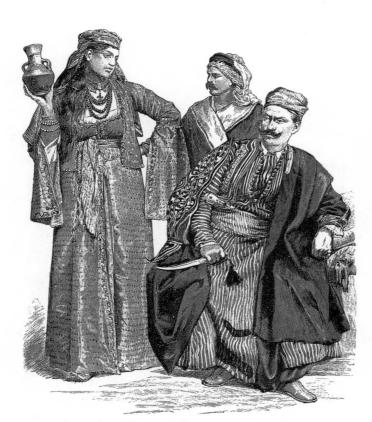

Armenian girl

Druse

Inhabitant of Damascus

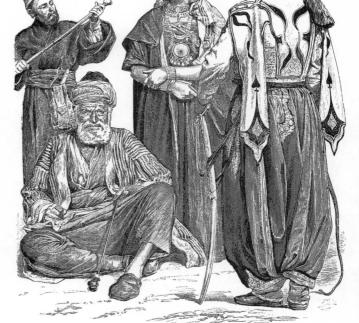

Dervish Syrian peasant Young Druse woman

Kavass (police officer) in Damascus

440

PLATE 110 LATE 19TH CENTURY; NEAR EAST

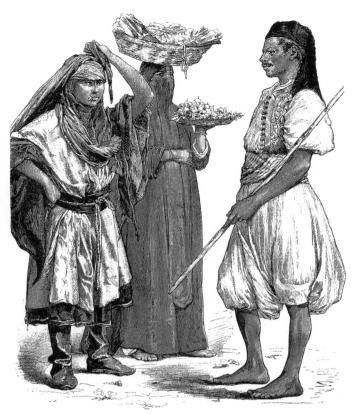

Bedouin girl

Fruit vendor 441

Messenger

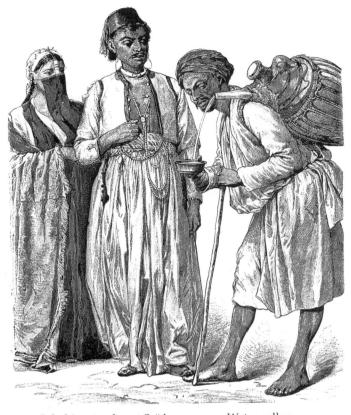

Inhabitants of port Saïd

Water seller

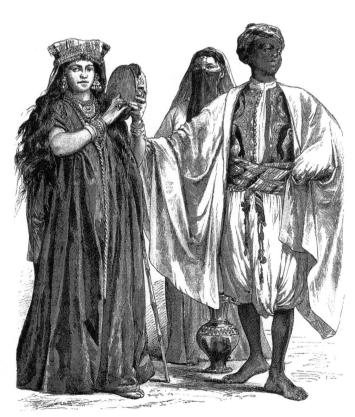

Tambourine player

Water carrier Servant 443

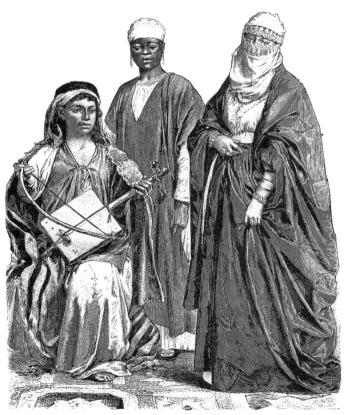

Bedouin musician

Slave girl 444

Street dress

Plate 111 Late 19th Century; Egypt

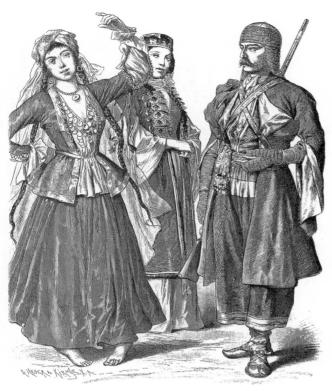

Bayadere from Georgian woman Circassian from Shemakha Khevsur Khevsur 445

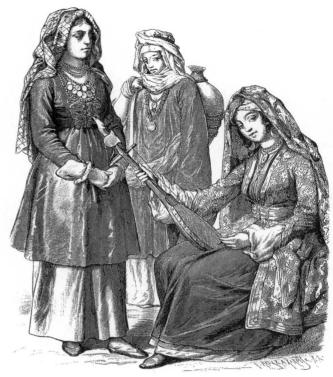

Cossack girl from Cherlenaya

Woman from Akhty in Dagestan 446

Woman from Kazanistih

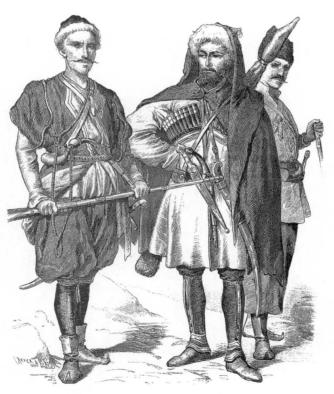

Tushin

Militiaman at Anapa Lezghian

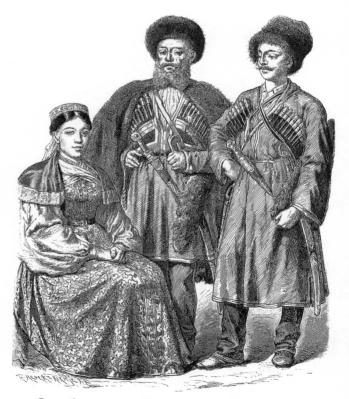

Cossack woman from the Black Sea

Cossack of the line 448

Inhabitant of Kabardah

PLATE 112 LATE 19TH CENTURY; CAUCASUS

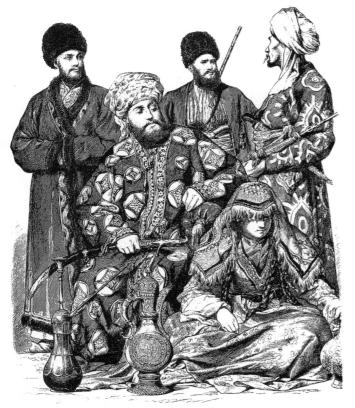

Man from Khiva

Emir of Bukhara

Teke Turkmen 449

Girl from

Police soldier Samarkand from Bukhara

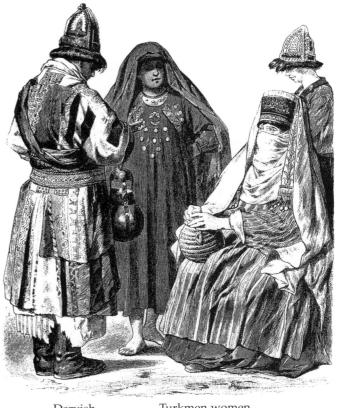

Dervish

Turkmen women

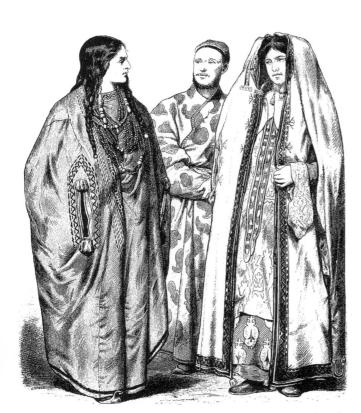

Sartish women and man from Turkestan on the Chinese border 451

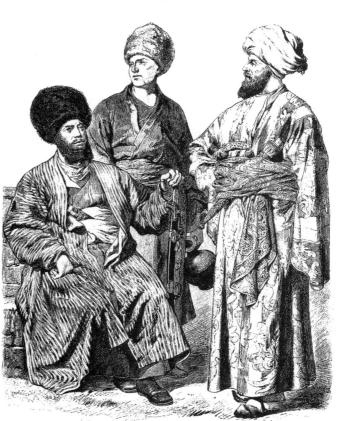

Men from Khiva 452

PLATE 113 LATE 19TH CENTURY; CENTRAL ASIA

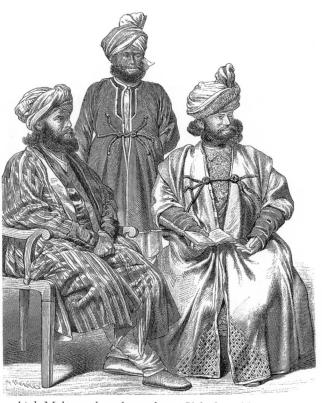

Atah Mahomed, ambassador at Kabul, and his retinue \$453>

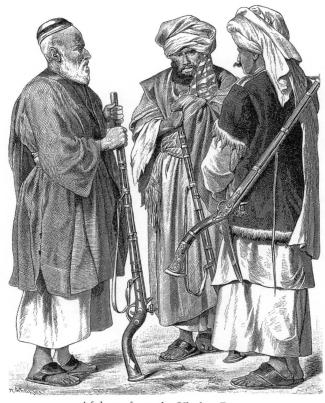

Afghans from the Khyber Pass 454

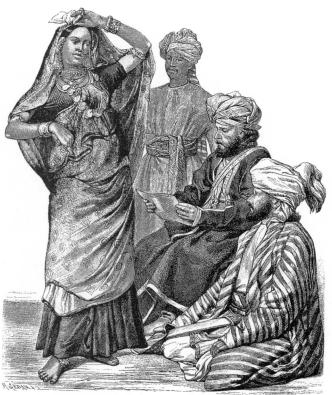

Indian dancing girl

Afghans

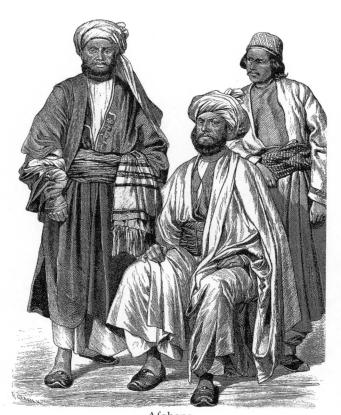

Afghans 456

Plate 114 Late 19th Century; Afghanistan

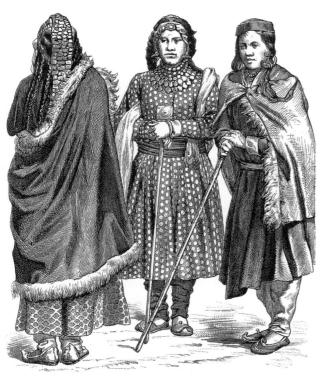

Tibetan women and girl 457

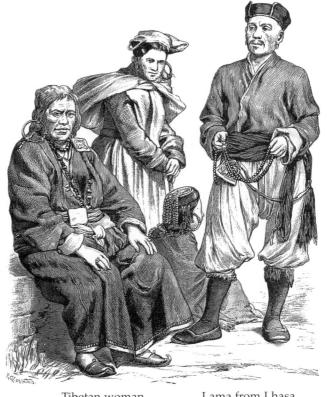

Tibetan woman

Lama from Lhasa

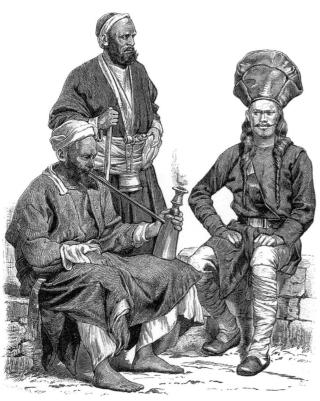

Kashmir: Men from Ladakh in the Himalayas

Soldier of the Maharajah

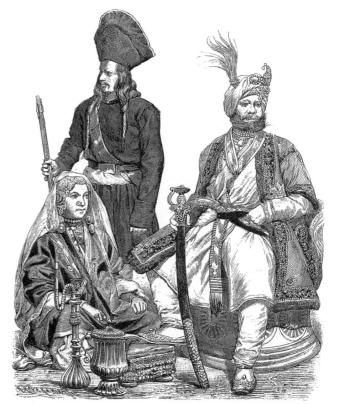

Kashmir: Dancing girl

Personal guard of the Rajah 460

Rajah

PLATE 115 LATE 19TH CENTURY; TIBET AND KASHMIR

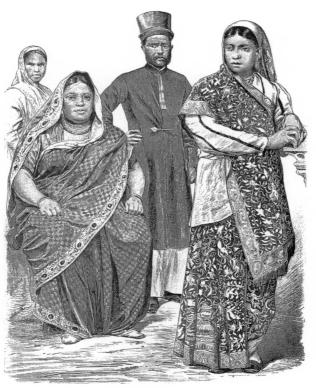

Parsees from Bombay in Singapore 461

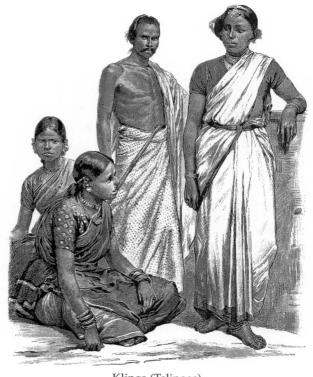

Klings (Telingas) 462

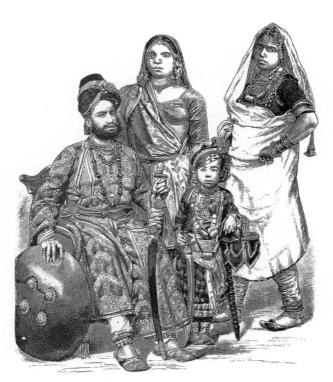

Prince and woman of Rajputana Hindu woman 463

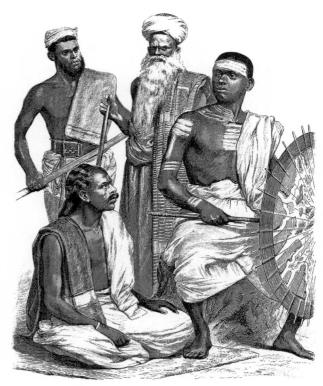

Coolie

Muham 464

Kling (Tjetti)

Plate 116 Late 19th Century; India and Malaysia

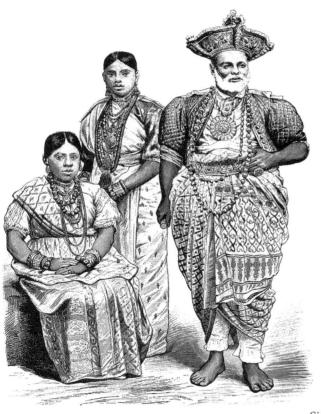

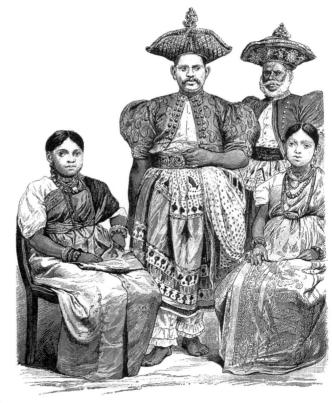

Singhalese

466

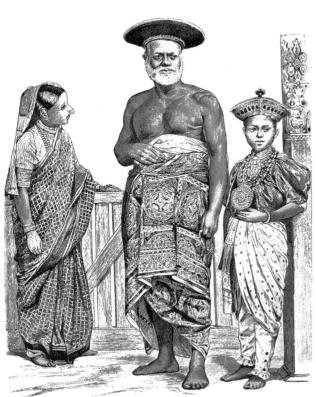

Singhalese nobleman 467

Page of the Governor of Ceylon

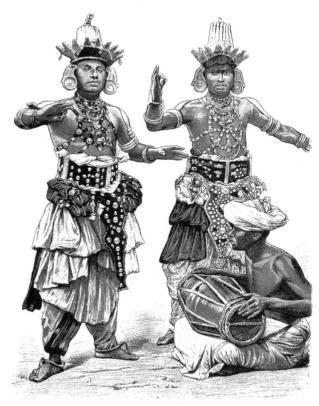

Singhalese devil dancers 468

Plate 117 Late 19th Century (1880); Ceylon

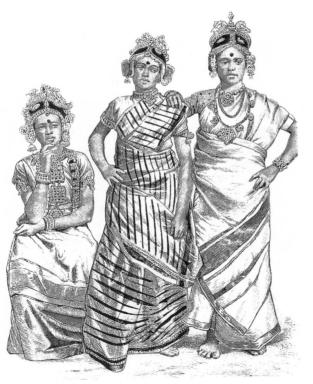

 $\begin{array}{c} \text{Actresses from Jaffna, on Ceylon} \\ 469 \end{array}$

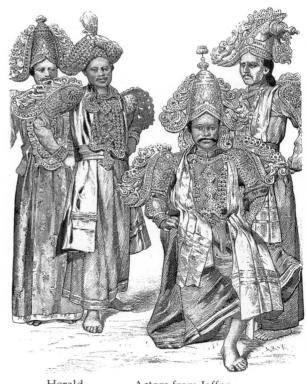

Herald Actors from Jaffna 470

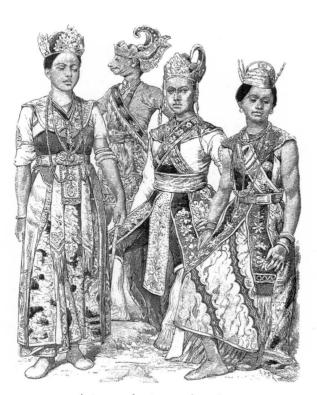

Actors and actresses from Java 471

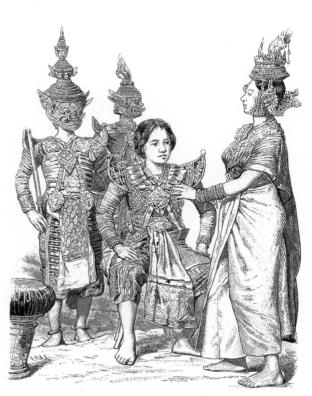

Actors and actresses from Siam

PLATE 118
LATE 19TH CENTURY; CEYLON, JAVA, SIAM

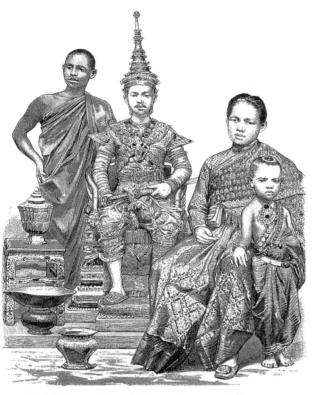

Buddhist monk

King and queen of Siam 473

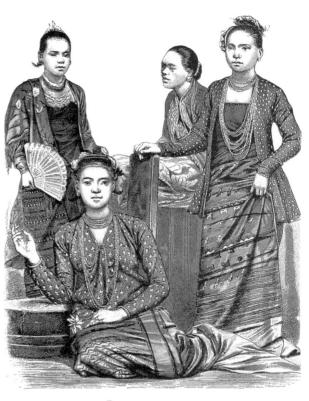

Burmese women 474

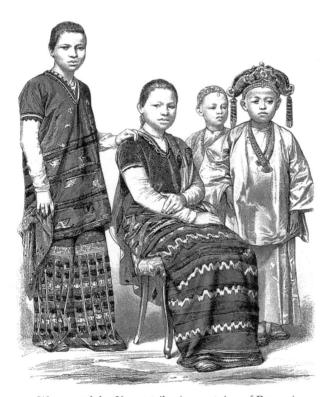

Women of the Karen tribe (mountains of Burma) \$475\$

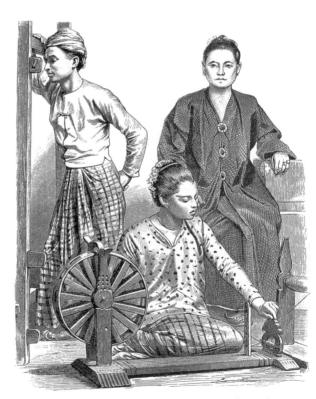

Pu-cho weavers from Burma

Woman from Ava, former capital of Burma

PLATE 119 LATE 19TH CENTURY (1886); SIAM AND BURMA

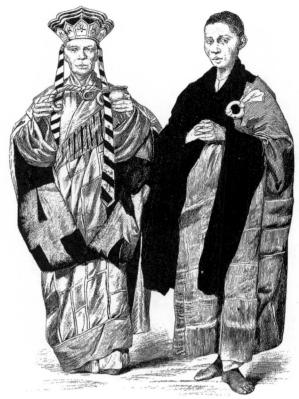

Priests from Annam 477

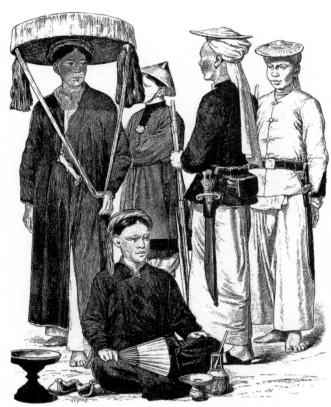

Town dress of woman from Tonkin

Woman from Tonkin 478

Cult objects

Riflemen from Tonkin

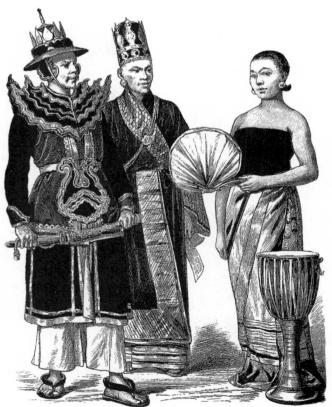

Burma: Officer (older uniform) gala with the

Minister in tsalve order 479

Girl from Drum Mandalay

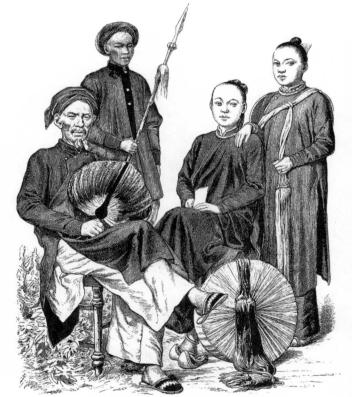

Nobleman from Annam

Girls from Annam

PLATE 120

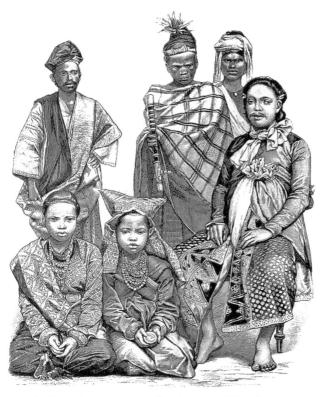

Malays from Minangkabau, Sumatra

Bataks from Sumatra 481

Man from Macassar, Celebes

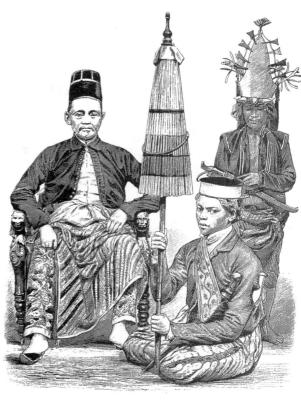

Regent of Cheribon, Java $\,$ Man from the island of Nias $\,$ 482

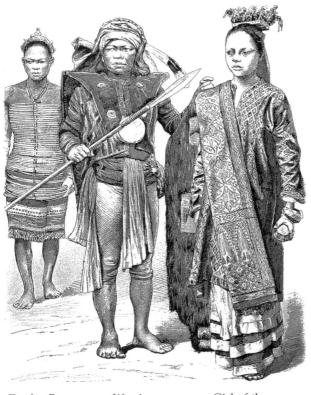

Dyaks, Borneo: Woman

Warrior 483

Girl of the aristocracy

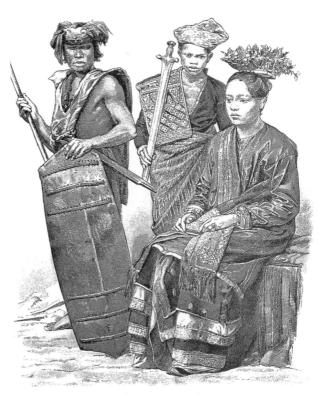

Dyaks

Princess

PLATE 121
LATE 19TH CENTURY; EAST INDIES

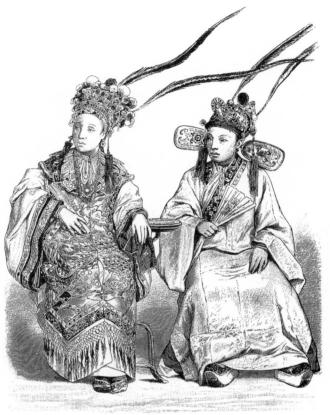

Actresses 485

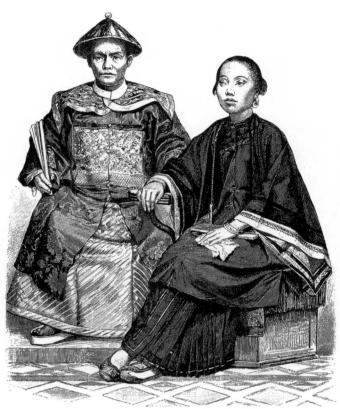

Merchant from Penang Woman from Macao in festive dress 486

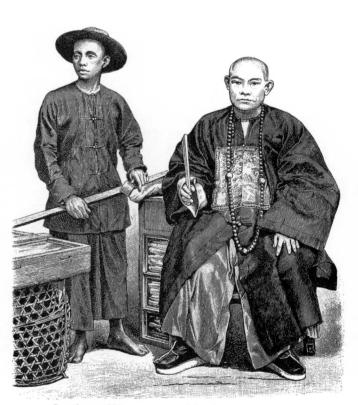

Southern Chinese (from Fukien)

Merchant in Penang

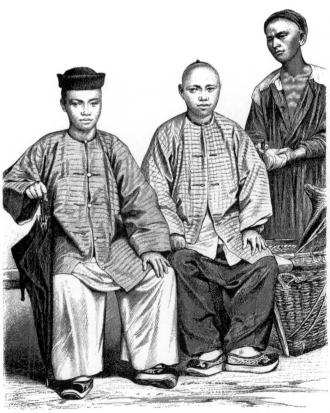

Babas from the Straits Settlements

Shoemaker (opium eater) from Singapore

188

PLATE 122 LATE 19TH CENTURY (1880); CHINESE IN MALAYSIA A APA Table of the same

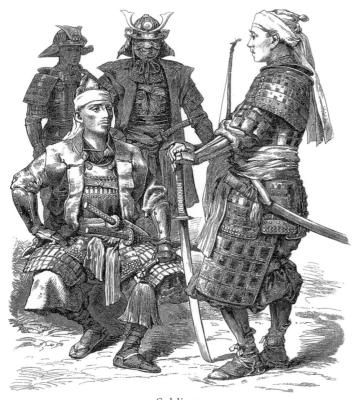

Soldiers 489

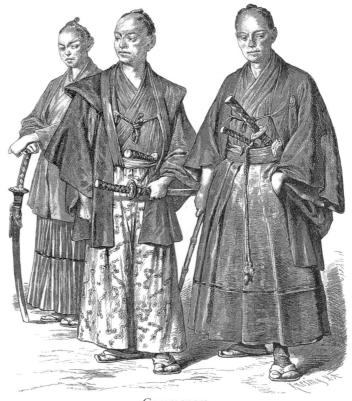

Commoners 490

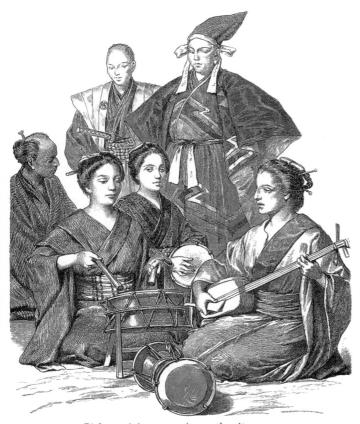

Girl musicians

An authority 491

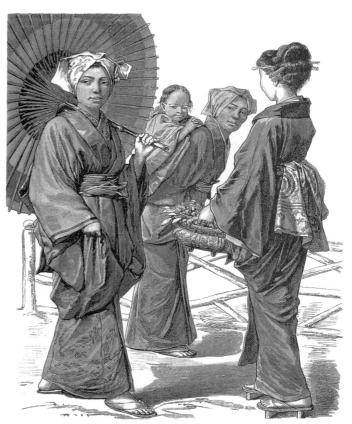

Girls and women 492

Plate 123 Late 19th Century; Japan

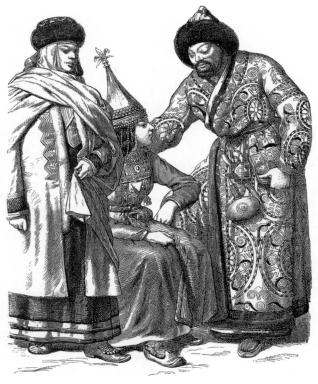

Guberniya of Tomsk

Kurghiz woman and man 493

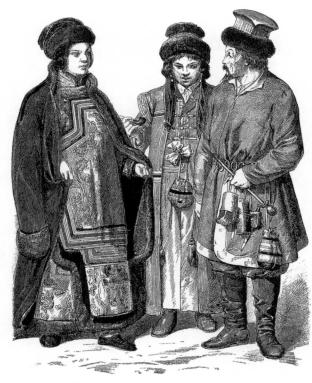

Siberia Tatar woman

Kalmucks 494

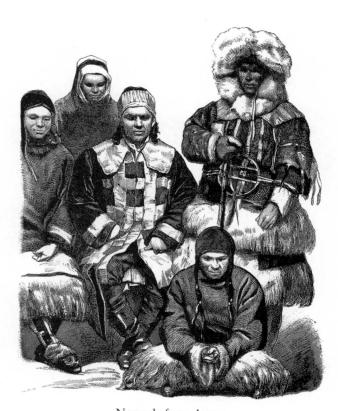

Nomads from Amur 495

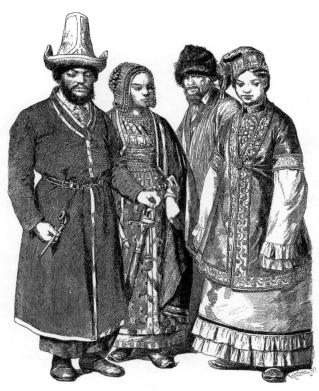

Bashkirs

496

Steppe dweller Tatar woman from Kazan

PLATE 124 LATE 19TH CENTURY; ASIATIC RUSSIA

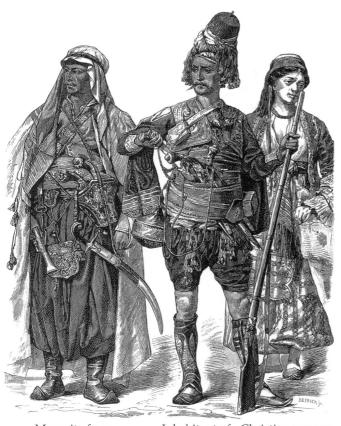

Maronite from Lebanon

Zeibek

Inhabitant of Christian woman from Lebanon

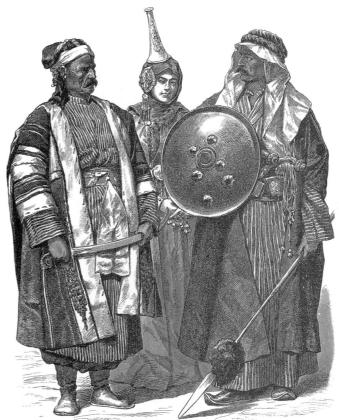

Belka, Syria Arab from Bagdad Woman from Damascus

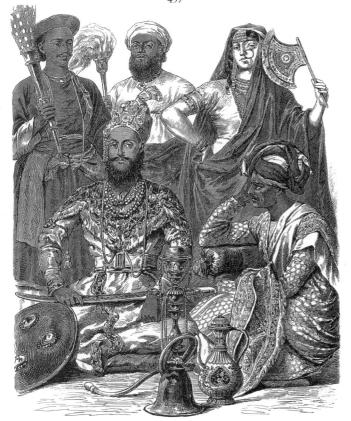

India: King of Delhi

Brahmanic student

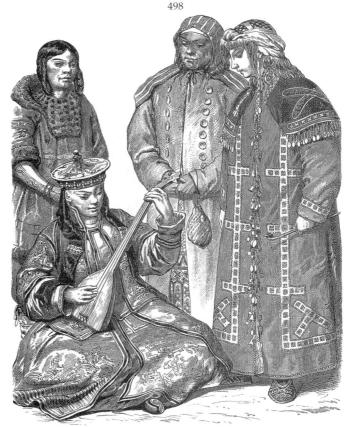

Chukchi woman Buryat woman

Ostyaks from Obdorsk

PLATE 125 LATE 19TH CENTURY; ASIA

EYEWITNESS BOOKS

COWBOY

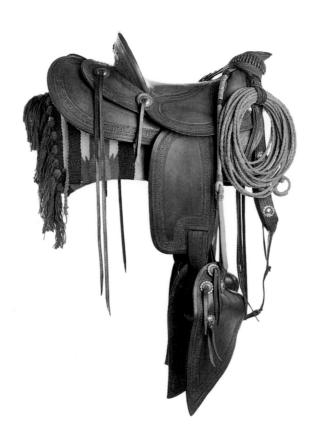

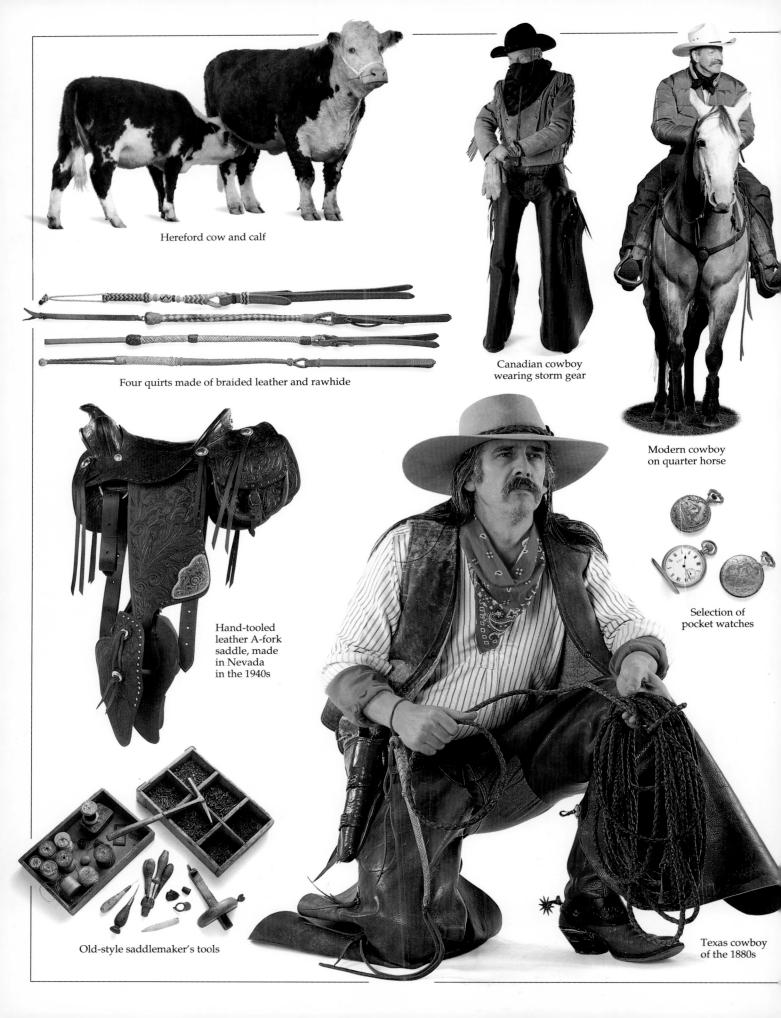

EYEWITNESS BOOKS

COWBOY

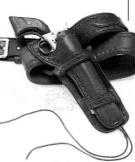

Old-style leather holster with Colt .45 revolver

Written by DAVID H. MURDOCH

Photographed by GEOFF BRIGHTLING

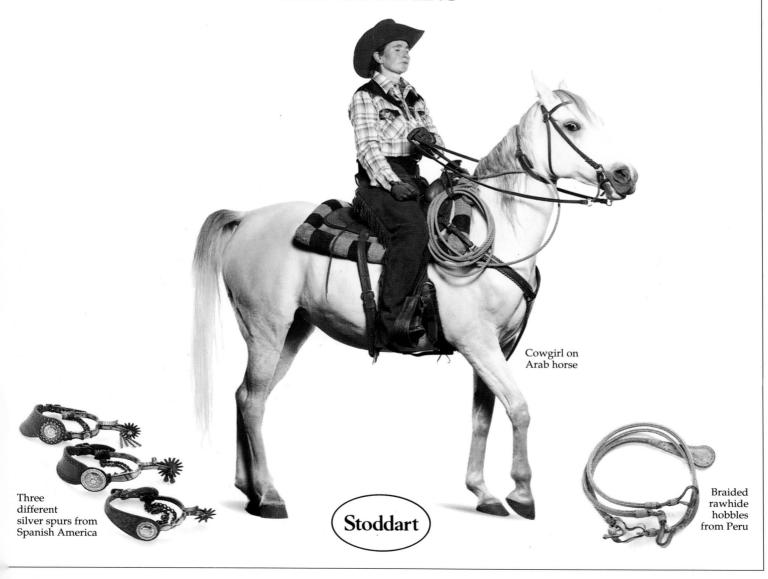

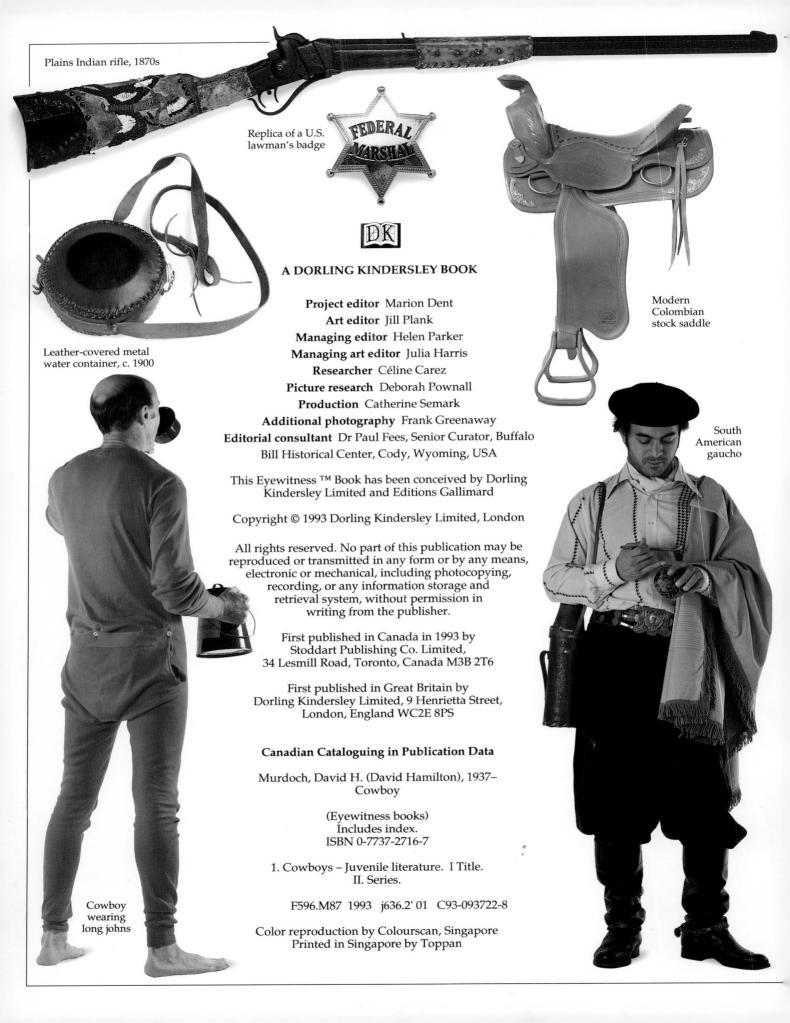

Contents

6
What is a cowboy?
8
Charros and vaqueros
12
The best horses
14
Saddles – old and new
16
Saddling a horse
18
North American cowboy
20
Hats and more hats
22
Dressing a cowboy
24
Boots and spurs
26
Chaps in "chaps"
28
Life on a ranch
30
Cattle and branding
32
Cutting cattle out of a herd
36
Home on the range
38
On the trail drive
42
Law and order

Guns and gunslingers

46
Six gun

48
The South American gaucho

52
Camargue Gardians

56
Cowboys down under

58
Cowgirls

60
Cowboy culture

62
Rodeo thrills and spills

64
Index

THE COWBOYS OF SOUTH AMERICA The horsemen who herded the cattle of the South American plains (pp. 48–51) had different names – gaucho in Argentina and Uruguay, *llanero* in Venezuela, and *huaso* in Chile – but shared a love of independence.

What is a cowboy?

Cowboys were frontiersmen. On the world's great grasslands, wherever cattle raising began and horses ran wild, cowboys lived and worked beyond the security of settlements and the comforts of civilization. The work, attracting men who were independent and self-reliant, required courage and endurance. Cowboys, therefore, believed that their work made them different from others and took pride in their lifestyle. Sometimes the authorities and city dwellers took another view; in the U.S. and Argentina, cowboys and gauchos were regarded as wild and dangerous. Yet in both countries they eventually came to symbolize values that the whole nation admired.

This process has perhaps gone farthest in the U.S., where the cowboy has become the center

of a myth built on the idea of the "Wild West." Hollywood has kept this myth alive, but the cowboys – and cowgirls –

of western movies act out a fantasy that tells little of real life on the range.

The Romans called those who tended their herds of cattle buteri. The name has survived, for in modern times the cowboy of Italy is the buttero. He usually rides a particular breed of horse, the maremmana. Bred in Tuscany, in north central Italy, the maremmana is not very fast but is much prized for its endurance and calm, steady temperament.

NORTH AFRICAN HORSEMEN

A gardian on his Camargue white horse

Members of the fierce warrior tribes of North Africa were superb horsemen. After their conversion to Islam, they began a war of conquest into Europe through Spain, but their relentless advance was finally stopped in France, in A.D. 732. They rode barb horses, famed for their endurance and remarkable speed over short distances. Barbs interbred with Spanish Andalusians (pp. 12–13), and so came to influence cowboy horses throughout the New World.

The powerful mustang – an ideal cow pony

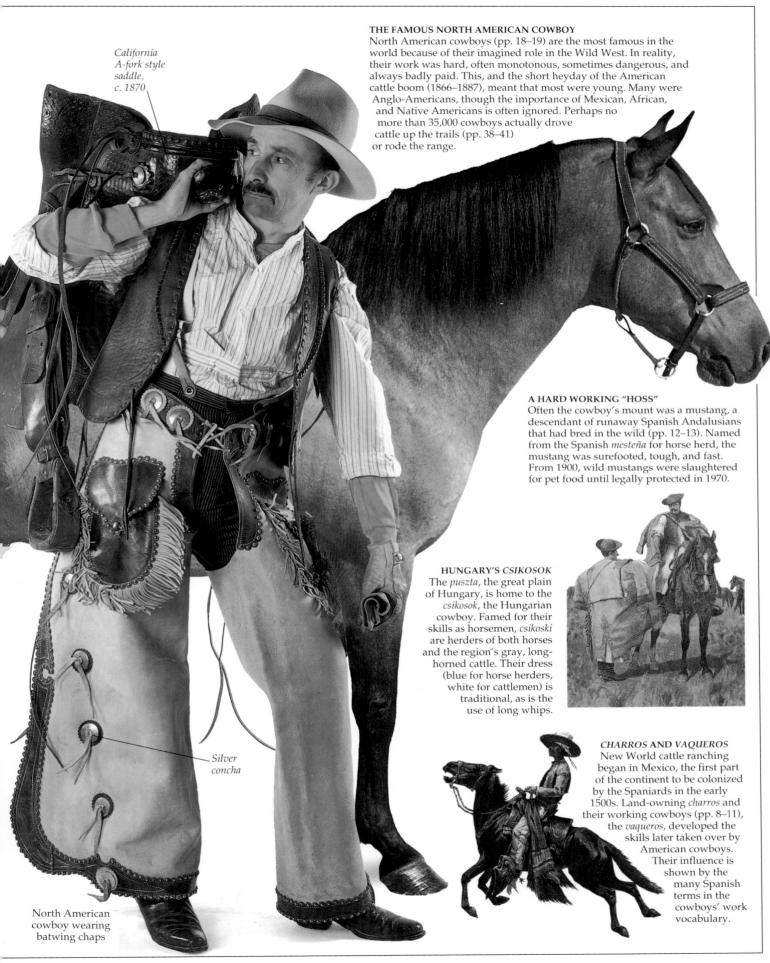

Charros and vaqueros

The Spanish settlers of Mexico in the early 1500s brought long-horned Iberian cattle and Andalusian horses to a continent that previously had no horses or cattle. Many colonists turned to cattle ranching, a profitable as well as "honorable" occupation, because of the great demand for hides, horn, meat, and tallow. By 1848, when Mexico lost much territory to the U.S., ranching had spread to Texas and California. Rich, ranchowning *charros* liked to display their wealth with personal ornaments of silver, much of it from the great mines at Zacatecas in north central Mexico. Ranching techniques spread from Mexico throughout the Americas, and horses that escaped into the

wild became the mustangs of the U.S., the pasos of Peru, and the criollos of Argentina.

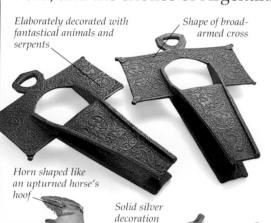

CRUCIFORM STIRRUPS

Stirrups, used in Europe from the eighth century, were essential for heavily armed riders to stay in the saddle, but lightly armed Asian nomads and Native Americans fought without them. These iron stirrups may have belonged to a 16th-century Spanish conquistador, or conqueror, in Mexico. Elaborately decorated, their shape echoed their rider's role as a Christian soldier of the cross.

This magnificent *charro* saddle was made about 1870 by David Lozano, *talabarteria* (saddlemaker) of Mexico City. The artistic tooling, stitching in silver-covered thread, silver-plated conchas (decorative disks), and solid silver on the saddle horn and behind the cantle, all suggest that this was the property of a *hacendado* (great ranch owner).

Padded pommel

Heavily tooled leather showing village scenes and floral designs

A FINE SEAT

Silver

monogram

on stirrup

From the 1600s, women (condemned to wear long, heavy skirts) were able to ride only by using a sidesaddle. This late 1800s Mexican sidesaddle has a support rail on the left, with a saddlebag below it, and a shoe stirrup on the right side. With her right foot in the stirrup, the rider crooked her left knee around the padded pommel, resting her left foot on her right knee – this is much more secure than it looks! The doeskin seat and elaborate decoration show how wealthy the owner was.

Leather stamped and carved with ornate decorations

\\ \Saddlebag \\ View of

Ladies' sidesaddle, Mexican, late 1800s

A MAGNIFICENT MOUNT Charros sometimes imported horses from the U.S., like this palomino saddlebred, a strong breed from Kentucky, capable of covering great distances without tiring. Long,

wedge-shaped,
leather covers on
the stirrups, called
tapaderos, prevented the rider's feet
from slipping
through the stirrups,
being ripped by
thorny brush – or
bitten by the horse!

Rawhide-edged, leather holster, holding an expensive version of a model 1872 Colt .45, with silver butt plate and gold strap

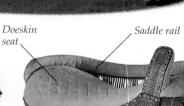

Classic-style

tapaderos are

long and slim

Back view of

charro on horseback

View of right side Shoe stirrup

left side

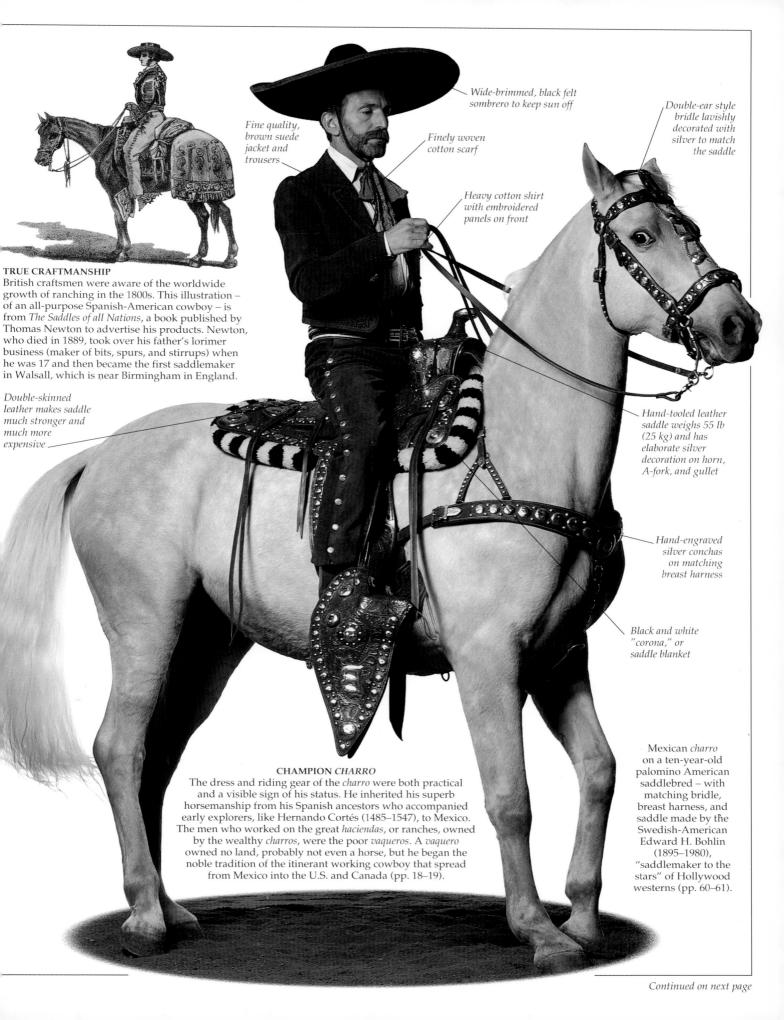

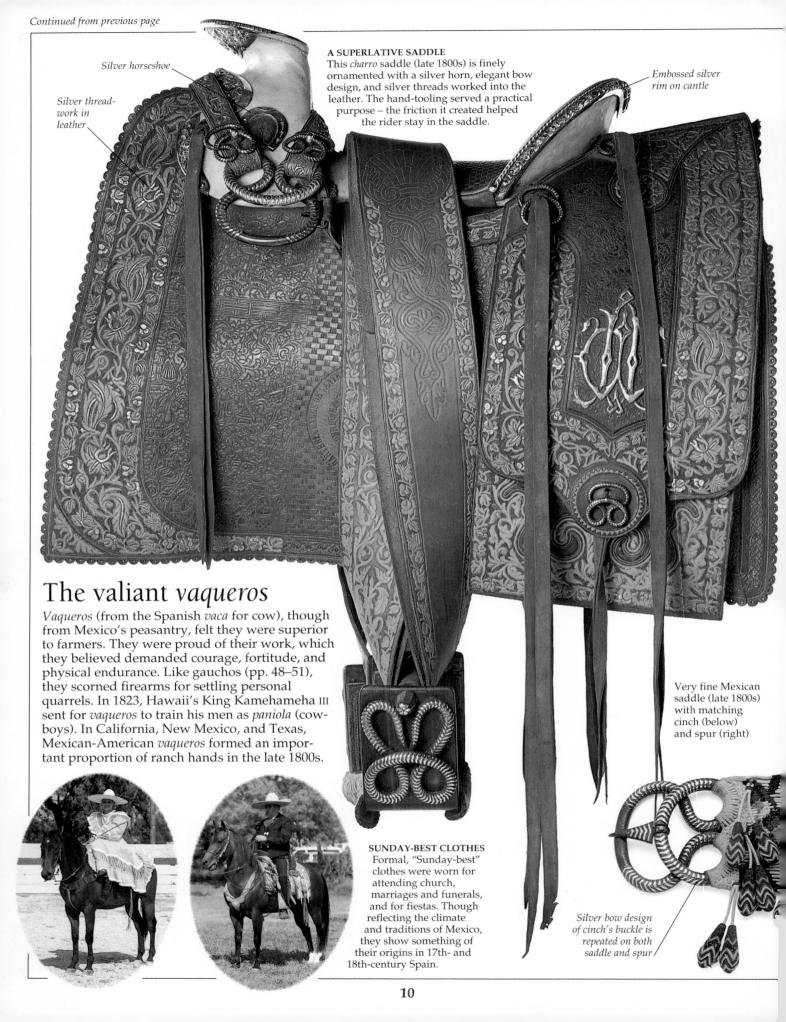

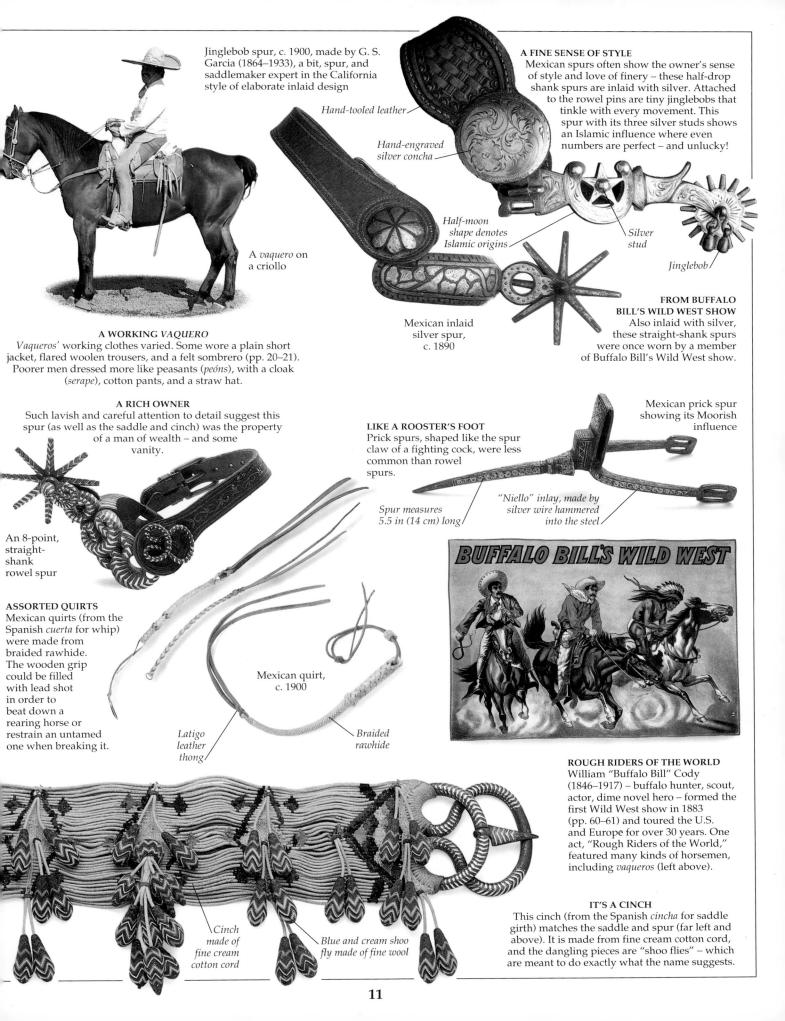

"TURN HIM LOOSE, BILL" This painting by Frederic Remington (pp. 26–27) shows a cowboy "breaking" an untamed horse. After getting the horse used to a hackamore, or training bridle, and saddle, cowboys tried to ride the bucking animal to a standstill, in order to break its resistance. The cruel use of quirt and spurs

was common.

The best horses

Horses and people have worked together since wild horses were first domesticated, probably in eastern Europe 4,000 years ago. Horses changed the direction of human history. They enabled nomadic cultures to range across continents. As chariot pullers and then cavalry mounts, horses transformed warfare. They became the tractors of premodern agriculture and were essential to any kind of large-scale cattle raising. Wild horses died out, except for the Prze-walski. All present-day horses are descended from these original, domesticated animals and form one species

— Equus caballus. Cross-breeding and

different environments have created different colors, sizes, abilities, and characteristics.

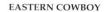

The conquering horde of Genghis Khan (1162?–1227), which created an empire from China west to the Black Sea, rode shaggy Mongol ponies. Kazakh herdsmen in northwest China still ride these animals' descendants.

THE GAUCHOS' COW PONY

Like the mustang of the north, the criollo is descended from feral Andalusians (pp. 8–9) that wandered into South America from Mexico. Strong, agile, and surefooted, in Argentina it became the cow pony of the gauchos (pp. 48–51) – the cowboys of the pampas. Crossed with thoroughbreds, criollos produced the famous Argentinian polo ponies.

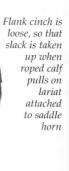

A TEXAS COW PONY
This Texas cowboy, c. 1885, is riding
a mustang. Both Native Americans and cowboys used
mustangs, descendants of 15th-century Andalusians
that had escaped and multiplied across the North
American plains. Though small, the cow pony had
great endurance and was hard working.

Saddles – old and new

A cowboy sat on his horse for up to 15 hours a day – he did not sit behind a steering wheel or at an office desk. His saddle was, therefore, his most important piece of equipment. Unlike his horse (pp. 12-13), which probably was one of several loaned to him by the rancher, his saddle was his own and cost at least a month's wages - but it would last 30 years. Cowboy saddles evolved from the 16th-century Spanish war saddle, with its high pommel (combination of horn and fork at the front) and cantle (the raised part of the seat at the back) to hold its armored rider in place. Over time they changed in weight and shape, but all were built on a wooden frame (pp. 16–17) covered with wet rawhide - which made the

frame rigid as it dried - then re-covered

with dressed leather.

Cantle at

back of saddle

FROM OLD MEXICO This battered Mexican saddle shows the link with 16th-century warriors' saddles. The horn and cantle are carved wood, and the simple frame is covered with tooled leather. wooden horn at

> Stamped cowhide 1970s taps with sheepskin lining for extra warmth

Mexican saddle, made of leather

and wood

Pommel

TOUGH TAPS Taps (from the Spanish tapaderos, pp. 8-11) fitted over the stirrup and gave the rider's foot extra protection from thornbrush and from rain and snow in winter. The two pairs above were called "hawg's snout" from their pig-nose shape; the pair on the right is in the "eagle's beak" style.

Hooded 1920s taps

made from verv

strong cowhide

Taps (1890s) from Buffalo Bill's Wild West show

This 1870s California saddle has an A-fork frame (from its shape), a slim horn, and steam-bent wooden stirrups. Lighter than Texas or Denver saddles, it burdened the horse less.

DEEP IN THE HEART OF TEXAS

This 1850s Texas saddle had a thick horn for heavy roping and fenders to keep horse sweat off

the rider's legs.

The Denver saddle (c. 1890) was longer than the one from Texas (top), with more leather covering. Cowboys liked the solid seat it gave, but its length and weight (40 lb, or 18 kg) sometimes gave the horses back sores.

> **CUTTING SADDLE** This 1890s Canadian stock saddle – for cutting out and rope work is double-cinched. The flank (rear) cinch is kept loose, so the strain on the saddle horn from a roped cow will pull the saddle forward and signal the horse to stop (pp. 34-35).

ONE FROM THE NORTH After the 1870s, saddles from the northern ranges of Montana and Wyoming had leather over the horn and usually square skirts.

front of

Front

Flank strap

or cinch.

saddle

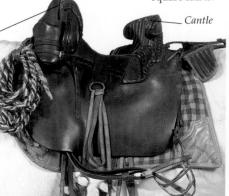

CAMARGUE STYLE

A Camargue gardian's saddle (pp. 52-55) has a curved cantle, a broad, solid pommel, and metal, cageshaped stirrups. Below the pommel, always on the left, is tied his seden (rope).

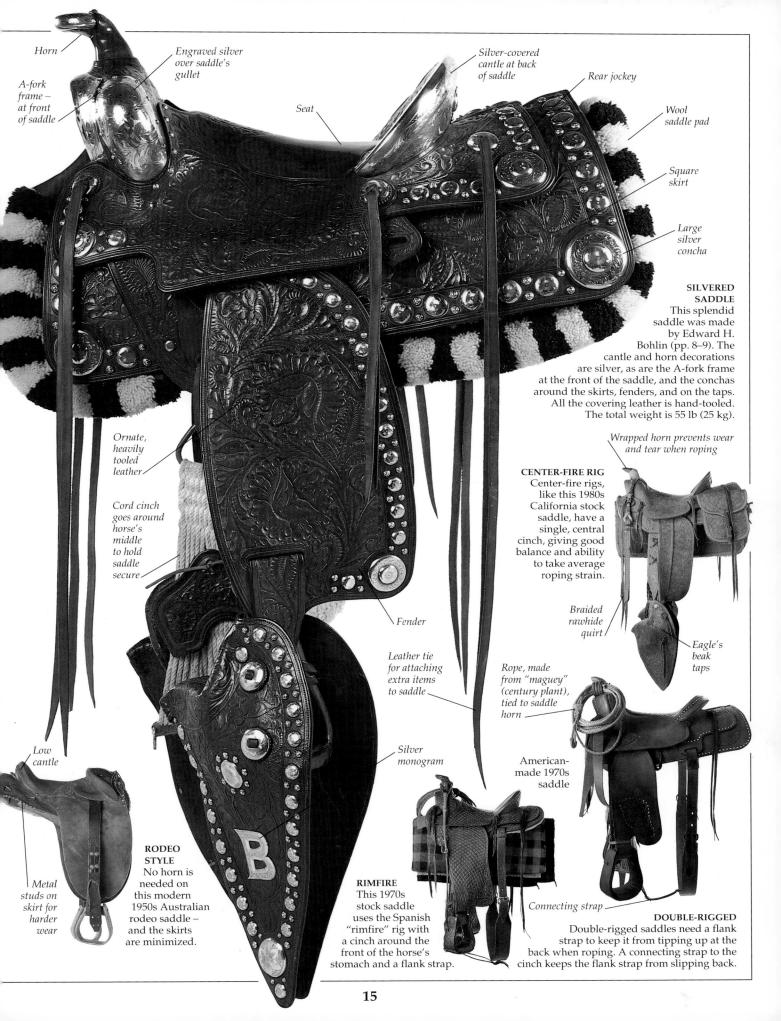

Saddling a horse

Sitting securely on an animal over 5 ft (1.6 m) high, and being able to control it, the cowboy was the inheritor of age-old knowledge of the horse. Bridles were used by the Egyptians by 1600 B.C., although horse riders sat on pads or cloths until the saddle was invented around A.D. 350. Stirrups were first used by the Huns a century later. In the 16th century, Spanish cavalry were the finest and best equipped in Europe, and Spaniards took their skills with them to the Americas. American cowboys later took this knowledge and adapted it. The cowboy's saddle (pp. 14–15) was a work platform on which he also had to carry his equipment. The bridle was designed to check the horse with

Spokeshave

Mau

Cantle

the slightest pull on the reins.

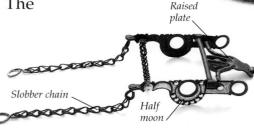

A MARMALUKE BIT

Split-ear

Like the old-style Spanish-American spade bit, the marmaluke bit had a raised plate that lay across the horse's tongue. Only the gentlest touch was used on the reins, so as not to cause the horse pain. Reins were attached to "slobber chains," so the horse did not soak the leather.

Crescent

knife

ON WITH THE BRIDLE Without a bridle, a horse cannot be controlled, so the bridle is put on first. It is made up of a bit and a headstall (split to go around the horse's ears) to hold it in place. The bit is a metal bar resting forward in the horse's mouth, so that the horse cannot get the bit between his teeth and bolt!

cutter

TOOLS

Saddlemaker's tools are simple. The strap cutter adjusts for cutting different widths of leather. The heavy maul, or hammer, is padded to prevent damage to the leather. Like the carpenter's tool, the spokeshave planes curves. The bag of shot holds down the leather without marking it, while the crescent knife allows a firm grip when cutting out curves in leather.

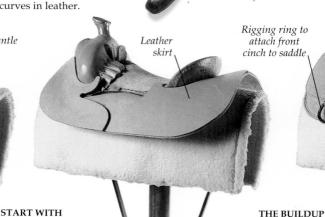

Bag of

shot

Rigging ring to attach front cinch to saddle

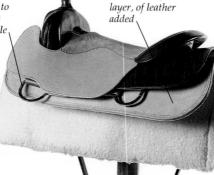

Second skin, or

Basic wooden tree with several coats of lacquer

A WOODEN TREE Made from straight-grained, knotfree pine, the tree contains the metal horn screwed to the fork. This is then covered in wet rawhide, which is dried at a controlled temperature,

then given several coats of waterproof lacquer.

The saddle is built up with a series of coverings beginning with the horn, then the underside of the fork, the seat, fork, cantle, and skirts. Different thicknesses of

leather are used, each shaped, then stitched with damp rawhide.

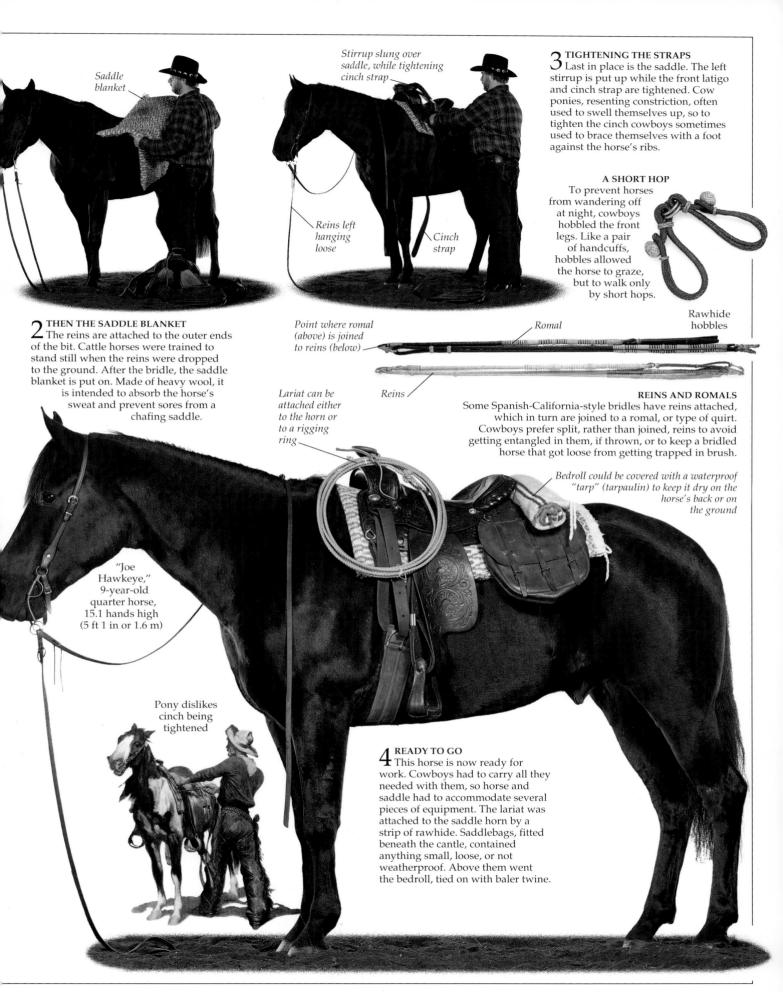

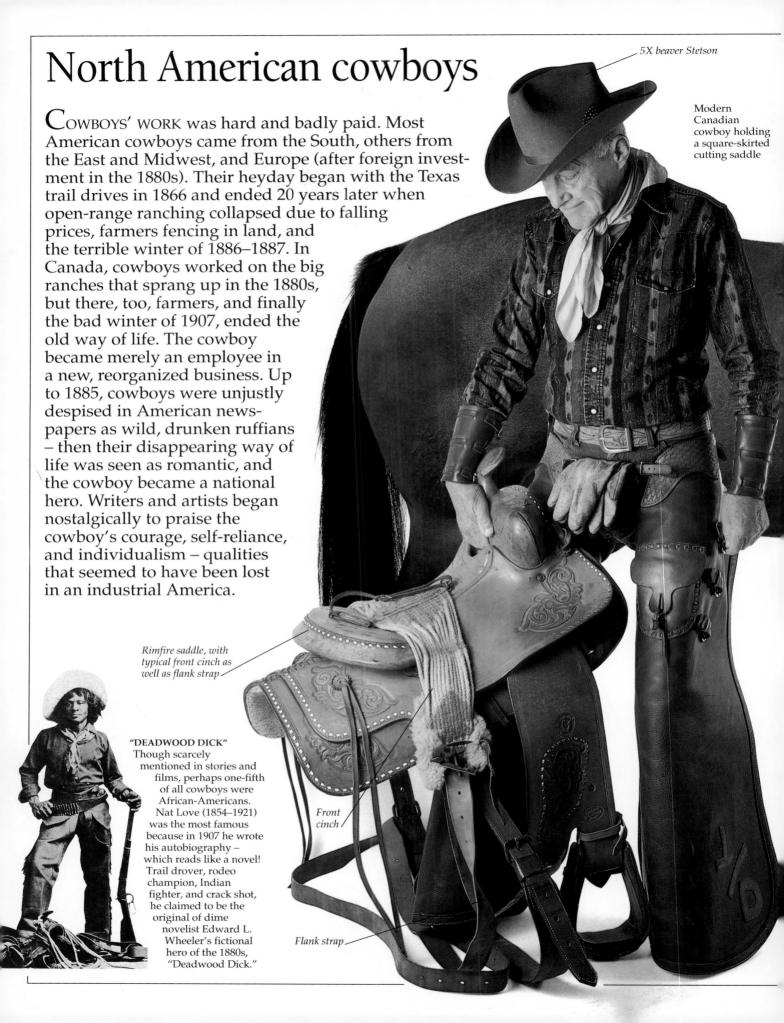

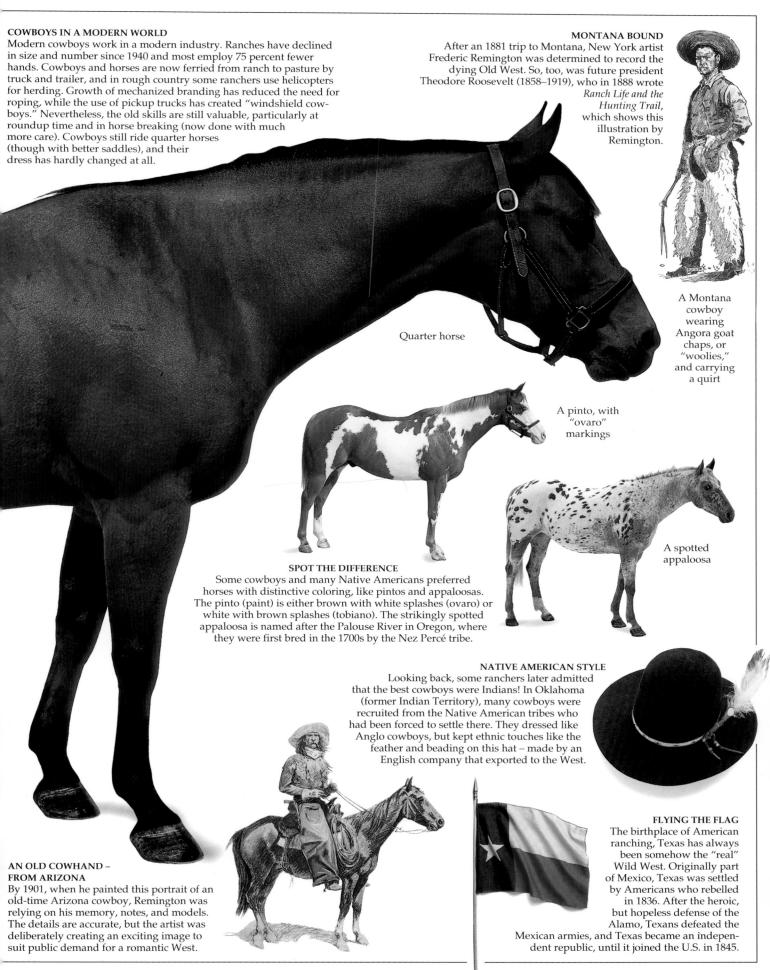

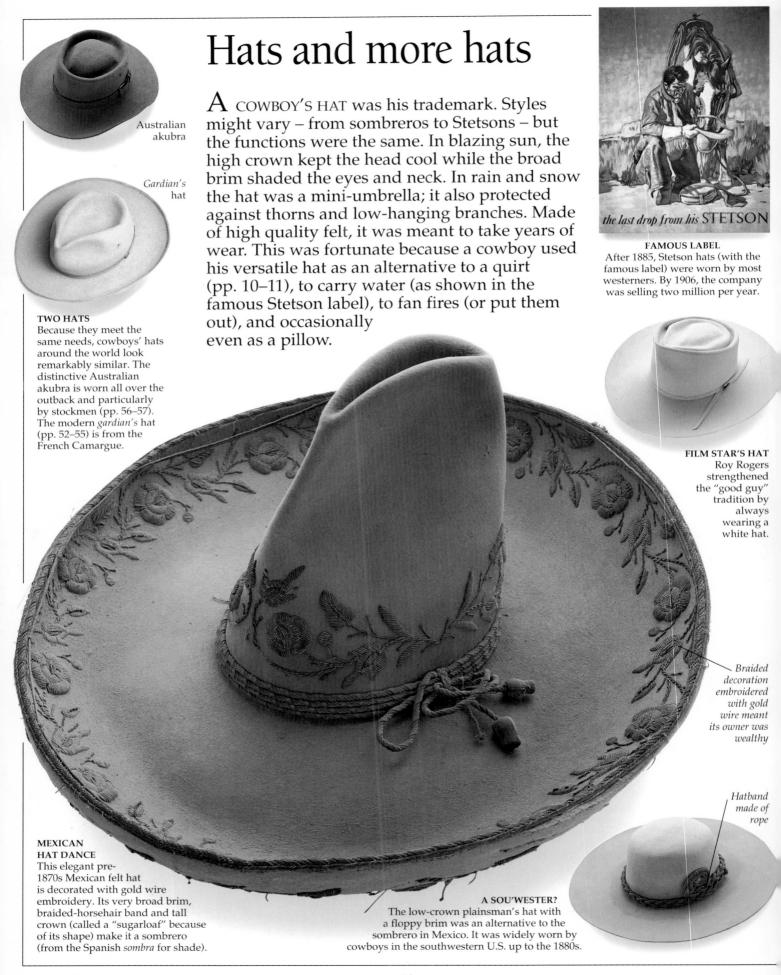

"TWENTY-GALLON TENDERFOOT" In Son of Paleface, Bob Hope (b. 1903) wears a double ten-gallon hat as a "tenderfoot" pretending to be a westerner.

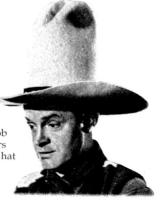

FILM STAR

In 1925, the Stetson company named a hat for cowboy film star Tom Mix (pp. 60–61). It had a 7.5-in (19.5-cm)crown and 5-in (13-cm) brim.

MODERN STETSON Today's Stetsons meet the modern preference for a lower crown. This one is top quality and water-resistant, creased in the cattleman's style. The number next to the "X" denotes the quality of the hat's material the higher the number, the

better the quality.

5X beaver Tom Mixstyle Stetson Stiff brim

> Best quality 10X beaver Stetson

Horsehair tassel

HOOKED ON HATS In the Old West, it was not considered impolite to wear one's hat in the house. However, if provided, a hatstand also made good use of horns and hide.

TOP HAT "ten-gallon" hat. This double tenearn its wearer

A high-crowned hat was nicknamed the gallon hat should some stares!

A HANDSOME HAT

Stetsons never had any decoration, except for a fancy hatband, perhaps. Mexican sombreros, however, were often ornamented - this one has suede appliqué and leather tassels.

Philadelphia, Pennsylvania, in 1865 and

soon produced the design that became

famous - and made him

a multimillionaire.

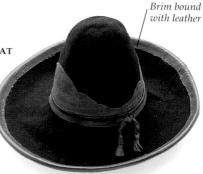

NOT SO PLAIN PLAINSMAN The plainsman's style came in more

expensive versions, such as this Mexican hat, c. 1900, made of suede with appliqué ribbon trim.

WEAR AND TEAR!

This Mexican hat has seen some hard wear. Dating from the early 1900s, it was probably the working headgear of a vaquero. It also looks like those that Hollywood always insisted bandits wear in silent westerns!

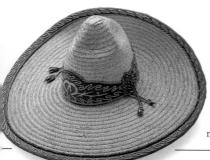

STRAW **SOMBRERO**

Less durable, but less expensive than felt hats, Mexican sombreros were sometimes made of straw - like this one, c. 1900.

LUCKY LUKE The invention of French cartoonist "Morris" (Maurice de Bevère), Lucky Luke has been cheerfully cleaning up the West since 1946. He still rides Jolly Jumper and hums "I'm a poor lonesome cowboy. . ."

Colt .45/ in a leather holster

HIGH-RIDER HOLSTER

Common through the 1870s and 1880s was the "high-rider" holster, which was fitted over the belt, so that the gun rested high on the hip. The cutaway for the trigger guard, as well as practice, helped a fast draw.

Dressing a cowboy

A COWBOY WOULD CHOOSE HIS CLOTHES and equipment to cope with the often brutally hard work, the country, and the climate. Clothing had to be strong to withstand heavy wear-and-tear from working closely with animals amid thorny brush. It had to deal with both scorching hot days and freezing cold nights. Differences in local conditions and local customs created different styles of cowboy dress in the U.S. between the southwest, such as New Mexico and Texas, and the northern ranges of Wyoming, Montana, and the

Dakotas. Revolvers were supposedly necessary to deal with threats both animal and human, but some cowboys could not afford them – a new Colt could cost a month's wages. Northern ranchers tried to discourage their cowhands from carrying guns. Cowboys also followed fashion – one old ranch hand confessed that high-heeled boots were worn out of vanity, not necessity!

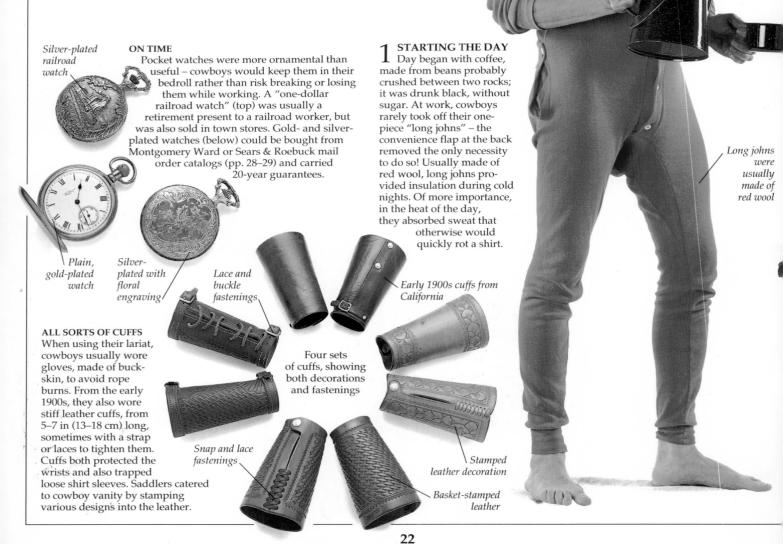

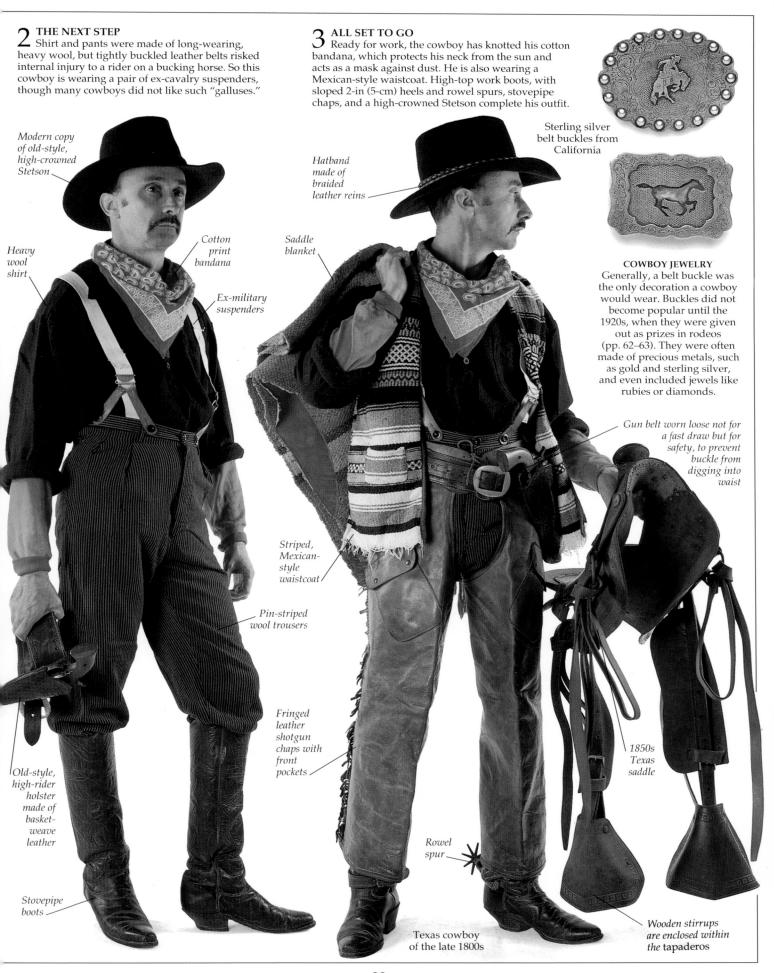

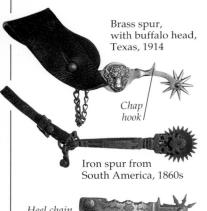

Heel chain secures spur to Steel trail spur from Texas, boot c. 1900

SPURRED ON!

Spurs were not intended to harm the horse, but to penetrate matted hair so the horse could feel the prod. A chap hook was an integral part of the metal shank to keep chaps or trousers from catching on the rowel.

STOVEPIPE STYLE

Old-style "stovepipe" boots came up close to the knee to offer more protection. This pair dates from the 1880s or 1890s. The extreme underslung heel was just for fashion and must have made walking painful - as well as potentially dangerous!

Boots and spurs

COWBOYS TOOK CARE CHOOSING THEIR BOOTS – in the 1880s, custommade boots cost \$15, half a month's wages. The high, tapered heel ensured that the boot would not slip through the stirrup, and it could be dug into the ground when roping on foot (pp. 34–35).

Western boots have remained popular, though their shape and style have changed a good deal. Today, many are not work boots, but fashion

items. Because cowboys rarely groomed

their horses, spurs were needed to penetrate the matted hair to prod the horse, though rowels were usually filed blunt.

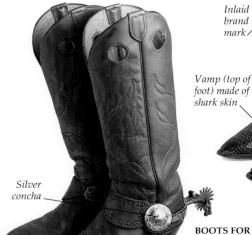

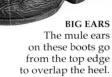

BUCKAROOS Tall so they can be worn with armitas (pp. 26-27), the boots have finger holes for pulling them on.

Inlaid

brand

mark.

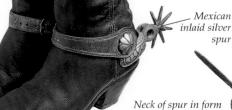

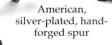

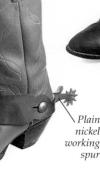

working

SHORT AND SCALLOPED

The shorter boot with scalloped top is a modern style, probably deriving from the kind specially designed for early movie cowboys (pp. 60-61), like Tom Mix (1880–1940). These storebought boots were made by Tony Lama of El Paso, Texas, in the 1970s. A former champion rodeo cowboy, Lama opened a boot factory on his retirement, and his products have become famous.

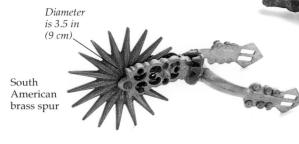

Spanish American, hand-forged, bronze prick spur

Curved tip at end of 6.25-in (17-cm) long spur, Spanish American, hand-forged, engraved, iron prick spur

HISTORICAL SPURS Spurs were brought to the Americas by Spanish settlers in the 1500s. Typically, they were large and heavy, traditionally made of silver mixed with iron, to create highly decorative spurs of great elegance. This Mexican style evolved in Texas and went north along the cattle

trails to Kansas,

Wyoming, and

Montana (pp. 38-39).

of female figure -

in western spurs called a "gal-leg".

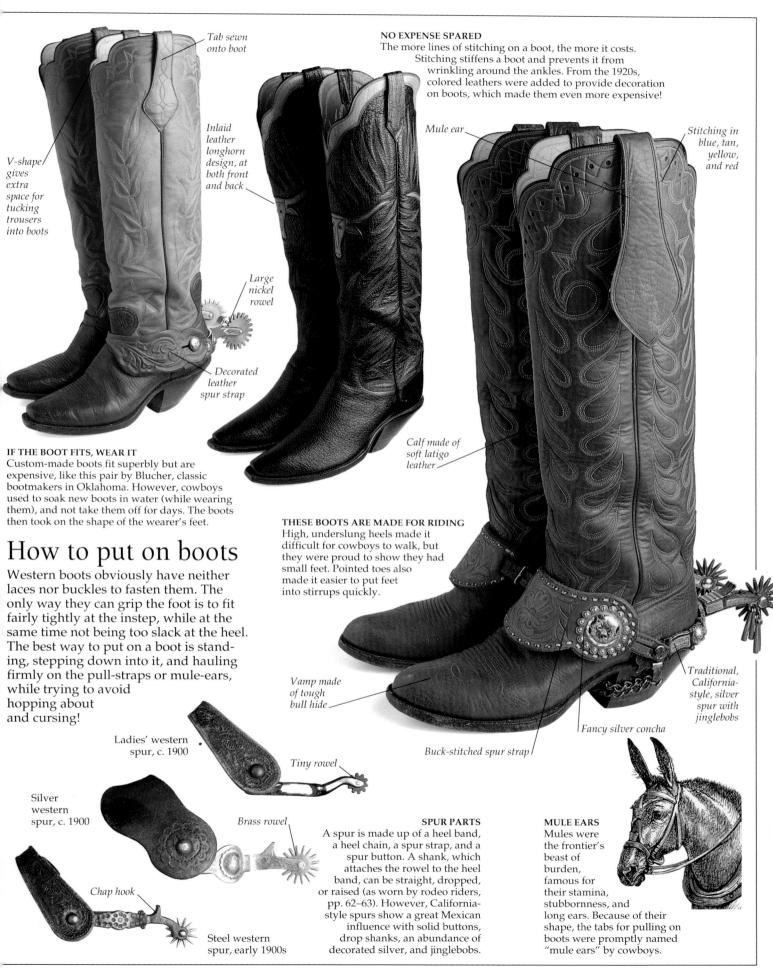

Chaps in "chaps"

 $R_{ ext{IDING}}$ hard through thorny brush could rip a horseman's pants and legs! Mexican vaqueros (pp. 8-11) taught cowboys to protect themselves from the chaparro prieto (thornbrush) by wearing leather chaparejos (shortened to "chaps," pronounced "shaps"). Different styles emerged. Mexican armitas looked like a long, split apron, ending below the knee; "shotguns" and "batwings" were both ankle length and took their nicknames from their shapes. On northern ranges and on

mountain slopes, chaps were usually made of Angora goat skin and were nicknamed "woolies." Chaps protected the rider from rain. cattle horns. horse bites, and chafed

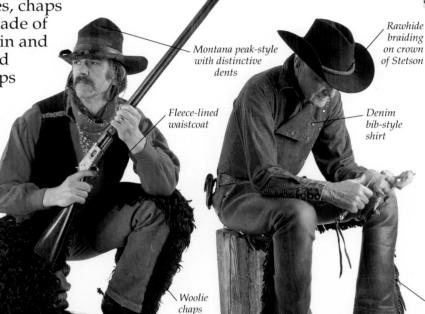

American

quarter used as concha

Back views of cowboys wearing armitas (left) and batwings (right)

SHOTGUN-STYLE CHAPS

This modern 1980s cowboy is sporting shotgun chaps, that were made in California – the leather has been oiled to ensure that the chaps are waterproof. His "bib," or shield-fronted, shirt suggests he may be a fan of John Wayne, who wore them in many of his movies, although old-time cowboys would not have been likely to do so. This cowboy is enjoying his hobby of whittling a toy horse from a piece of wood.

Shotgun chaps with fringing down leg to keep the rain off

60-ft (18-m)

WINTER WOOLIES This 1880s cowboy

knees.

from Wyoming or Montana is dressed for the winter cold. His

woolies are made of soft, curly, heavy buffalo hide and his expensive, linen bib shirt has been imported from the East. His Colt Lightning slide-action rifle can be fired very rapidly, but it needs constant cleaning and oiling, especially in winter, to prevent it from jamming.

ROMANTIC COWBOY

In this 1910 picture, a cowboy is wearing Angora goat chaps ("woolies"). By this date, the romantic image of the cowboy was hugely popular through the paintings of artists like Frederic Remington (1861-1909) and

Charles Russell (1864-1926).

THREE KINDS OF CHAPS

These cowboys are wearing different kinds of chaps, which show how little the cowboys' clothing has changed since the 1860s. The cowboy on the left is wearing heavy leather chaps from Canada in the 1970s. His shirt is cotton, not wool, and he is wearing a "wild rag" (bandana). The center cowboy has on 1920s leather cuffs and armitas with a built-in waistband and open pockets on the thighs. He is holding a lariat (from the Spanish la riata). The cowboy on the right is wearing custom-made, batwing-style, heavy leather parade chaps, with scalloped edging. He is holding a hackamore (from the Spanish jaquima) headstall, or bridle, used for training horses up to five years old.

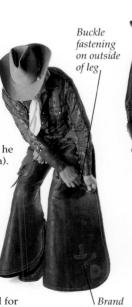

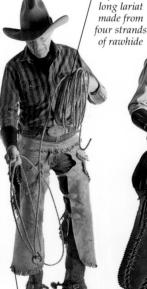

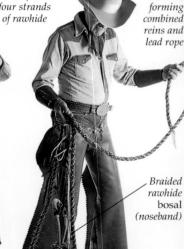

rawhide bosal (noseband)

Horsehair

mecate,

Fringe on outside leg only mark on chaps

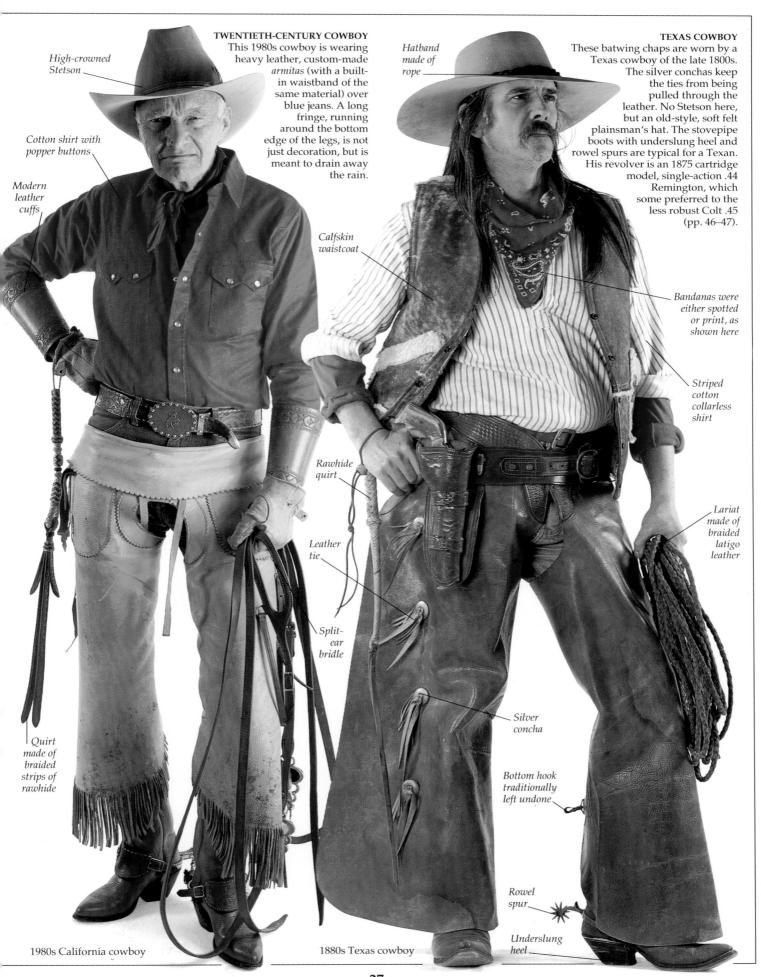

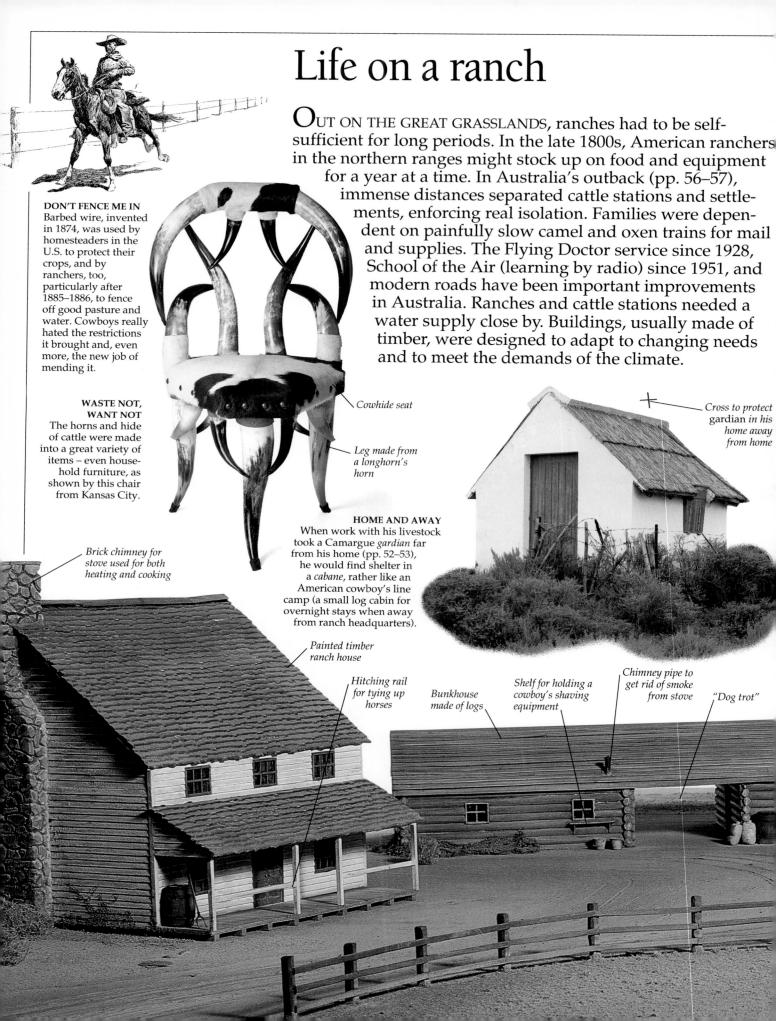

WHERE THE BUFFALO ROAM
Up to the 1860s, millions of buffalo roamed the North American plains.
In the mid-1870s they were ruthlessly slaughtered for their meat and skins by hunters. With cattle taking over their range, severe winters, and drought, buffalo nearly became extinct.

SUCCESS STORY

Herefords, with their distinctive red and white coloring, are considered to be the most successful of the beef breeds and are renowned for their hardiness, early maturity, and swift, efficient conversion of grass into meat. In the American West, they were imported from Britain into the northern ranges in the early 1880s and, crossbred with local cattle, they eventually replaced longhorns in Wyoming and Montana. With their ability to thrive anywhere, there are now more than five million pedigree Herefords in over 50 countries.

As well as its original brand, a calf had a road or trail brand added behind its left ear at the start of a cattle drive north from Texas.

Two branding irons from North America

Cattle and branding

People have reared cattle for thousands of years, but it was the population explosion of the 19th century in Europe and America that turned cattle raising into an industry. Demand for meat encouraged ranching to spread across the world's great grasslands, so that it became an important enterprise in the U.S., Canada, Brazil, Argentina, and Australia. No cattle had existed in any of these countries before European settlers brought them. European cattle were originally hardy but lean. From the 1770s, however, a breeding revolution in Britain produced new, heavy beef strains like the Hereford, shorthorn, and Aberdeen angus. From the 1870s on, these were increasingly exported to replace or crossbreed with the old European longhorns in the New World.

In Spain and in the Camargue in southern France, bulls are still bred solely for fighting. **Typical** white head of Hereford TEXAS LONGHORNS Descendants of Spanish cattle imported in the 1520s, longhorns spread from Mexico into the American West. Always half-wild, they were fierce and badtempered. Though poor quality beef – mostly muscle they were very hardy and could survive on the sparse grass of the dry plains. This magnificent, 6-year-old prizewinning pedigree Hereford bull, named "Ironside," MAKING A MARK weighs 3,100 lb

Branding was the easiest means for a rancher to identify the ownership of cattle roaming the open range. Marks, usually simple shapes or letters, or combinations such as Bar T (– T) or Circle B (O B), were burned through the hair into the surface of the animal's hide with red hot irons. Cowmen claimed this was relatively painless – cows probably thought otherwise!

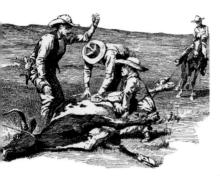

DISPUTING A BRAND

Rustlers, or cattle thieves, tried various tricks to claim cattle. They branded over an existing mark or used a "running iron" (like a big iron poker) to change a brand. For example, Bar C would look like "-C" and could be changed easily to Lazy T Circle, "+O" (where the "T" appears to be on its side). Originally, wandering "mavericks" (calves that had left their mothers) could be branded by whomever found them, but ranchers soon tried to stop this practice.

Volvo," a 20-month-old,

purebred Aberdeen angus bull by a

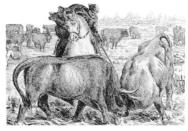

FRENCH MARKS

The fierce black bulls of the French Camargue are raised by local ranchers solely for the exciting and dangerous sport of the course à la cocarde (pp. 54–55). Each rancher separates the yearlings annually at the ferrade, or branding, and stamps them with their owner's mark – just as in the American West.

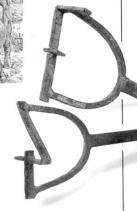

Branding irons from the French Camargue are used for both horses and bulls

The Aberdeen angus was originally bred, as its name indicates, in Aberdeenshire in Scotland. This is a naturally hornless breed which matures quickly (so it is ready for market early). It yields a high proportion of high quality meat – some say it makes the best steaks.

The breed was first introduced into the U.S. in 1873.

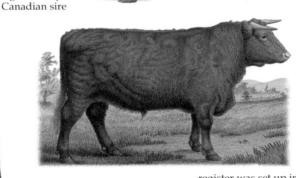

BY A SHORT HORN

Shorthorns, as shown in this 1890s engraving, were first bred in Durham county in England and became the most popular of the new breeds until they were replaced by the Hereford. They were exported to the U.S., Argentina, and Australia. In the U.S. the first shorthorn

register was set up in 1846, and in Canada, in 1867. Shorthorns were brought to the northern ranges of the West during the 1870s.

CANNED MEAT

Most big American cities had meatpackers – firms preserving and packaging meat for transporting to market. Those buying western beef were centered in St. Louis, Kansas City, and above all Chicago. This New York company's absurd 1880s advertisement shows Mexican *vaqueros* on a New York dock.

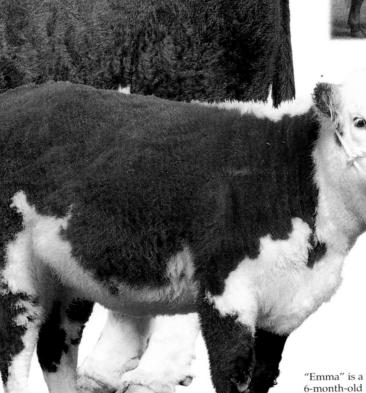

Hereford calf,

sired by

"Ironside"

FAST STOP

Stopping quickly from a gallop requires powerful braking! The "fast stop" is used both in cutting out and when roping (pp. 34–35). The horse brings the back legs forward, throws its weight back, braces its front legs, and skids to a stop. In reining pattern classes at western riding shows (above), the horse aims to complete a "sliding halt" within 25 to 30 ft (7.5–9 m).

Cutting cattle out of a herd

Separating a single animal from a whole herd of uneasy cattle was a routine task at the roundup. Nevertheless, it took skill and a real partnership between horse and rider to deal with a dodging, panicky cow – the process was called "cutting out." It was necessary in order to remove strange cattle that had accidentally been gathered up, but mostly to brand yearlings and calves (pp. 30–31). Top-class cutting horses were much valued, and mustangs seemed to have instinctive "cow sense." With a little training, the most alert and intelligent horse could be pointed at the animal to be caught and would follow it through every twist and turn with hardly any use of the reins. One western story tells of a cutting horse that brought a jackrabbit out of a herd!

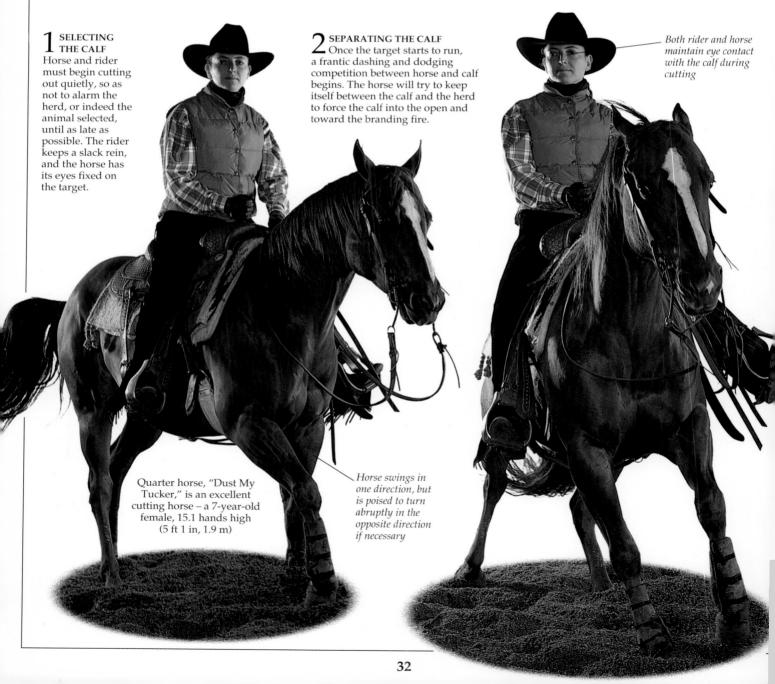

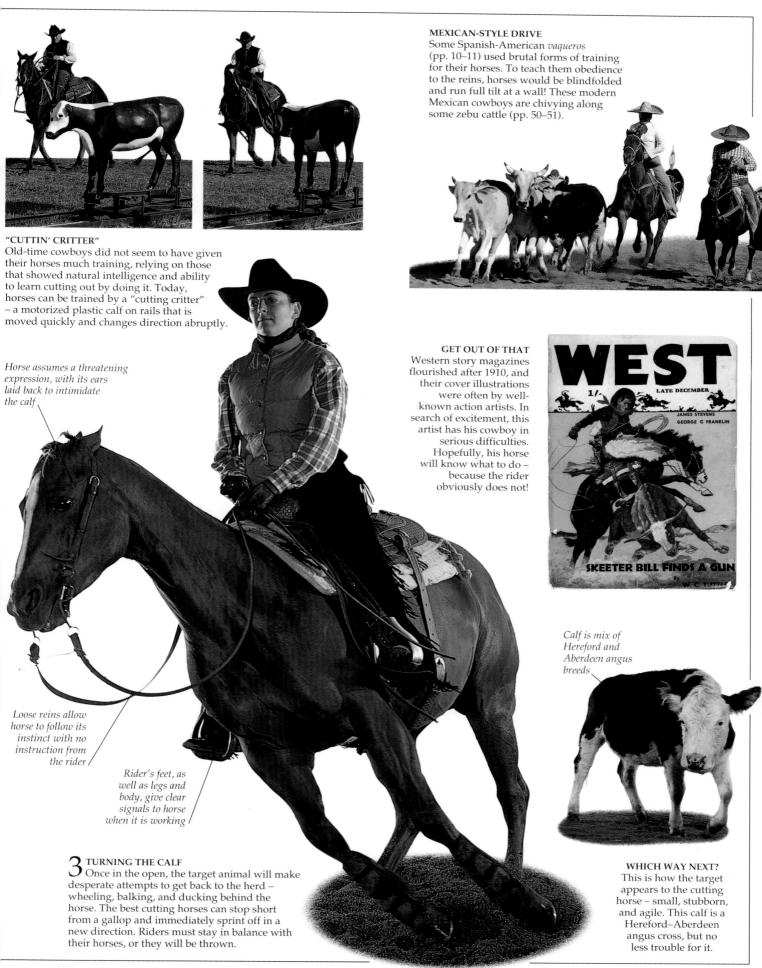

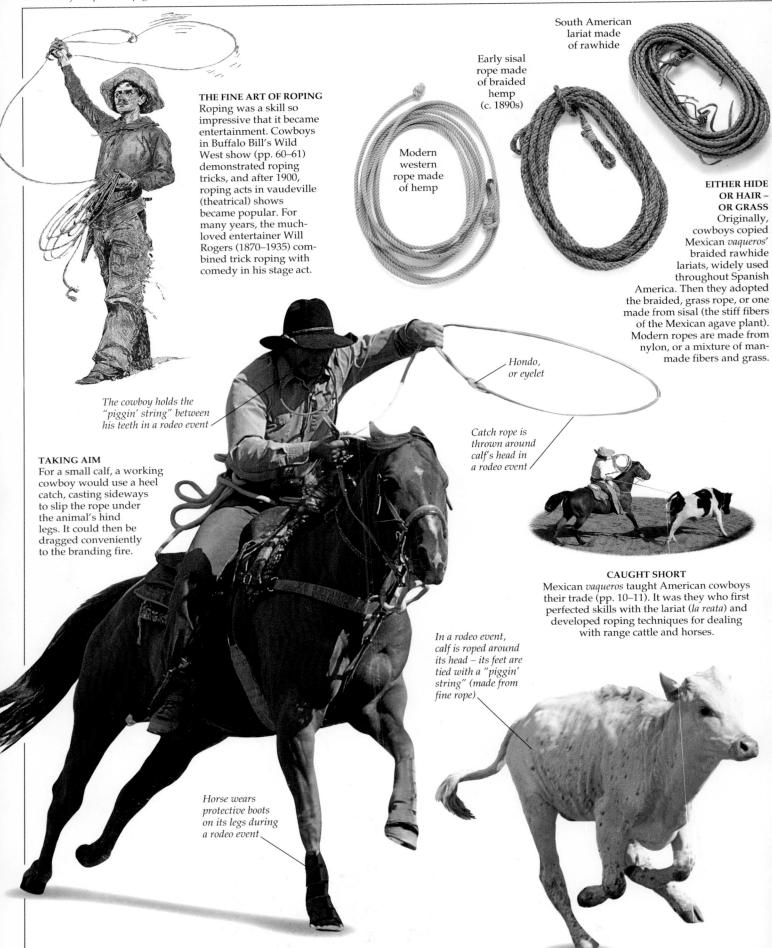

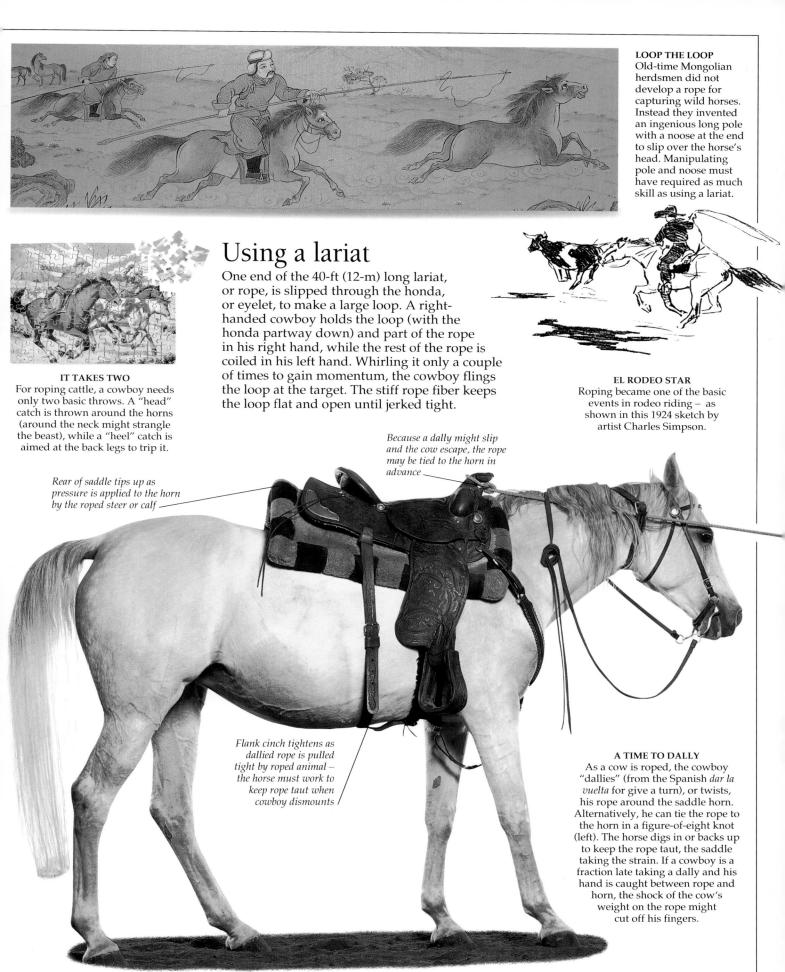

Home on the range

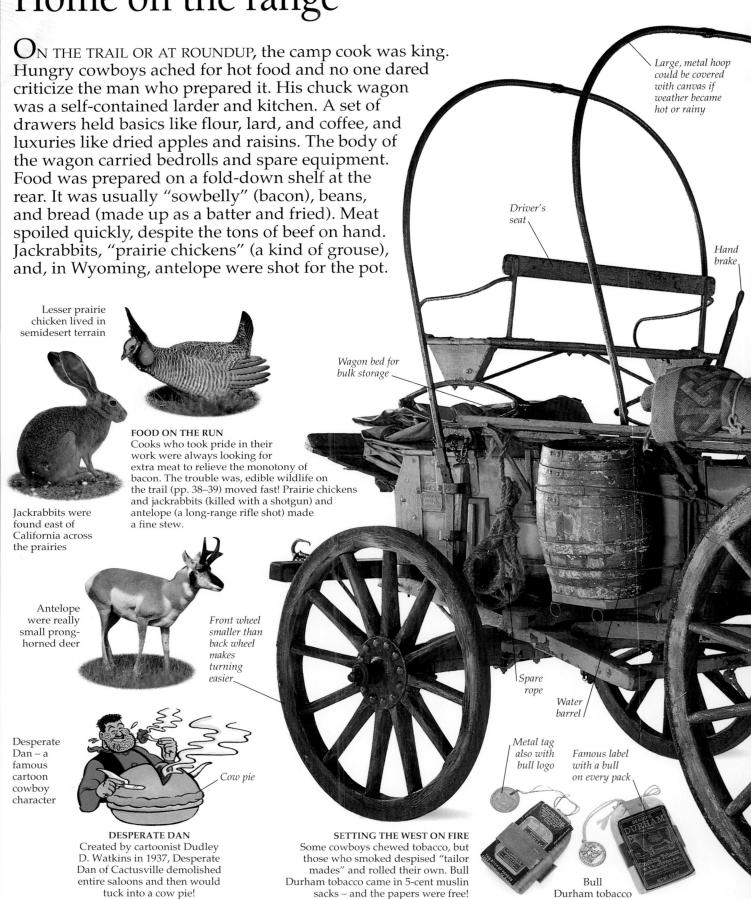

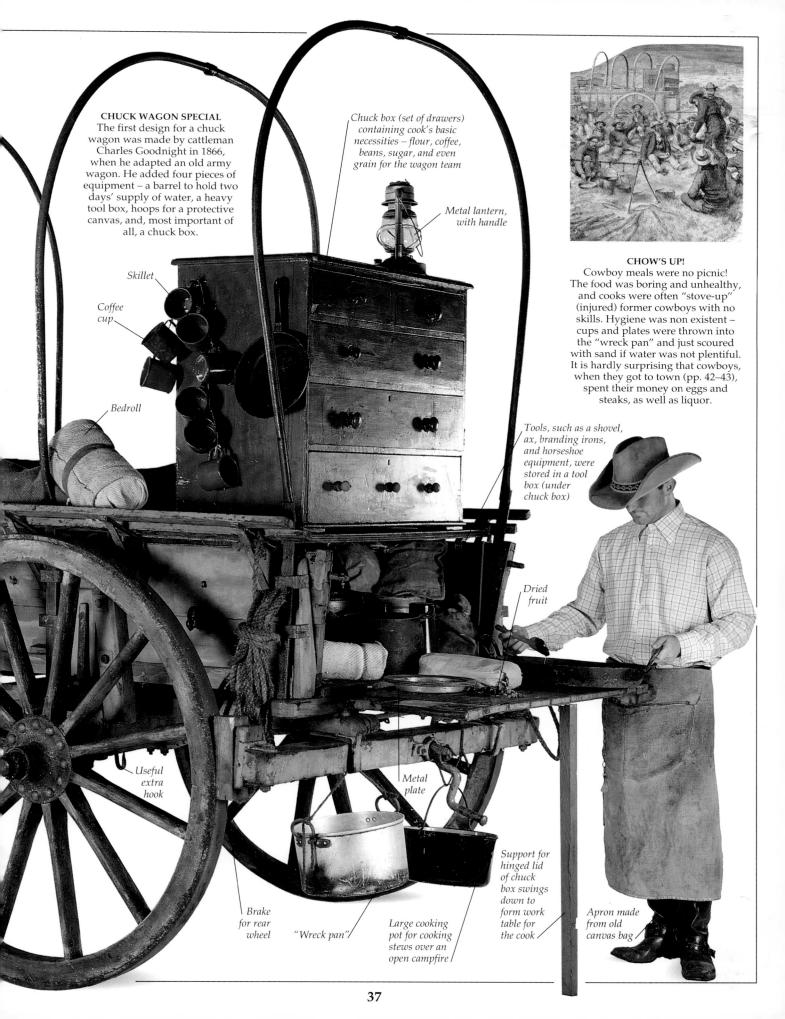

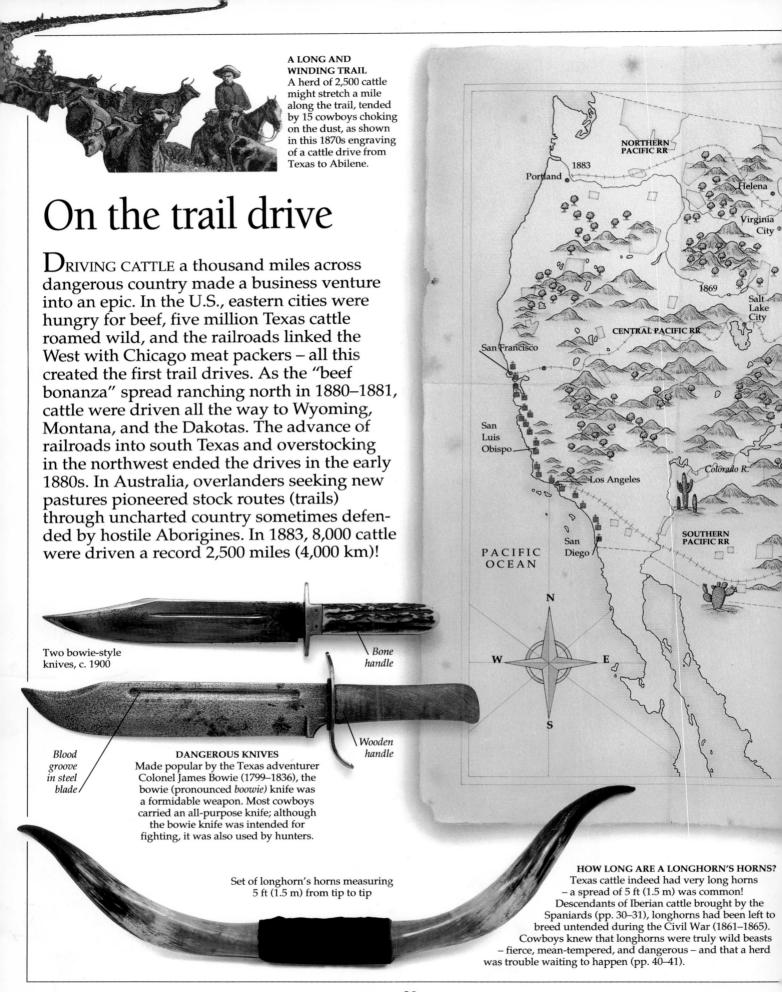

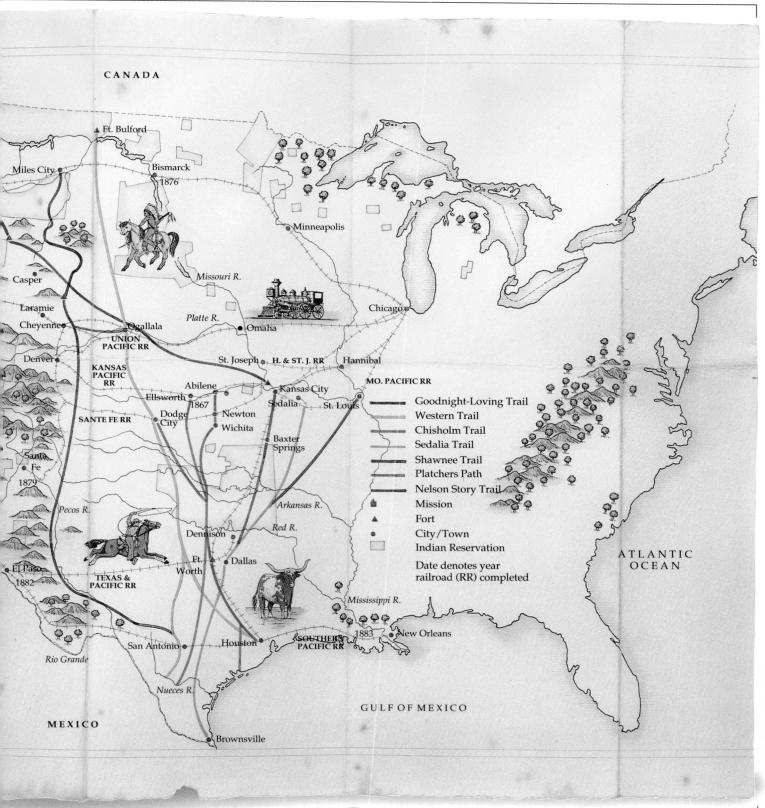

WET WEATHER
Trailing a herd in
a northwest
winter was
miserable
work! Oilskin
slickers were
the only protection
against rain and snow.

Jesse Chisholm
(1806–1868) laid out
a supply route from
Texas to Kansas
during the
Civil War – it
later became a
trail for herds
heading to
Abilene.

EPIC JOURNEYS

Cattle trails linked ranges with railroads. In 1866 fear of Texas fever infecting local cattle closed the Missouri border and the trails that led there. The alternative Chisholm Trail carried two million cattle up to the Kansas railheads between 1867 and 1871. In the 1870s, the Western Trail ran directly to Dodge City. Named after two ranchers, the Goodnight-Loving Trail was laid out in 1866 to supply Colorado mining camps, but was soon used to stock the ranges of Wyoming and Montana.

Dangers on the trail

A trail drive was not fun – it was hours of stupefying boredom interspersed with moments of acute danger. Cowboys rarely saw hostile Indians. Mostly they rode the flanks of a herd to keep cows from wandering off, while the "drag rider" at the rear, choking on dust, chivied stragglers. The main worry was finding water at the end of the day. But range cattle were easily alarmed, "ornery" (mean-tempered), and not very smart. At a river crossing they might not only drown themselves but, in panic, a cowboy too. The biggest threat was a stampede, where a second's mistake in a sea of tossing horns and pounding hooves was a death sentence.

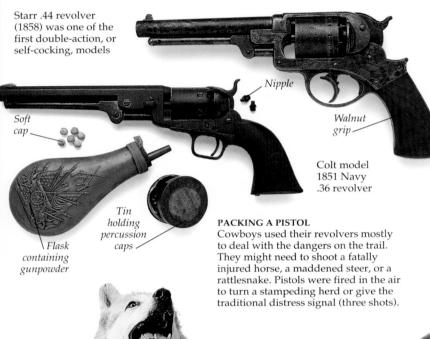

timber wolf was a serious problem to ranchers. Wolves were not a threat to

CRY WOLF The American

were not a threat to people, but after the buffalo had been wiped out, they preyed on calves and colts. They were killed by traps or poisoned with bait laced with strychnine.

NOT A CUDDLY TOY!

Brown bears ranged across America wherever the country was wild, mountainous, or forested. They were omnivores (eating animals and plants) and learned to add calves to their diet. Up to 6 ft (1.8 m) long and weighing 200 to 500 lb (90–250 kg), they were dangerous if alarmed.

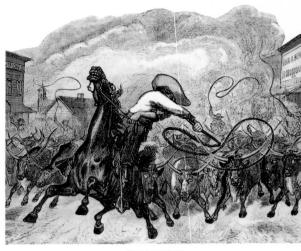

STAMPEDE!

Cattle were mindlessly nervous. A herd might be spooked by any unexpected sight, a sudden noise, or unusual scent – certainly lightning would terrorize them! The animals would then, without warning, burst into a stampede, running for miles. The cowboys' only hope was to race to the head of the herd and, by firing pistols, waving hats, and yelling, frighten the leaders into turning until the whole herd began to "mill," or circle, aimlessly.

FOOD ON THE HOOF

Grizzly bears saw horses and cattle as food. Ferocious, 8 ft (2.4 m) in height, and weighing up to 800 lb (365 kg), grizzlies were an infrequent but serious hazard. These teeth belonged to a grizzly shot in British Columbia, Canada, after killing livestock. The rifle cartridge shows how big the teeth were.

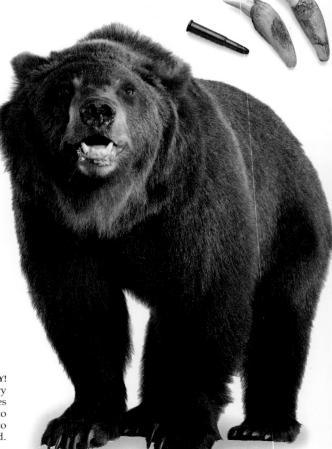

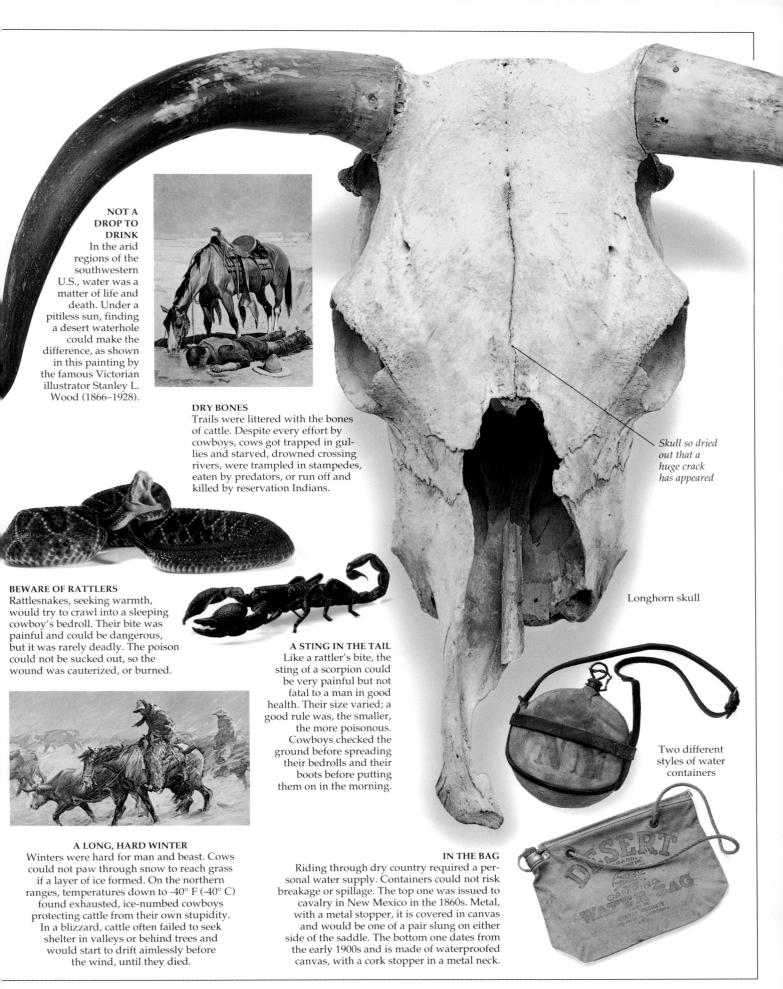

Law and order

STEELY-EYED LAWMEN, fast on the draw, kept the peace on Hollywood's frontier. In the real West things were usually less exciting. Sometimes, in addition to law enforcement, an elected county sheriff collected local taxes. Town marshals, usually appointed by

the city council, were expected to enforce health and safety regulations, collect license fees, and serve warrants. In some towns these jobs offered power

and opportunity to make money. Only in cow towns and mining communities, and only while conditions required it, were law officers gunmen.

Deputy's badge made of silver (1897)

SHOOT-OUT

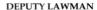

Shady characters as well as honest lawmen could become deputy marshals – Virgil Earp (1843–1906) held this post in Arizona in 1879.

Sheriff's Street gunfights jail keys were not as common as westerns suggest. Remington's drawing may be based on the shoot-out between Luke Short and Jim Courtright at Fort Worth, Texas, in 1887.

> Marshal's badge made of silver (c. 1870)

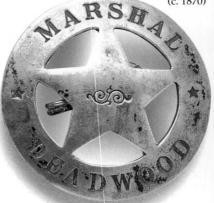

MARSHAL OF DEADWOOD

The marshal of Deadwood, a mining town in Dakota Territory, had to deal with frequent stage robberies and the murder of Wild Bill Hickok (1837-1876).

penitentiary in Arizona Territory, was the fate of many badmen. Here is an example of a 1900s prison guard's brass badge.

The death penalty

was unusual in the West. Prison,

like the Yuma

"IAILBIRD"

Bank guard's badge, made of nickel

TEXAS RANGERS FOREVER

First formed in 1835, the Texas Rangers were reformed in 1873 into a frontier battalion to deal with Indians, bandits, and rustlers. Since 1935, the Rangers have been part of the Texas Department of Public Safety.

SPECIAL AGENTS

The powerful stage line and banking firm, Wells, Fargo and Company, employed its own guards and company police. Its special agents were detectives - competent and tireless in tracking down those who preyed on it.

Pinkerton badge (1860)

shoot up the town and, if unchecked, they readily turned to serious violence. Strong law enforcement was demanded by respectable citizens. Wichita (above) had seven marshals from 1868 to 1871 - all ineffective until the firm rule of Michael Meager (1871-1874) brought order.

THE PINKERTON AGENT

PAINTING THE TOWN RED

After three months or more on the trail (pp. 38-39), Texas cowboys quickly spent

of Kansas on liquor, gambling, and

their hard-earned money in the cow towns

women. Even in good humor they might

The Pinkerton Detective Agency was a formidable private organization. It was detested in the West for bombing the James family (pp. 44-45) home in 1875 and for breaking miners' strikes in the 1880s.

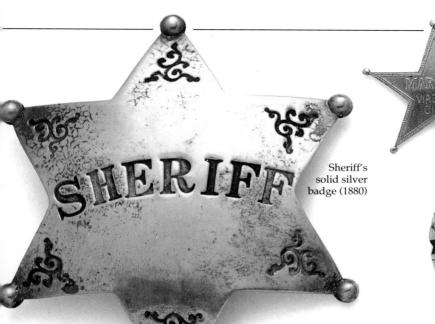

A LAWLESS TOWN As a young journalist, Mark Twain (1835-1910) knew Virginia City,

Nevada, as a "wide-open" mining town in the 1860s, when violence was commonplace.

Virginia City marshal's badge (c. 1860-1880)

MEXICAN LAWMEN

Mexico's history in the 1800s was different from that of the U.S. Outside the cities, order was kept by the detested guardia rurales (police cavalry). Towns. like Ensenada in Baja California, had a regular police force.

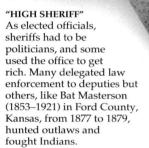

Reproduction of a Û.S. marshal's brass badge (c. 1900)

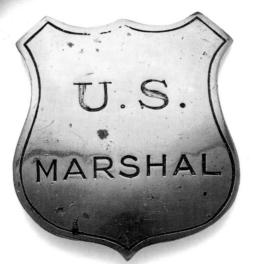

Three Mexican badges (c. 1900), made of copper plate (top right) and brass

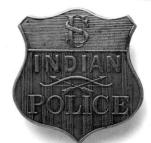

Indian police badge (c. 1880s)

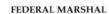

Appointed directly by the president, usually as a political reward, federal marshals were often just local businessmen, and some turned out to be crooks. Others, like Evett Nix of Oklahoma Territory in the 1890s, were dedicated lawmen and appointed deputies like the famous Heck Thomas. THE INDIAN POLICE

Indian police were first tried as an experiment in the middle 1870s on the San Carlos Apache reservation in Arizona. In 1878, Congress set up Indian police at each reservation agency. Reformers hoped this would be one more way to break tribal customs and make Indians "Americans."

A collection of items belonging to Wyatt Earp (1848 - 1929)

The good guys?

Desperate city councils sometimes appointed gunmen to deal with gunmen, as Abilene hired Wild Bill Hickok in 1871. However, journalists at the time (and filmmakers later) have made legends out of dubious figures who held the job of lawman, notably Wyatt Earp - who was

involved with gambling and prostitution.

Horn tobacco pouch made by Earp's father

LEGENDARY LAWMAN Wyatt Earp held police posts in Wichita (1874) and Dodge City (1878). A feud with the Clantons in Tomb-

stone, Arizona, led to the famous gunfight at the O.K. Corral in October 1881. Later he tried gambling and prospecting and ended up hanging around film sets in Hollywood. His fame as a Galahad

among lawmen was entirely invented by Stuart Lake in his 1931 book Frontier Marshal.

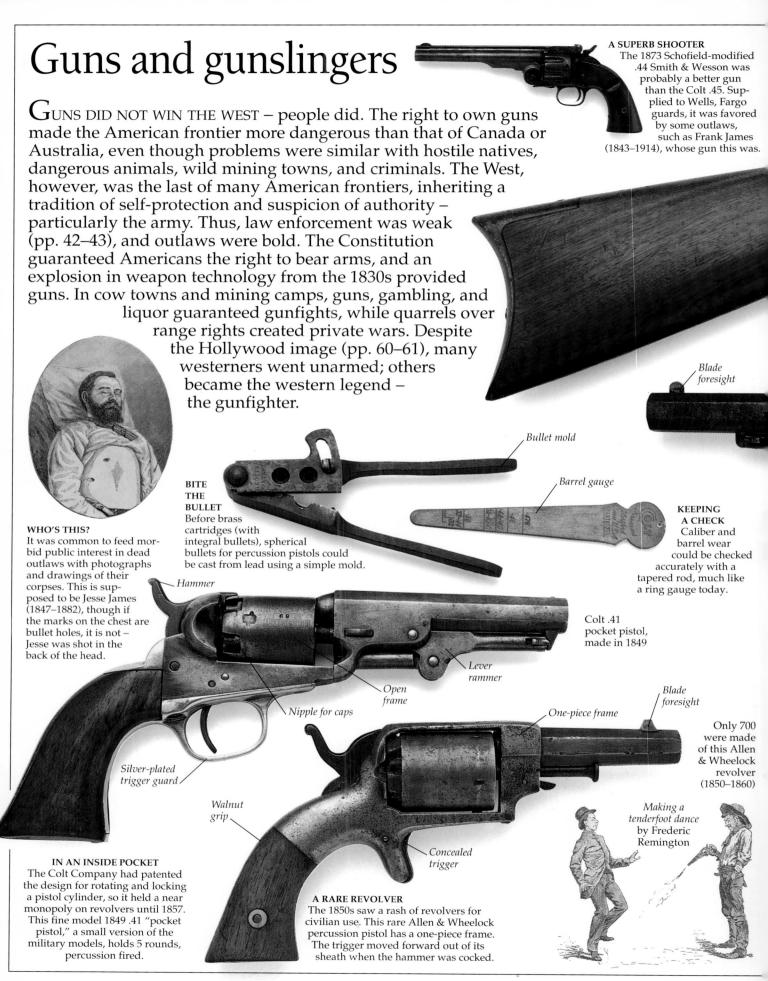

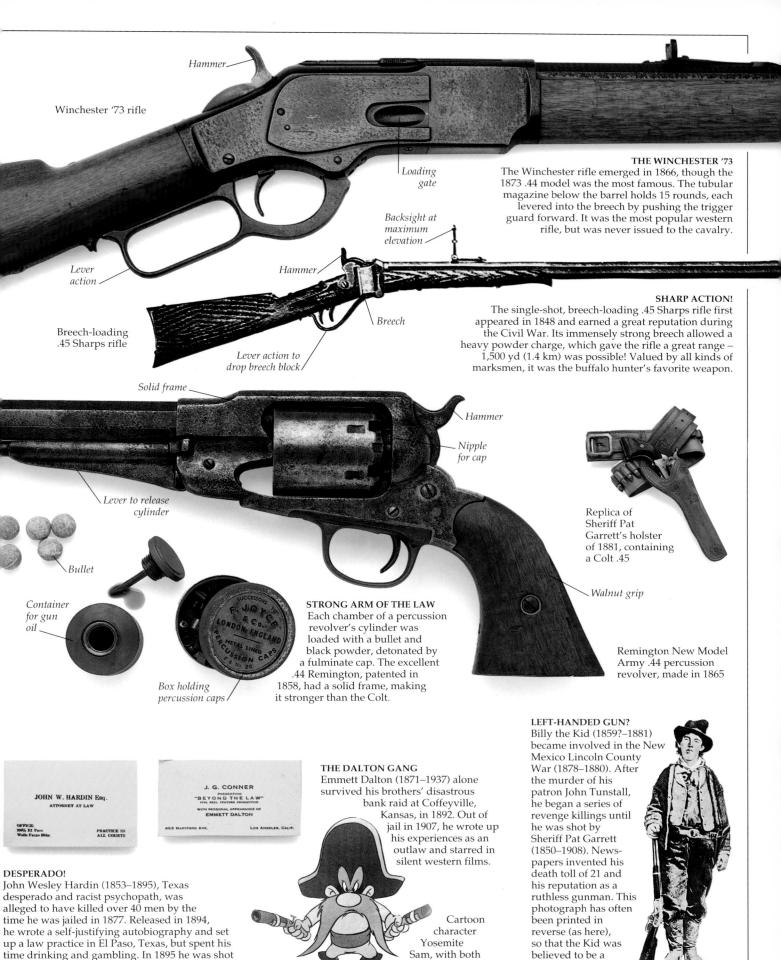

guns blazing

"left-handed gun."

in the back by a policeman he had threatened.

Six gun

 $T_{\rm HE~1873~COLT}$ single-action Army revolver has one real claim to fame – in the West it probably killed more people than any other. When production was suspended in 1941,

357,859 had been sold. In 1878, the .45 Peacemaker model was supplemented by the Frontier – its .44 caliber cartridge also fitted the Winchester rifle (pp. 44–45). Such large caliber pistols – heavy (2 lb 4oz, or 1 kg) to absorb the recoil – had guaranteed stopping power. The Colt was accurate, well balanced, and could be fired even if parts of the mechanism broke, which happened often.

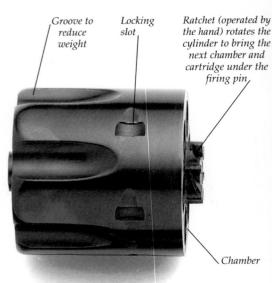

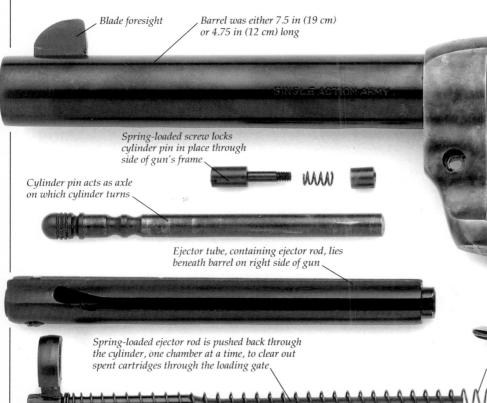

COCK AND FIRE

In a single-action revolver, the hammer is thumbed back. The hand rotates the cylinder, which is locked by the sear, setting the trigger. Cartridges are loaded through an opening in the right half of the gas deflector shield, a chamber at a time. When the trigger is pulled, the firing pin detonates the powder in the cartridge, forcing the bullet down the barrel.

Cylinder

Trigger pivot screw

Hammer pivot pin

Shield deflects gas

that escapes

when gun is fired

DISMANTLING A COLT

Here a single-action Colt .44 Frontier revolver is dismantled. However, in 1878, Colt made a double-action revolver – the Lightning, in .38 or .44 caliber. In this type of self-cocking weapon, a firm pull on the trigger alone lifted the hammer (and rotated the cylinder and locked it) and let it fall.

THE WALKER COLT

In 1847, the U.S. Army sent Captain Samuel Walker to buy Colt revolvers. Walker suggested several improvements and the new gun became known as the "Walker Colt." Though huge – 15.5 in (39 cm) long and weighing 4.5 lb (2 kg) – it was the basis for all future Colt designs until 1873.

TRIGGER ACTION

Frame

Spring

When the hammer is cocked, the sear sets the trigger on its spring to trip the hammer. It also locks the cylinder, so that the next cartridge is in line with the barrel and under the firing pin. Although the lock mechanism was an original Colt patent, it was notorious for breaking, especially the trigger spring.

Trigger sear and cylinder stop

Trigger spring

Trigger connected to hammer by trigger spring and sear

Trigger guard

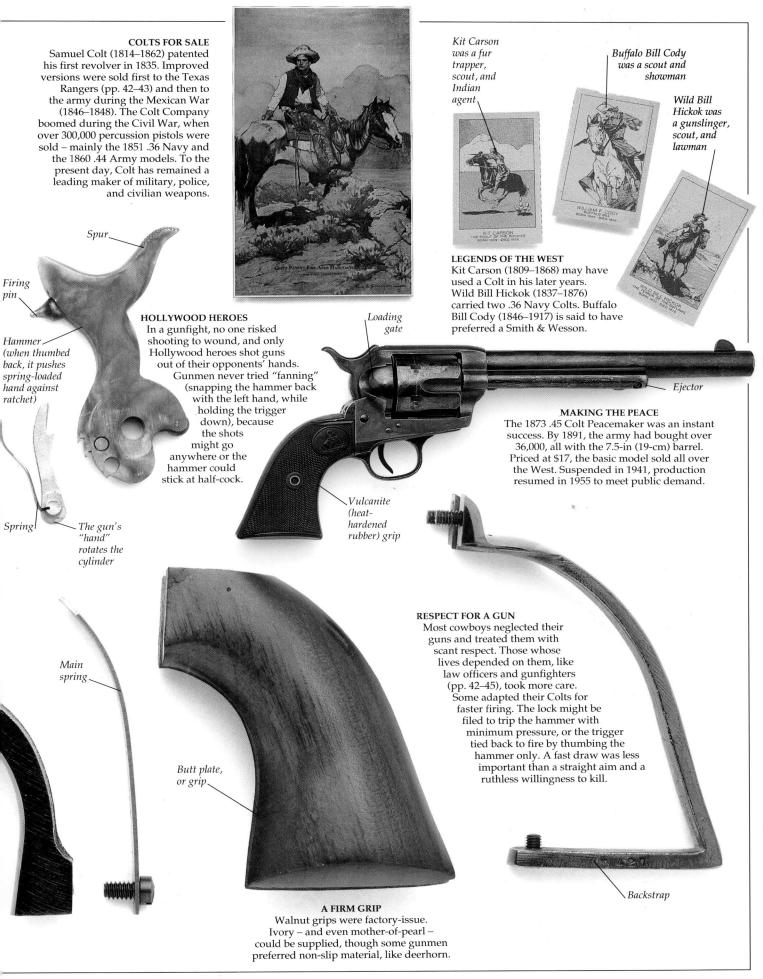

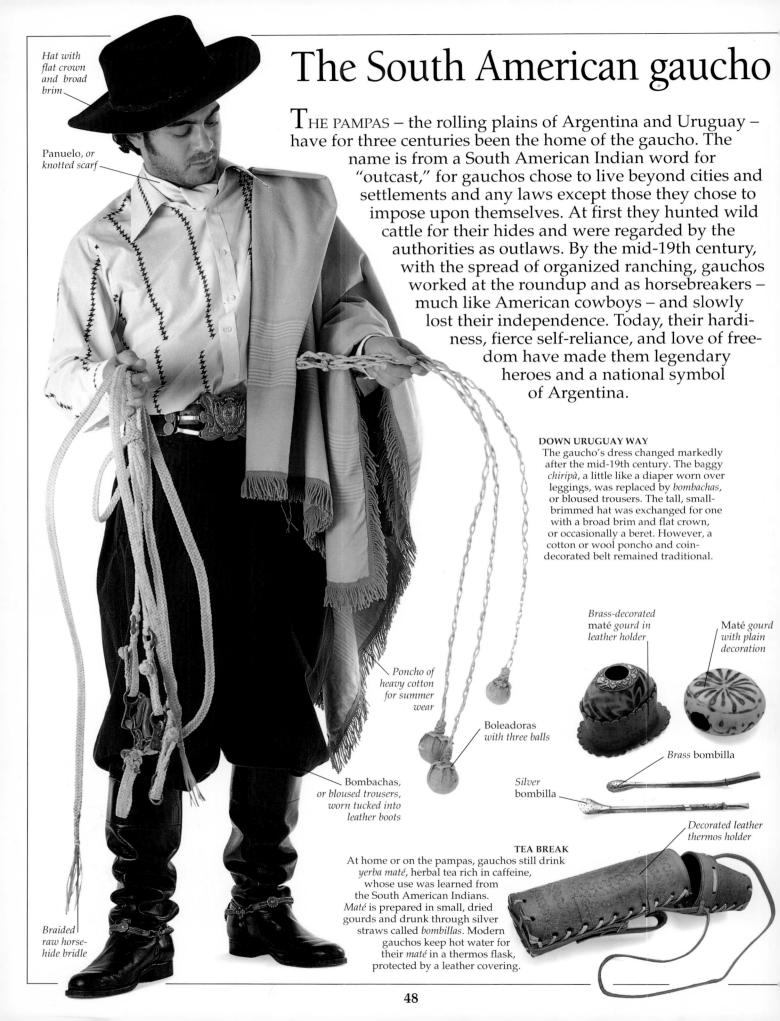

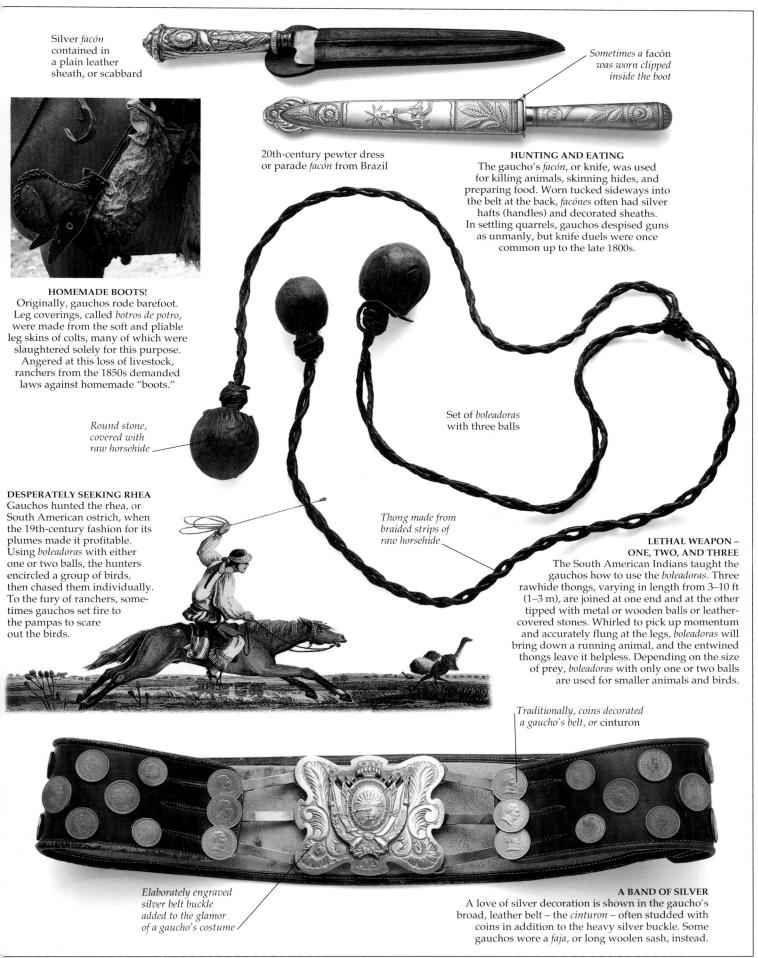

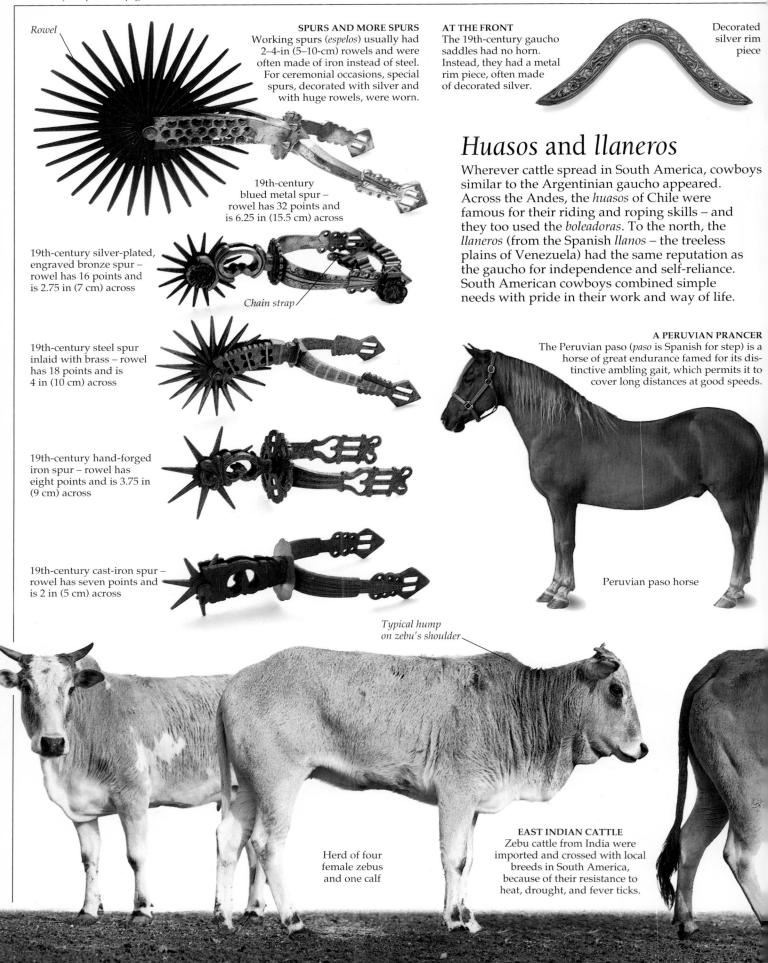

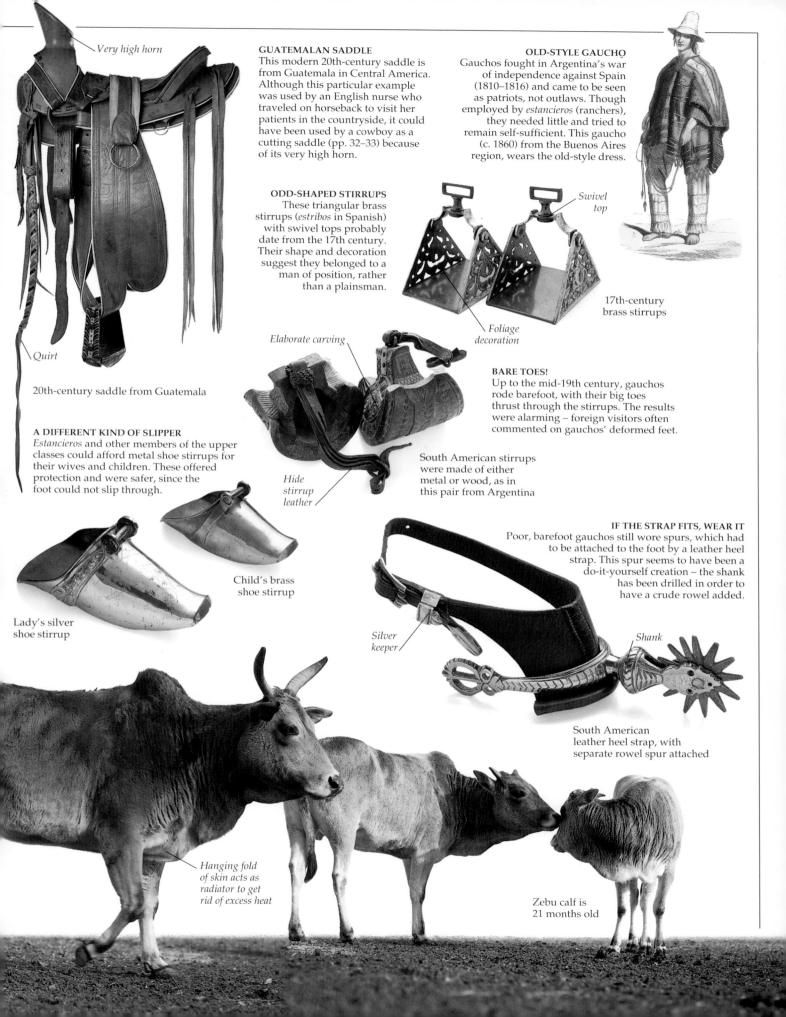

HERDER OF CATTLE This gardian of the late 1800s is dressed in winter clothes and tends a manade near his cabane. Usually one-roomed, these cottages had the door at the south end to shelter it from the mistral that blows from the north.

SUNDAY BEST

The beautiful traditional women's costumes of the Arles region are worn here by wives of gardians of the 1920s. Originally from the reign of Louis XV (1715-1774), this traditional dress had begun to disappear until encouraged by the poet Frederic Mistral (1830-1914), leader of the movement to revive Provençal culture. Now such costumes are worn for festivals.

MODERN MOTHER AND CHILD

Today, although few of the ranch owners are women, the wives and children of gardians share the work with the men, tending herds of both horses and bulls. This gardiane wears clothes similar to the men, except for the divided riding skirt. Children help, too, and learn to ride at a very young age. This boy is wearing a waistcoat and trousers made of "moleskin" (a type of cotton). His outfit is just like his father's (right), except for the jacket.

READY FOR A PARADE

These neat spurs (right) are worn for particularly elaborate events, such as parades and festivals. They look more elegant than working spurs (below) and are less likely to startle the horse.

Parade spurs

riding

A PAIR OF WORKING SPURS Gardians wear short, steel spurs with a ten-point rowel, held on the boot by a small strap. Horses are spurred only when real speed is necessary - for example, when dodging an angry bull.

Camargue Gardians

 ${
m A}$ wild landscape of salt marshes and sandy lagoons, the Camargue lies in the delta of the river Rhône in southern France. Hot and humid in the summer and swept by the cold *mistral* wind in winter, this part of Provence is sometimes called the "Wild West of France." Manades, or herds, of black fighting bulls are bred by the manadiers (ranchers) and tended by gardians (garder is French for "look after"), or keepers, who ride the unique white horses of the region. The gardians have their origins in the gardobesti (cattle keepers) of the Middle Ages (A.D. 500–1350) and follow a code of honor like the chivalry and courtesy of the knights of old. The Confrérie des Gardians (brotherhood, or Order, of the Gardians) was founded in 1512. Many customs had faded until the Marquis Folco Baroncelli

in the 1880s. He loved Provence, especially the lifestyle of the gardians, which he himself shared.

> Moleskin zvaistcoat

(1869–1943) revived them

Owner's brand

OLD-STYLE BOOTS

These are old-style riding boots, made of leather. Nowadays, short, calflength boots are more common, as in America. In the 1800s, some gardians wore sabots, or clogs, which had flat soles and no heels.

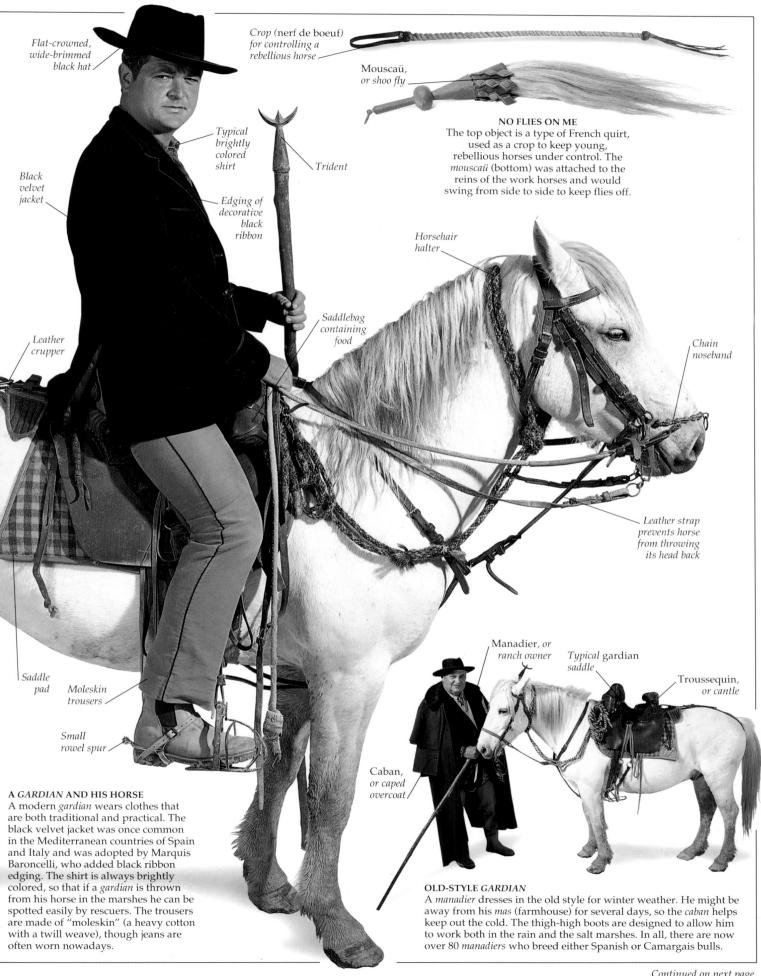

THE DRAMA OF THE BULLRING

So popular are the *courses* à *la cocarde*, or bullfights, that they are held in arenas. Some of these arenas date from Roman times, like this one in Arles that can hold over 23,000 people. *Courses* also take place in villages, set in improvised or permanent bullrings. *Cocardiers* are bulls that appear in the arena.

Bell for leading

bull or

cou

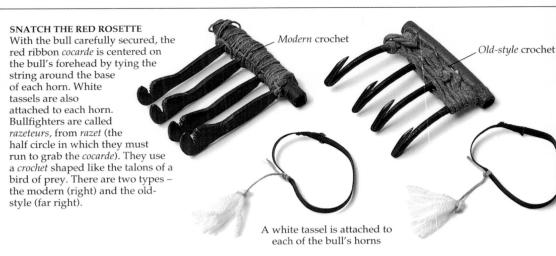

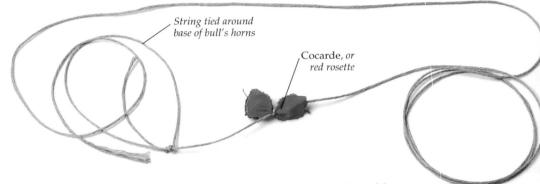

Only the brave fight the bulls

Provençal bullfights are tests of daring and skill, without the blood and death of the Spanish *corrida*. On foot, men try to snatch a *cocarde* (rosette) tied between the bull's horns, using a *crochet* (hook). A Camargue bull can charge quicker and turn more sharply than a fast horse, so the game is dangerous as

well as exciting. The bulls are taken back to their manade (herd) when the spectacle is over. Today in the Camargue, there are around 60 breeders of the black Camargais bulls, while over 20 breed the Spanish bulls.

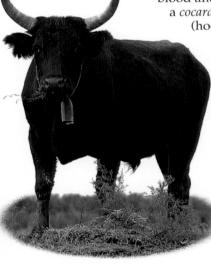

BULL'S BELL

Amid the marshes of the Camargue, wandering or injured animals may be hard to find. Gardians tie bells around the necks of herd leaders, both cows and bulls. The bells are made of brazed sheet metal. Different sizes and shapes make different sounds, so an owner can distinguish which is his animal.

THE BRAVE BLACK BULL

A distinct type, the original Camargue bulls may trace their ancestry back to those of the prehistoric cave paintings at Lascaux in southern France. With black, curly, shiny coats, they are fierce and independent. Raised only for fighting, some have been crossbred with Spanish bulls since a famous gardian, Joseph Yonnet, began this trend in 1869.

Ancient trident >

BY A NOSE

This mouraü is for weaning young calves.
Made of willow wood, it is fitted in the calf's nose.
If the calf raises its head to suckle at its mother's udder, the wood blocks its mouth, but it will swing away from the mouth if the calf lowers its head to graze.

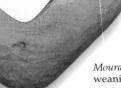

Mouraü – for weaning young calves

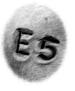

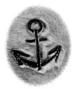

Two brand marks – the left one is from the French Stud Farm Service ("E" refers to the year of birth; "5" means the fifth foal of the year); the anchor brand (right) belongs to a former sailor

ABOUT BRANDS AND BRANDING

The ferrade (branding) of yearlings, both horses and cattle, is a popular spectacle. Each owner has his personal mark, usually initials or a simple symbol. The brand on the right, belonging to a prominent gardian family, is most elaborate. The two superimposed hearts symbolize a mother and her sons. Horses also must carry the mark of the French Stud Farm Service (left) – a letter and a number indicate the year and order of birth of the foal.

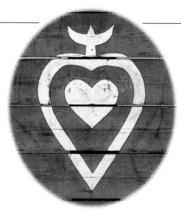

Brand marks of a well-known *gardian* family – the hearts symbolize a mother (outer heart) and her two sons (the inner hearts)

ON FIRE

Camargue branding irons, which are heated in a wood fire, have longer shafts than those used in America. Bulls used to be tripped up on the run with a trident and branded as they lay on the ground. Now cattle and horses are lassoed, made to lie down, given a type of local anesthetic, and branded on the left thigh.

ANCIENT AND MODERN

The gardian's trident is perhaps descended from the 14th-century knight's three-pointed jousting lance. It is still used in the fields to drive the cattle, to turn a charging bull, or to separate the bulls, which will

which will fight to the death sometimes. In the arena, there used to be a contest where a bull's repeated charges would be stopped by two men with tridents.

Modern

trident.

WILD WHITE HORSES OF THE CAMARGUE

These "white horses of the sea" have bred wild in the marshes of the Camargue for over a thousand years. They have distinctive wide heads, short necks, and long, thick manes and tails. Their very broad hooves have adapted to the soft, wet marshland. The 1951 French film *Crin Blanc* (White Mane), aroused world interest in these striking horses and the Camargue.

Confrérie dates from the 1820s. Made of crimson embroidered silk, it carries the emblem of St. George slaying the dragon.

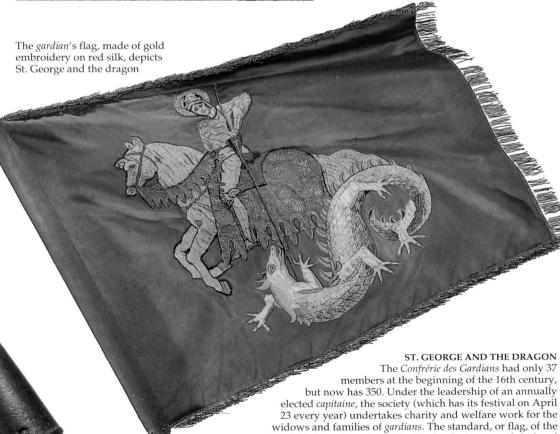

ABORIGINAL STOCKMEN Australia's original inhabitants (the Aborigines) were made to work on outback cattle stations in the 1800s. However, Aborigines quickly adapted to stock work and made it part of their way of life. Since the 1970s they have been buying and running

Cowboys down under

On the drief of all the continents, raising cattle in Australia's vast outback has never been easy, though it has been an important industry since the 1830s. The stockman, or "ringer" – from ringing, or circling, the mob (herd) at night – has become a legend like the American cowboy. For mustering (rounding up) and droving he rode a waler, a distinctive breed from New South Wales. However, the legend belies the fact that many stockmen were Aborigines or, indeed, women. And today, jackeroos (trainee cattle station managers) have been joined by jilleroos. Stations can be huge – some average over 500,000 acres (200,000 hectares). Light airplanes, helicopters, and motorcycles are replacing horses for mustering. Australia now has more cattle (24 million) than people (17 million). By eating the land bare during drought, cattle are becoming a threat to the environment.

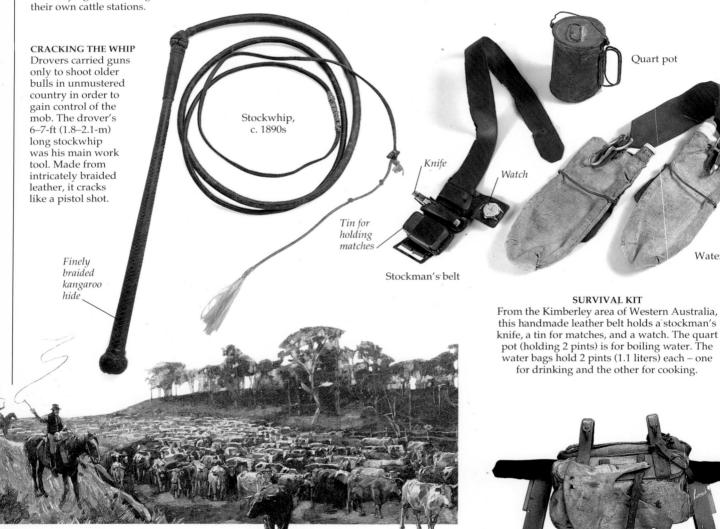

Stockmen drove mobs of cattle incredible distances across the continent (pp. 38–39). Nat Buchanan pioneered stock routes from Queensland into the Northern Territory. In 1883, he and 70 drovers brought 20,000 shorthorns 1,800 miles (3,000 km) to stock Victoria River Downs.

INTO THE FAR COUNTRY
For mustering and droving trips, pack saddles
carried food and essential equipment. They
were expected to endure long, hard use, so
were made from and repaired with
greenhide (untanned leather).

Water bags

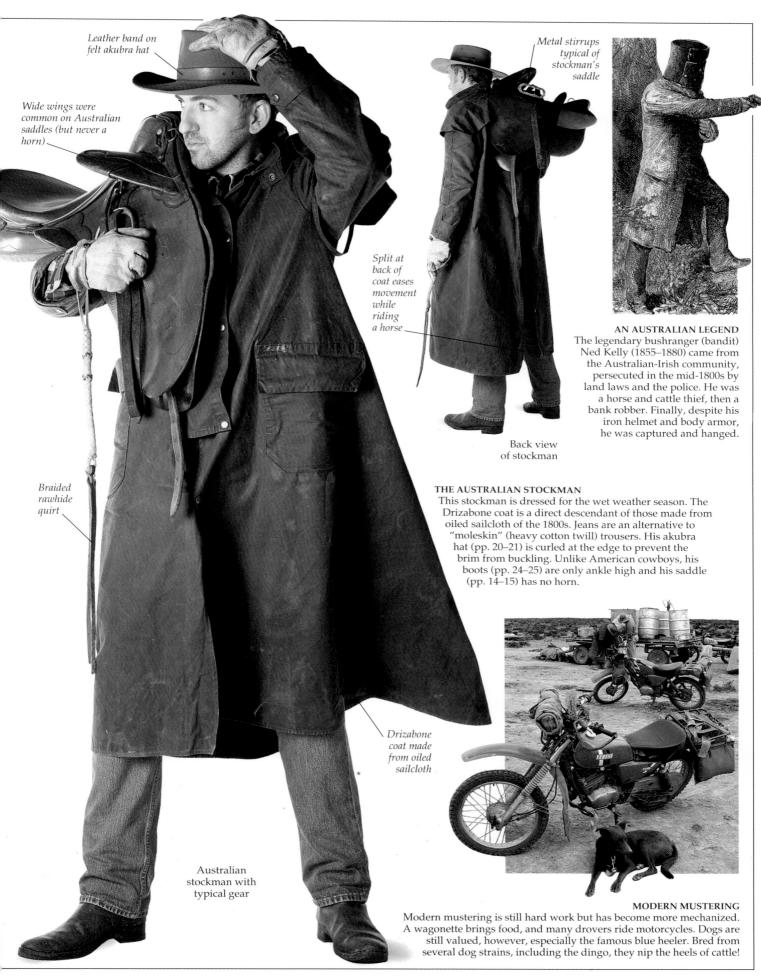

"WHEN THEY WERE BAD, THEY WERE HORRID"

Belle Starr (1848–1889), the "Bandit Queen," was invented by newspapers and dime novelists. The real Belle had a procession of outlaw boyfriends, then organized her own small-time gang in Indian territory, until she was shot – possibly by her own son.

On the world's cattle frontiers in the 1800s, women made their own contribution to taming the wilderness. Those who married worked desperately hard to make homes in grim conditions – and many died of it. In the American West, cowgirls as such were unknown until recent times, though there were some cattle baronesses, like Susan McSween, widow of one of the participants killed in the Lincoln County War (pp. 44–45) in

1878. Hollywood has glamorized the job of saloon girl, at best a brief and unrewarding career. Some women turned to crime and had their exploits exaggerated by a sensationalist

press, like those of "Cattle Annie" McDougal and Jennie "Little Britches" Stevens in 1893–1894.

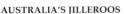

Jackeroos, those who aimed to become managers of Australia's cattle stations, have traditionally learned the business by first working as stockmen (pp. 56–57). In recent years, so too have more and more women, like these two iilleroos from New South Wales.

CANADIAN COWGIRL

including the uneasy

addition of a pistol.

Wives and daughters of Canadian ranchers came to share range work as strict 19th-century attitudes toward women faded. This camera-shy cowgirl (c. 1920) from western Canada wears a cowboy's outfit,

Body leans in direction that

rider wants

horse to take

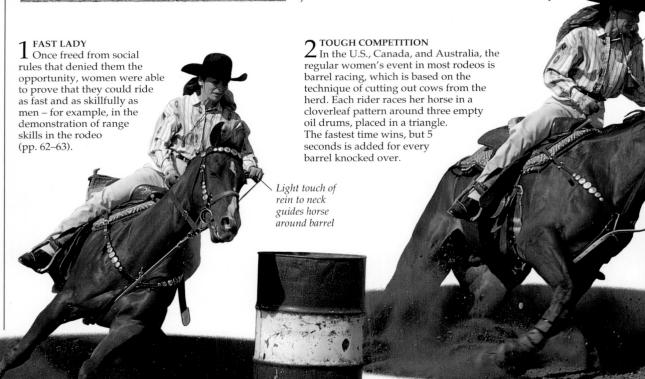

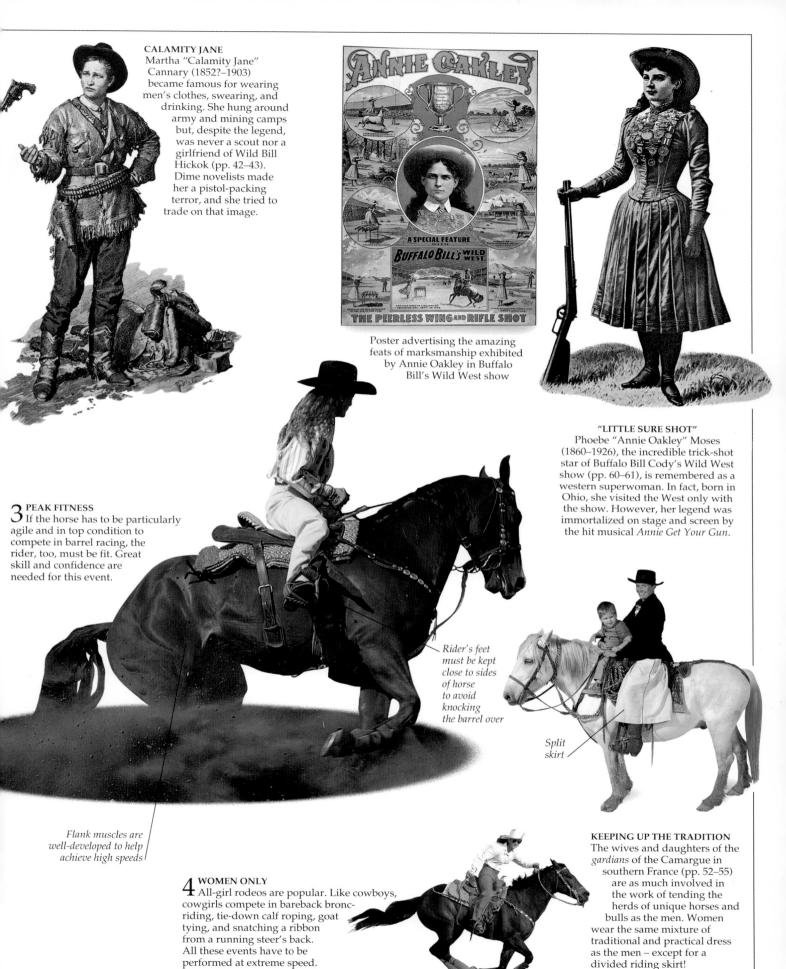

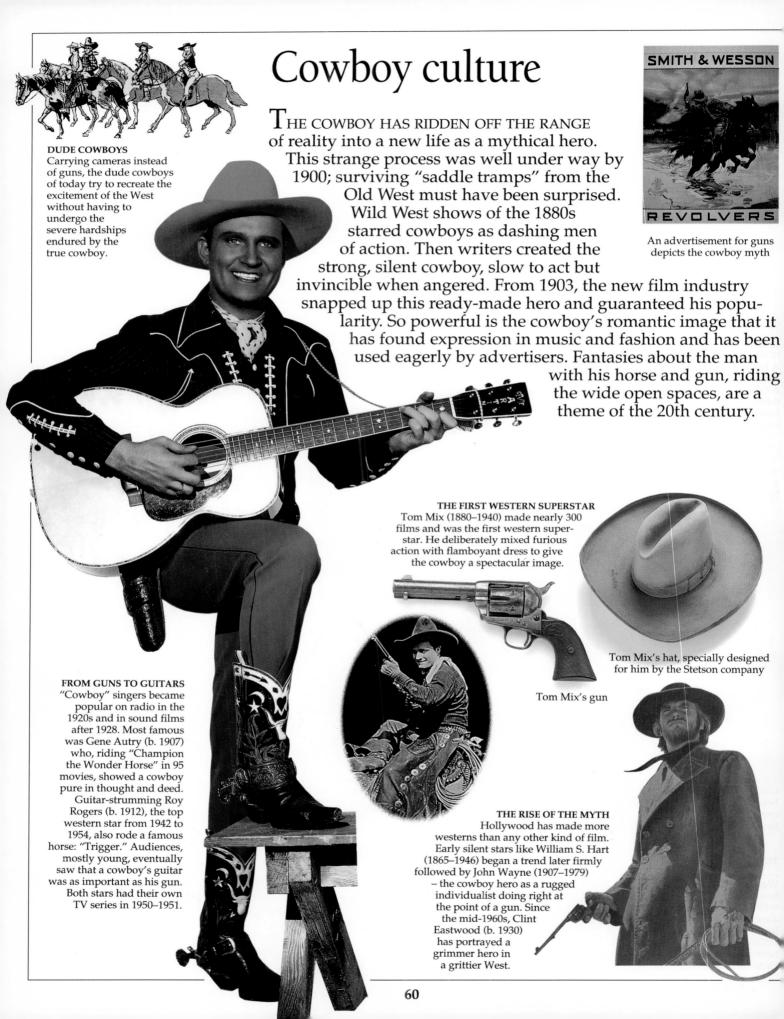

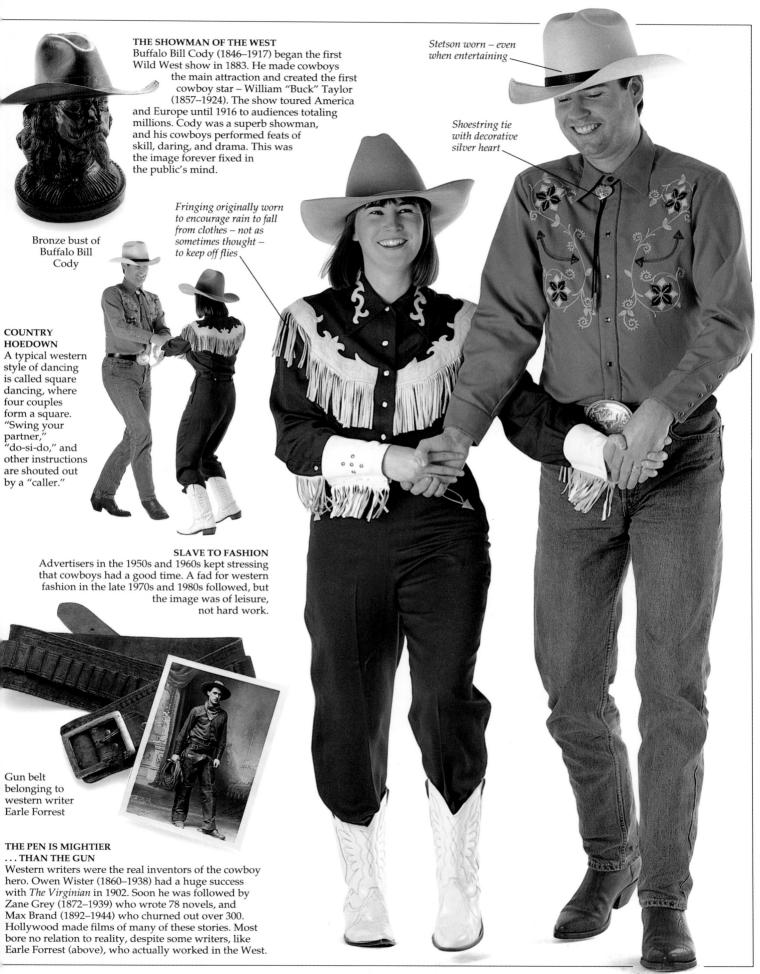

Rodeo thrills and spills

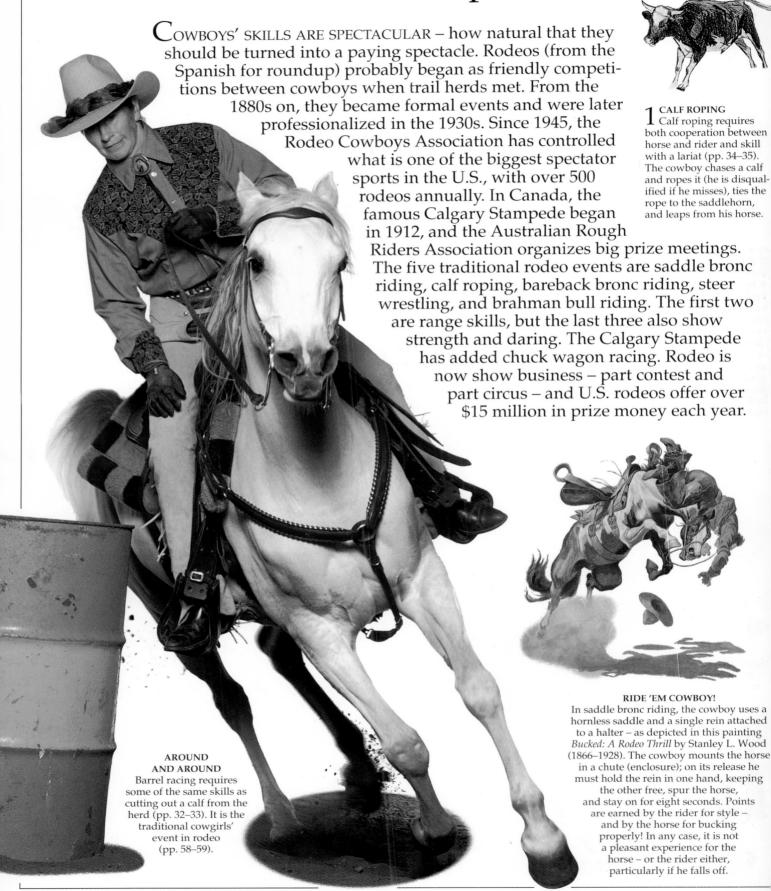

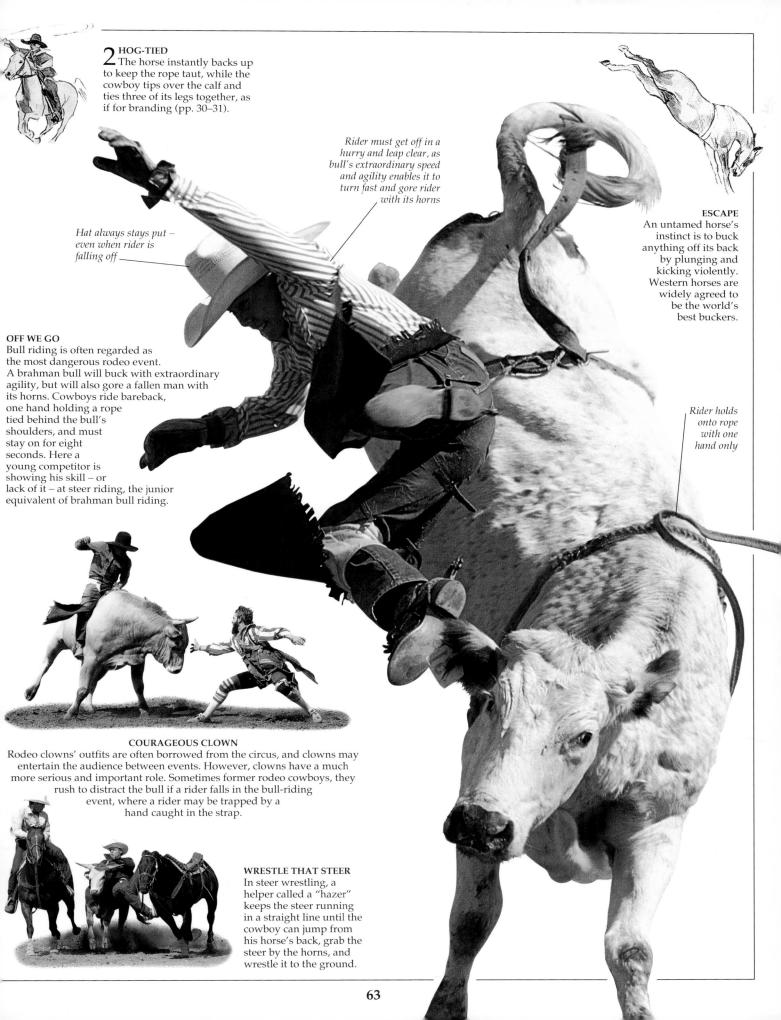

Index

A

Aborigines 38, 56 African-Americans 18 Allen & Wheelock gun 44 Annie Oakley 59 Australian Rough Riders Association 62 Autry, Gene 60

В

barbed wire 28 Baroncelli, Marquis 52-53 barrel racing 58-59, 62 bedroll 17, 22, 36-37, 41 bell (lead animals) 13, 54 belt buckles 23, 49, 61 Billy the Kid 45 bits 16-17; marmaluke 16 blue heeler 57 Bohlin, Edward H. 9, 15 boleadoras 48-49 hombachas 48 bombilla 48 boots 22-27, 41, 49, 52-53, 57; botros de potro 49 bosal 26 Bowie, Colonel James 38 Brand, Max 61 brands/branding 19, 24, 26, 30–32, 34, 52, 55, 63 breaking horses 11-12, 19,48 bridles 9-10, 12, 16-17, 27, 48, 53; hackamore 12, 16; headstall 16, 26 bronc riding: bareback 59, 62; saddle 62 Buchanan, Nat 56 bucking horses 62–63 buffalo 30, 40, 45 bullfighting 13, 54 bull riding 62-63 bulls 6, 30-31, 52-55 buttero 6

C

caban 53 cabane 28, 52–53 Calamity Jane 59 calf roping 34, 59, 62–63 Calgary Stampede 62 Carson, Kit 47 cattle 6–8, 30–35, 38–41, 48; Aberdeen angus 30–31, 33; Hereford 30–31, 33; longhorn 8, 25, 28, 30, 38, 41; shorthorn 30–31, 56; zebu 33, 50–51, 63 "Cattle Annie" 58 cattle station 28–29, 56, 58 cattle trails 24, 36, 38–39,

cattle station 28–29, 56, 58 cattle trails 24, 36, 38–39, 42; dangers 40–41 *chaparejos* (chaps): *armitas* 24, 26–27; batwing 7, 18–19, 26–27; shotgun 23, 26; woolies 19, 26

18–19, 26–27; shotgr 23, 26; woolies 19, 2 chap hook 24–25 charros 7–11 Chisholm, Jesse 39 chuck wagon 36–37; racing 62

cinch (girth) 10–12, 14–17, 35 cinturon 49

Clantons 43 clothes: American cowboy 7, 16–19, 22–23, 26–27, 39, 41; charro 7–9; gardian 6, 52–53; gaucho 48–49; stockman 37; vaquero 11 cocarde/cocardiers 54 Cody, Buffalo Bill 11, 47, 61; Wild West shows

11, 14, 34, 59–61 Colt guns/rifles 8, 22, 26–27, 40, 44–47 Colt, Samuel 47 conchas 7–9, 11, 15, 24–27 Confrérie des Gardians 52 Cortés, Hernando 9 course à la cocarde 31, 54

cow towns 42 crochet 54 csikosok 7 cuffs 22, 26 cutting cattle 32–35 "cutting critter" 33

cowgirls 32–33, 58–59, 61–62

DE

dally 35 Dalton, Emmett 45 "Deadwood Dick" 18 Desperate Dan 36 drag rider 40 drovers 18, 56–57 dude cowboys 60 Earp, Virgil 42; Wyatt 43 Eastwood, Clint 60 espelos 50 estancieros 51 estribos 51

F G

facón 49 ferrade 31, 55 Forrest, Earle 61 Garcia, G.S. 11 gardians/gardianes 6, 14, 20, 28, 52-55, 59 Garrett, Pat 45 gauchos 6, 10, 12, 29, 48-51 goat tying 59 Goodnight, Charles 37, 39 Grey, Zane 61 guardia rurales 43 guns 8, 22-23, 26-27, 40, 44-47,60 gunslingers 42-45, 47

Н

hacendado 8 hacienda 9 Hardin, John Wesley 45 Hart, William S. 60 hats 18-21, 23, 26-27, 48, 53, 57, 60; akubra 20, 57; sombreros 9, 11, 20-21; ten gallon 21 Hickok, Wild Bill 42-43, 47,59 hobbles 17 holster 8, 22-23, 27 honda 34 horses 12-13, 32-35; American saddlebred 8-9: Andalusian 6-8. 12-13; appaloosa 19; barb 6; Camargue 6, 13, 52-53, 55; criollo 8, 11-12; Don 13; lusitano 13; maremmana 6; mustang 6-8, 12, 32; nonius 13; Peruvian paso 8, 50; pinto 19; Przewalski 12; quarter horse 13, 17, 19, 32; thoroughbred 12; waler 56

IJK

Indian Police 43 jackeroos/jilleroos 56, 58 James family 42; Frank 44; Jesse 44 Kamehameha III, King 10 Kelly, Ned 57 knives 38, 49; bowie 38

I

Lake, Stuart 43 lariat 12–13, 17, 22, 26–27, 34–35 law badges 42–43 lawmen 42–45, 47 line camp 28 "Little Britches" 58 *llanero* 6, 50 long johns 22 Love, Nat 18 Lozano, David 8 Lucky Luke 21

M

mail order catalog 22, 29 manades/manadiers 52-53 mas 53 Masterson, Bat 43 maté 48 mavericks 31 McSween, Susan 58 Meager, Michael 42 meatpackers 31 mecate 26 Mistral, Frederic 52 Mix, Tom 21, 24, 60 mob (of cattle) 56 Mongolian herdsmen 29, 35; Kazakh 12 "Morris" 21 mouraü 54

N O P

тоиѕсай 53

"mule ears" 24–25

mustering 56-57

Native Americans 7–8, 12, 19, 40–42, 48–49; Nez Percé tribe 19 nerf de boeuf 53 Newton, Thomas 9 Nix, Evett 43 O.K. Corral 43 paniolo 10 panuelo 48 "piggin' string" 34 Pinkertons 42 polling 31 pony: Argentinian polo 12; Mongol 12; Texas cow 12, 17

Q R

quirt (whip) 11-12, 15, 17, 20, 27, 51, 53, 57 railroads 38-39 ranch 28-29 ranchos 29 razeteurs 54 reining patterns 32 reins 16–17, 26, 32–33 Remington, Frederic 12, 19, 26, 42, 44 Remington guns 27, 45 rifles 26, 36, 40, 45-46 rodeo 18, 23-25, 34-35, 58-59, 62-63; clowns 63 Rodeo Cowboys Association 62 Rogers, Roy 20, 60 Rogers, Will 34 romals 17 Roosevelt, Theodore 19 ropes and roping 24, 32, 34–35, 50 roundup 32, 48; modern

ST

Russell, Charles 26

rustlers 31

sabots 52
saddlebags 8, 13, 17, 53
saddle blanket 9, 17, 23
saddlemaking 8–9, 16
saddles 7–10, 14–18, 23,
35, 50–51, 53, 56–57
saddling a horse 16–17
seden 14
Sharps rifle 45
shoo fly 11, 53
sidesaddle, ladies 8
Simpson, Charles 35
Smith & Wesson gun 44,
60
Spanish conquistadors
7–9, 13, 16, 24, 30, 38
spurs: gal-leg 24; jinglebob 11, 24–25; prick 11,

24; rowel, 11, 23–27, 50–53; shank 11, 25 square dancing 61 stampede, cattle 40 Starr, Belle 58 Starr revolver 40 steer wrestling 62–63 Stetson, J.B. 21; label 20 stirrups 8, 16, 23, 51, 57; shoe 8, 51 stockmen 20, 56–58 stock routes 38, 56 stockwhip 56

Т

talabarteria 8
tapaderos (taps) 8, 14–15, 23
Taylor, "Buck" 61
Texas 18–19, 23–24, 27, 29, 30, 38–39, 45
Texas Rangers 42, 47
Thomas, Heck 43
tobacco, Bull Durham 36
trail drives 18, 38–41
trident 53–55
troussequin 53
Twain, Mark 43

VWY

vaquero 7-11, 21, 26, 31, 33-34 Walker, Captain Samuel watches, pocket 22, 56 water containers 41; supply 28, 40-41, 56 Watkins, Dudley D. 36 Wayne, John 26, 60 Wells, Fargo 42, 44 Western advertisements, fashion, films, books, magazines, music 6, 9, 18, 20–21, 24, 31–32, 43, 47, 55, 60-61 Wheeler, Edward L. 18 "wild rag" 26 Winchester rifle 45–46 windmill 29 Wister, Owen 61 wolf 40 Wood, Stanley L. 41, 62 Yonnet, Joseph 54 Yosemite Sam 45 yurt 29

Acknowledgments

Dorling Kindersley would like to thank:

The Mailhan family (Marcel, Pascal, Caroline, Raoul, and Jacques), Roger and Louis Galeron, and Mme. Françoise Yonnet for providing props, animals, and models for the photo shoot in the Camargue, and Céline Carez for organizing the trip. Graham and Karen Aston, BAPTY & Company Ltd, The Rev. Peter Birkett MA, Brian Borrer's Artistry in Leather (Western Saddlemaker), Goodev's Foxhill Stables & Carriage Repository, J.D. Consultancy (agent for J. B. Collection), Bryan Mickleburgh's American Costumes & Props, Ros Pearson's Avon Western Wear, David Gainsborough Roberts, and Walsall Leather Museum for providing props for photography.

Pam and Paul Brown of Zara Stud, Peter and Mandy Richman of Cotmarsh Horned Pedigree Hereford/ Creeslea Aberdeen Angus (Swindon), Sterling Quarter Horses, Val Taylor's Moores Farm, Twycross Zoo, and Sheila Whelan's The Avenue Riding Centre for providing animals and riding arenas for photography. Karl Bandy, The Rev. Peter Birkett, Brian Borrer, Pam and Paul Brown, John Denslow, Wayne Findlay, Dave Morgan, Andrew Nash, Helen Parker, Scott Steedman, Francesca Sternberg, and J.B. Warriner as models Bob Gordon, Manisha Patel, Sharon Spencer, Helena Spiteri, and Scott Steedman for editorial/design help. Lucky Productions S.A., Geneva, Switzerland for permission to reproduce "Lucky Luke".

huaso 6, 50

Authenticators: Graham Aston, Jane Lake, and James White Index: Lynne Bresler Map: Sallie Alane Reason Model: Gordon Models Mongolian paintings: Ts Davaahuu

Picture credits

a=above, b=below, c=center, l=left, r=right Australian Picture Library, Sydney 58cl. Australian Stockman's Hall of Fame 56cr, 56br.

Bettmann Archive, New York 40tr.
Bruce Coleman 36ct, 36cl, 36cb.
Culver Pictures Inc., New York 39bc.
© Dorling Kindersley: Bob Langrish 6–7ct, 13tr, 13ctr, 13cbr, 13ch, 18–19ct, 19c, 19cr, 50cr; Jerry Young 40bl, 40br, 41cl, 41c;
Dave King 45t, 47cr.

Mary Evans Picture Library 6tl, 7cr, 7br, 13br, 25br, 31cr, 33cr, 34tl, 51tr, 56bl, 57tr. Ronald Grant Archive 45bc.

Hamlyn Publishing Group (from The Book of the West by Charles Chilton, © Charles Chilton 1961) 60tl. Guy Hetherington & Mary Plant 29tr, 35t. Hulton Deutsche/Bettmann Archive 45br. Hutchinson Library 6cl, 12cl, 49tl. Kobal Collection 21tr, 601. Bob Langrish 10bl 10bc, 11tl, 12bl, 32tl, 33tl, 33tc, 33tr, 34bl, 34cr, 58bl, 58br, 59cl, 59b, 59br, 62l, 63cl, 63bl, 63r. From the "Dalton Brothers Memory Game" published with the authorization of LUCKY PRODUCTIONS S.A., GENEVA, SWITZERLAND 21br. Peter Newark's Western Americana and Historical Pictures 11cbr, 12tl, 17bl, 18bl, 19bc, 20tr, 26bl, 28tl, 30cl, 31br, 37tr, 38tl, 39bl, 41tl, 41bl, 42cr, 43cl, 45ct, 47tc, 58tl, 58tr, 59tl, 59tc, 59tr, 60tr, 60cb, 60br, 63cr. Photographic Library of Australia, Sydney: Robin Smith 29cl, 56tl; Richard Holdendorp 57br. © D.C. Thompson & Co. Ltd. 36bl.